Dear Pam and ...
Merry Christmas ...
a Happy New Year!
Vida, Kuti...

Berlin, Dezember 2004

4

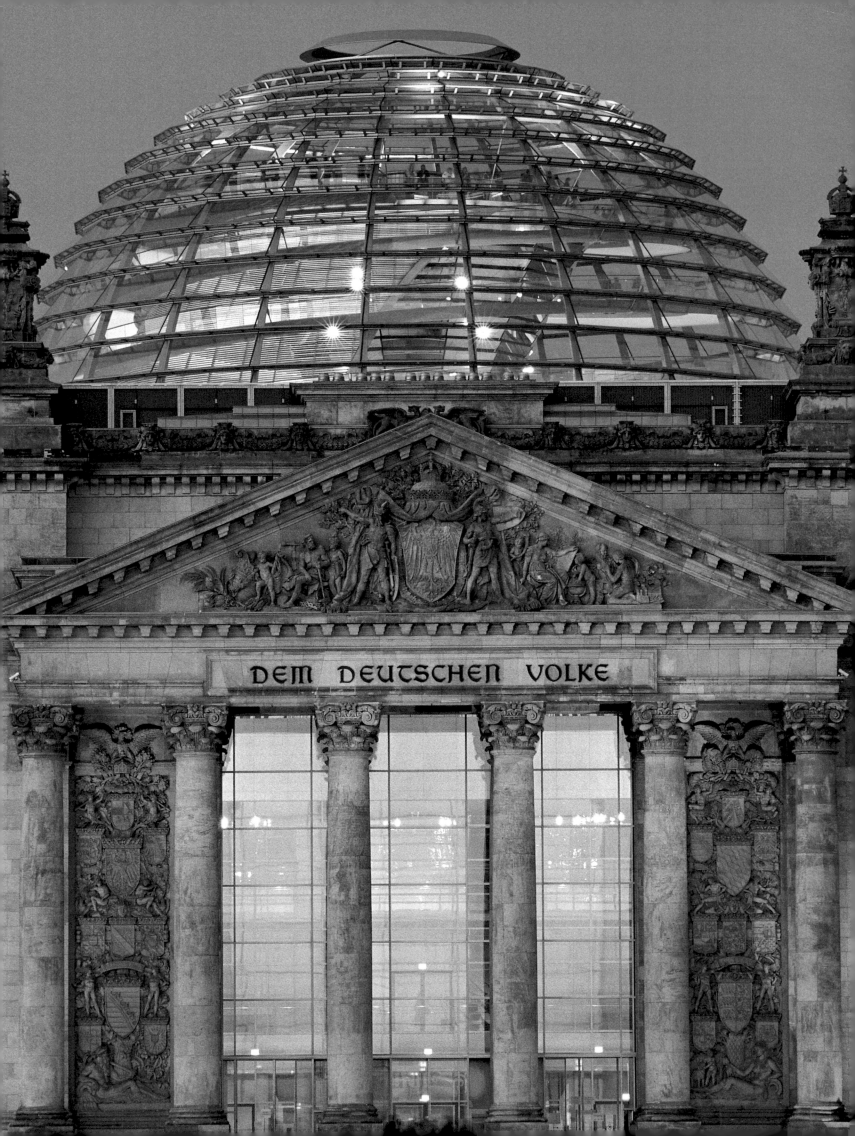

BERLIN

Brandenburg Gate and Pariser Platz, now completely pedestrianised, have become Berlin's eye of the needle. Locals don't mind the inevitable detours and long traffic jams, however; they're pleased to have gained a new public showcase bang in the heart of the city.

WITH PHOTOS BY JÜRGEN HENKELMANN AND TEXT BY VOLKER OESTERREICH

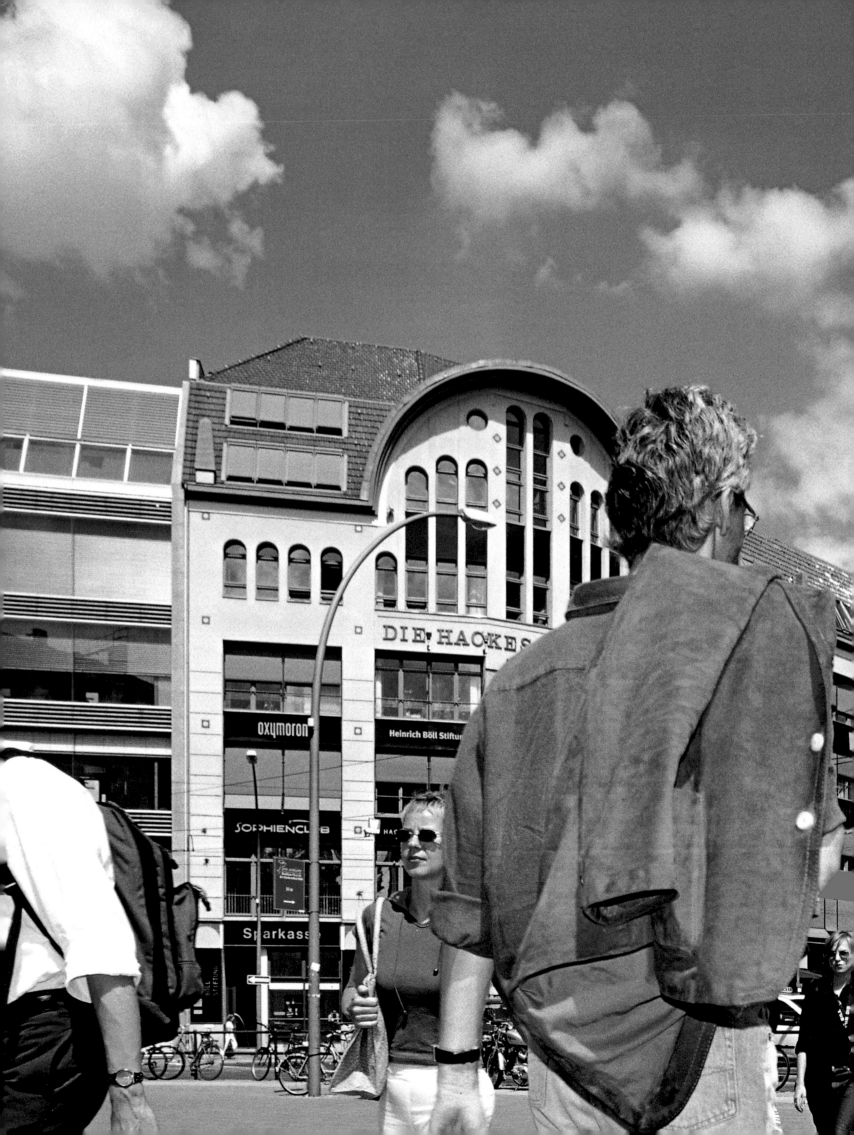

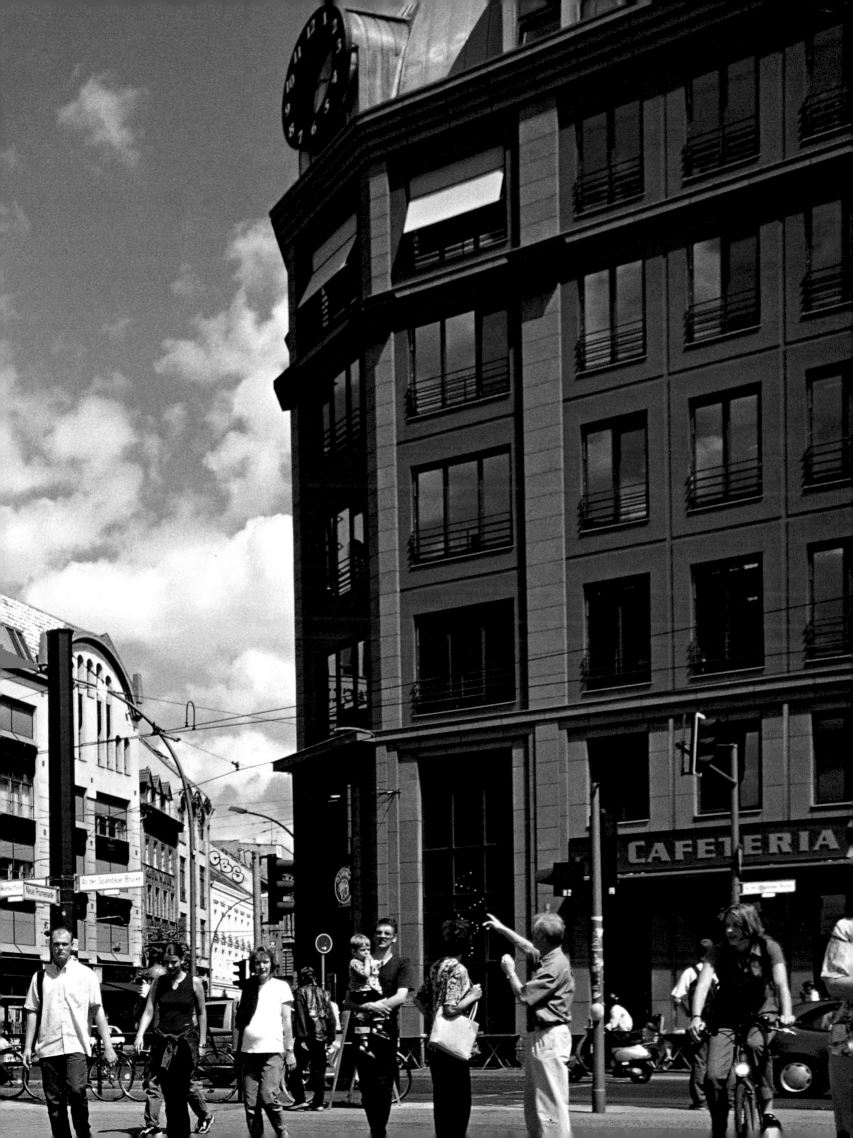

CONTENTS BERLIN

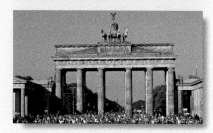
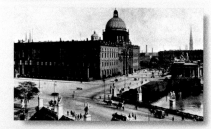

First Page:
The symbol of the Berlin Republic.
Under the new glass dome of the Reichstag
Germany's politicians engage in their daily
wranglings over taxes, unemployment and
defence. Soon after the move from Bonn
to Berlin the building began to loom large
on TV sets across the country, a popular
backdrop to interviews and special reports.

Page 8/9:
Huge amounts of cash have been pumped
into the restoration of the Hackesche Höfe –
and the investment was well worth it.
The colourful mixture of art galleries,
theatres and restaurants – hidden behind
the fenestrated facade on the left – has
become a real crowd-puller.

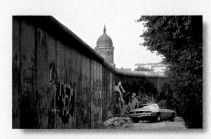
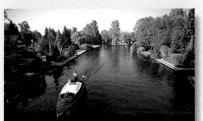

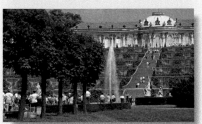
Page 12/13:
Berlin Cathedral in winter. The architectural
language of the mighty domed edifice from
1905 eloquently expresses the religious fer-
vour and imperial might of Prussia's former
rulers, the Hohenzollern. Many are laid to
rest in the cathedral vaults.

Page 14/15:
The glass roof covering the piazza of Helmut
Jahn's Sony Center like a giant umbrella is a
real feat of engineering on Potsdamer Platz.
The pool and fountains in the centre of the
square reflect the roof and sky beyond.

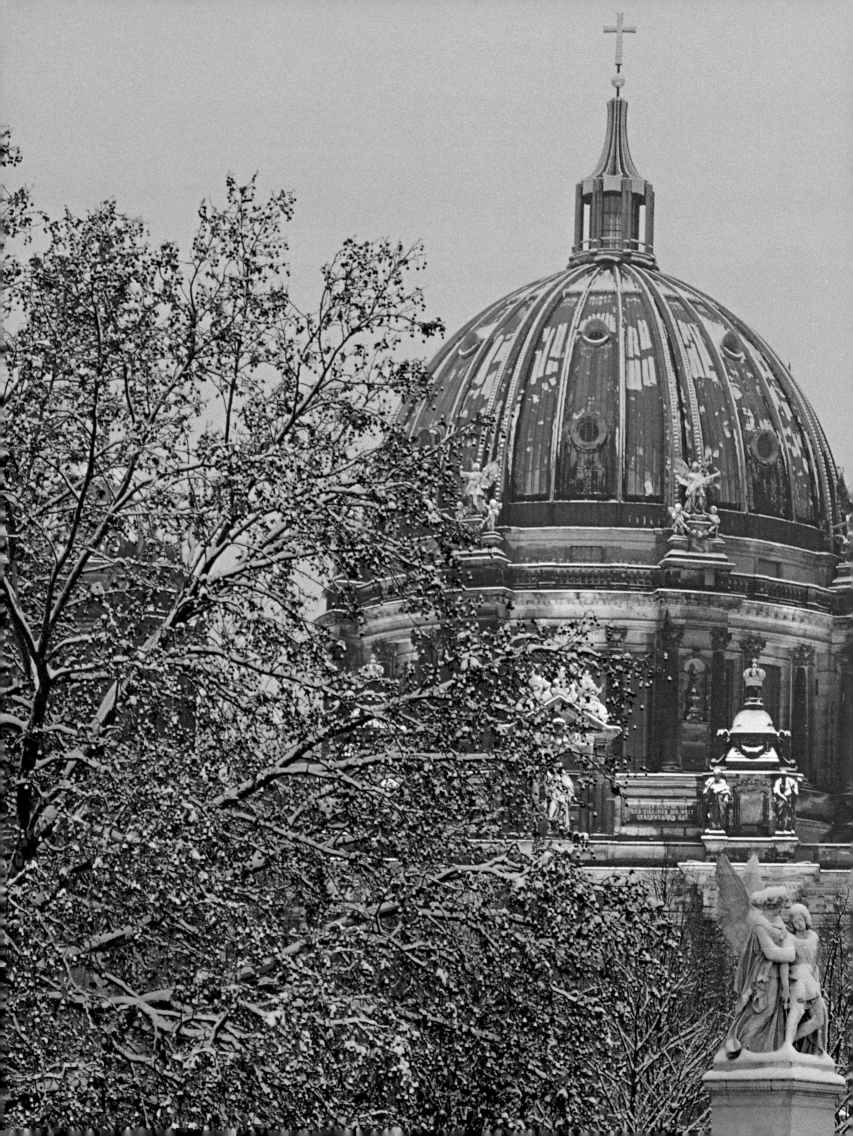

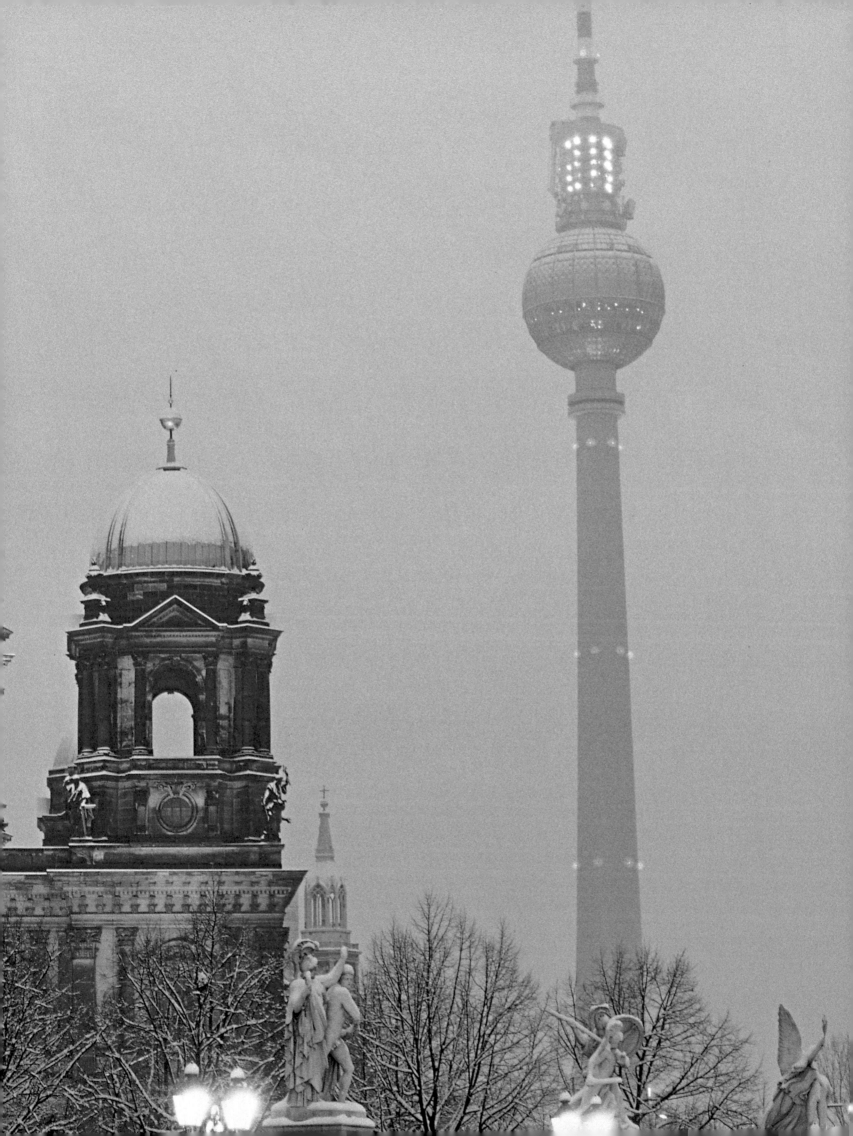

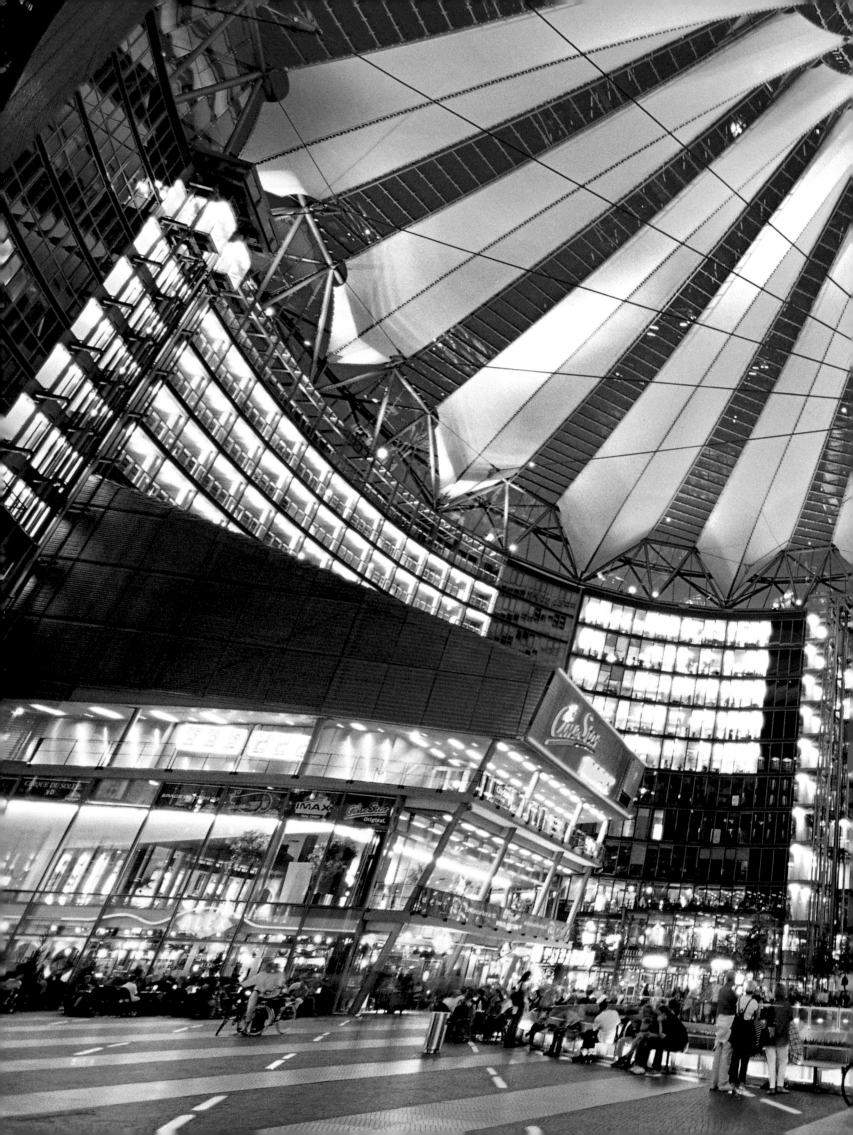

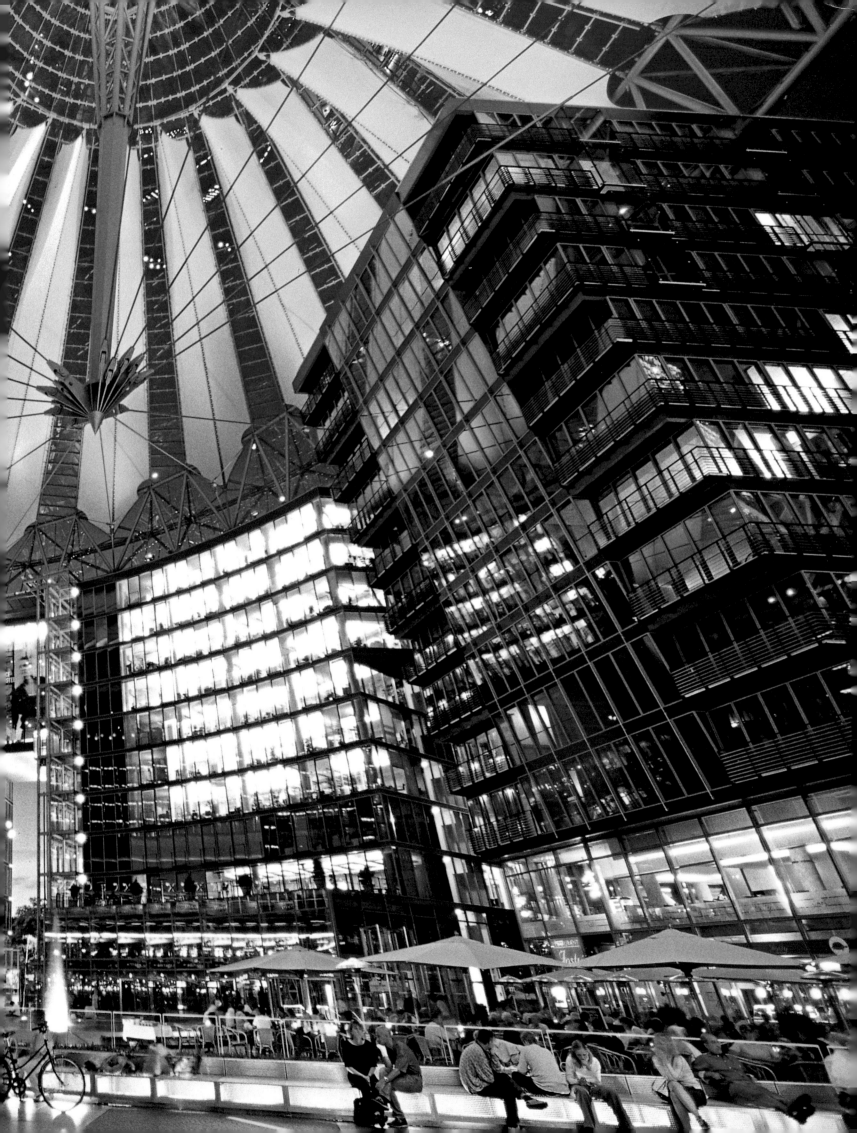

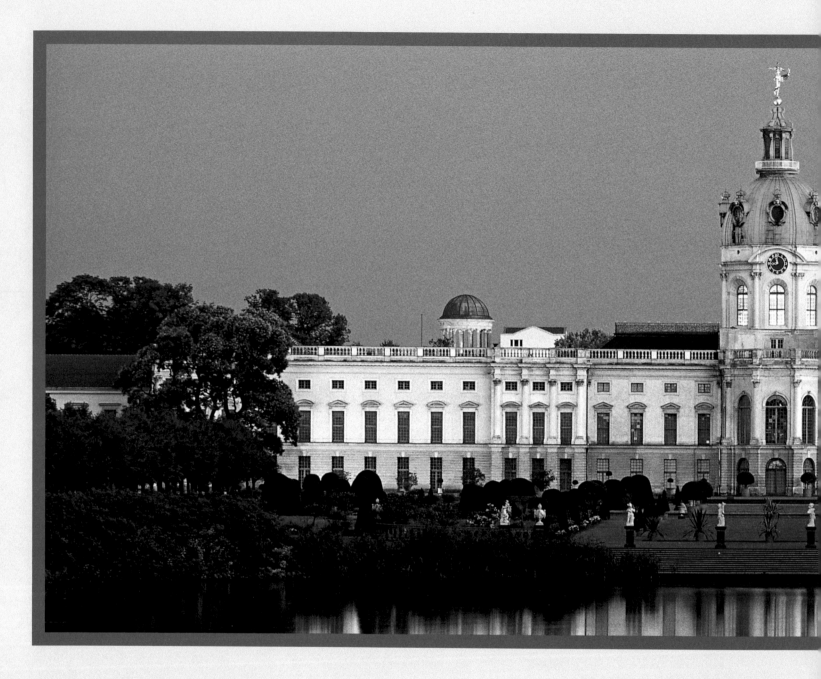

OPPOSITES ATTRACT – 345 SQUARE MILES OF BERLIN

In no other city in Europe do yesterday, today and tomorrow coexist as readily as they do in Berlin. When the coalman trudges down into a cellar in Wedding or Karlshorst with a bundle of briquettes on his back, Charles Dickens immediately springs to mind; modern contemporaries gazing up in awe at the futuristic glass Fujiyama of the Sony Center on Potsdamer Platz feel as if they've been beamed into some distant galactic time zone. And while the occasional crumbling facade in one of Berlin's more degenerate districts is still pockmarked with bullet holes from the Second World War, the powers that be in the city's administrative headquarters – with varying degrees of success – are already

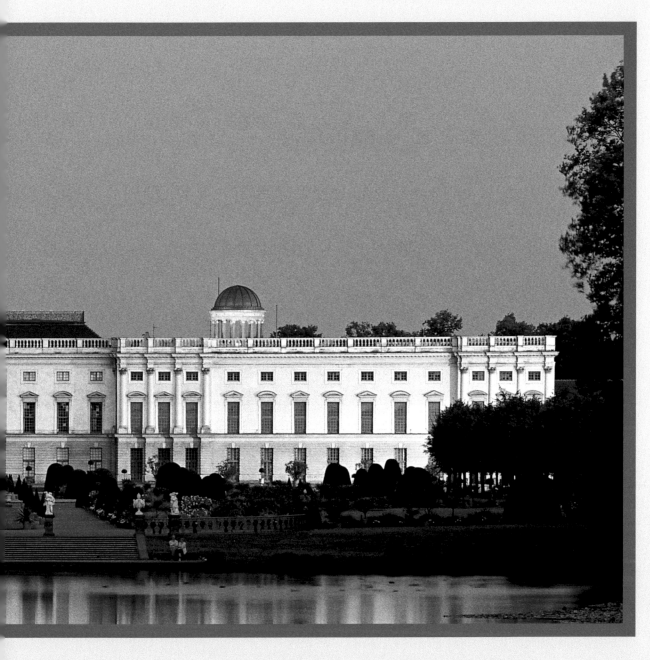

Almost totally annihilated during the Second World War, Schloss Charlottenburg has now been completely restored, providing advocates of the rebuilding of the old city palace in Berlin-Mitte with a solid argument for their cause. Baroque Charlottenburg is enormous, stretching over half a kilometre in its entirety.

piecing together the future of the Continent. These are dimensions very similar to the crass contrasts of Fritz Lang's classic silent movie "Metropolis", both grey and ugly and bright and colourful. In his social satire "Fabian", published at the beginning of the 1930s, Erich Kästner eloquently encapsulates the idiosyncratic melange that is Berlin when he writes: "In as far as this enormous city is made of stone, it is much as it always was. As far as the inhabitants are concerned, however, it has long been a mad house. The east is home to crime, the west to swindle, the north to squalor, the south to fornication, and every which way you turn you find decline."

TURNSTILE BETWEEN EAST AND WEST

The huge urban conglomeration which is Berlin, sprawled out across the aqueous network of the Spree, Havel, Dahme, Panke and Wuhle rivers, is indeed difficult to fathom, even for the locals. Unless you merely concentrate on the tourist attractions, that is, nicely packaged into two bus trips aboard either the 100 or the 200, running from Bahnhof Zoo to Alexanderplatz or a GDR "Plattenbau" estate near the Jewish cemetery at Weißensee. By car the journey from Kladow in the far southwest to the idyllic Rauchfangswerder Peninsular in Köpenick takes a good two

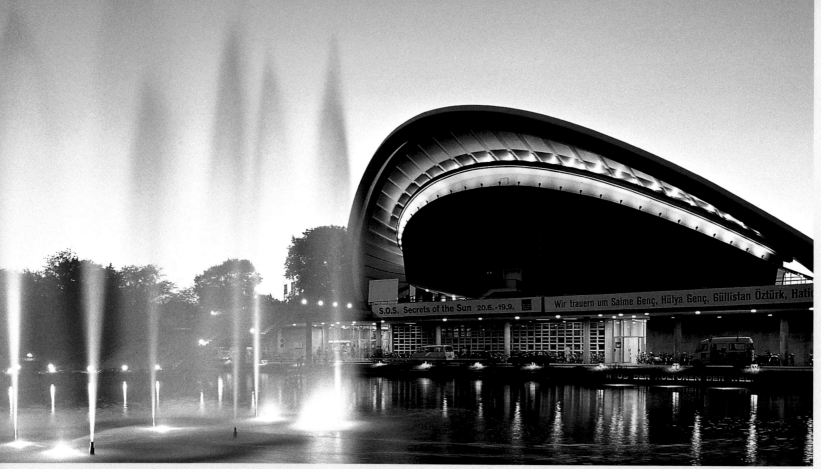

hours. The metropolis is home to 3.5 million and measures 40 kilometres (25 miles) in diameter. At 890 square kilometres (345 square miles) it even dwarfs New York and its entire five districts. The 134,000 students at Berlin's four universities and 12 colleges of higher and further education alone are enough to populate an entire city. The same goes for the 140,000 Turks whose shops and markets are a composite part of the city's makeup, particularly in Neukölln, Kreuzberg, Wedding and Tiergarten. And if you want more numbers, a full circuit of the motorway orbital round Berlin will put 195.8 kilometres (122 miles) on the clock. That's about the same as driving from Frankfurt to Cologne, from London to Birmingham or from New York City to Philadelphia, PA.

Many see Berlin's location as its biggest asset; first mentioned in documents from 1237, today the city is more and more becoming a turnstile between Central and Eastern Europe. From its easternmost boundaries it's a mere 70 kilometres (44 miles) to Poland from whence many come to seek casual labour or do some big-time shopping on the Spree. The Russians, too, are positively drawn to Berlin as if by magnetic force – particularly those who got rich quick

after the collapse of the Eastern Block, preferring to shop in the posh boutiques of Charlottenburg or the Friedrichstadtpassage rather than at the GUM state department store on Red Square.

Stores selling the more luxurious of labels have even employed shop assistants skilled in foreign languages in an effort to make their new clientele feel at home. This influx from the east isn't new to Berlin; in the Roaring Twenties, when a good 200,000 Russians fled to the capital in the wake of the October Revolution, the district of Charlottenburg was known as Charlottengrad, with the top-notch boulevard of Kurfürstendamm becoming known as Kurfürstenprospekt in true Soviet style.

THE OLD AND NEW HEART OF BERLIN – POTSDAMER PLATZ

The target of the tourist hype surrounding Berlin has got to be Potsdamer Platz. Karl Scheffler's much-quoted quip that Berlin "is damned to constantly evolve and never to be" is best manifested in the precipitous development of this city within a city. Standing under the enormous glass tent spanning the 4,000 square metres (ca. 43,000 square feet) of the Sony Center piazza, you can only rub your eyes in disbelief at this shiny new edifice glowing alternately green and purple in the urban twilight.

After Daimler-Benz subsidiary debis the Japanese electronics magnate was the second big investor to reawaken this legendary no-man's-land from its Cold War slumber, transforming

it within the space of a few years into the exuberant epicentre of Berlin.

Way back in 1896 a character in Theodor Fontane's "Poggenpuhls" rhapsodised that Potsdamer Platz "...was the liveliest place. And life is the best thing a big city can have." The novelist, theatre critic and "wanderer through the Marches of Brandenburg" knew the square like the back of his hand, as he lived just around the corner from it. "Potsdamer Straße 134c, Fontane, Theodor, writer" was the terse entry in Berlin's address book from the 1880s. The house (later renumbered 15) no longer exists; it was torn down in 1905. A few decades later Fontane's "liveliest place" became even livelier.

In 1928 Theodor Wolff's much revered "Berliner Tageblatt" reported in one of its features on the "herds of automobiles", on the countless omnibuses, on the people who became faceless in the crowds. At that time Potsdamer Platz was said to be the busiest square in Europe. Germany had its first set of traffic lights here, a strange metal tower with clocks, a police platform and a row of flashing signals. A replica squeezed in between the red Kollhoff skyscraper and the glass headquarters of the Deutsche Bahn AG conjures up images of the hectic cities of the

Twenties, inspiring Walter Ruttmann – among others – to compile a magnificent movie collage entitled "Berlin, Symphonie einer Großstadt" (Berlin, Symphony of a City).

Films are big on Potsdamer Platz. Together with the Arkaden shopping centre, the hotels and the musical theatre on Marlene-Dietrich-Platz (part of the overall complex) this medium is the biggest pull for the ca. 70,000 to 100,000 visitors flooding daily to Berlin's new nucleus. Entertainment is a must here – as it was back in pre-war Berlin, when punters flocked to the now legendary Haus Vaterland for their evening cheer.

Below:
Live and let live. During the summer, the legendary Café Golgatha in Viktoriapark is the place where the cool dudes of Kreuzberg hang out, keen to demonstrate that the scene is alive and kicking.

Above left:
"Dolce far niente": Tiergarten park, designed by Peter Joseph Lenn, (1789–1866), is the most treasured green oasis in the middle of the city.

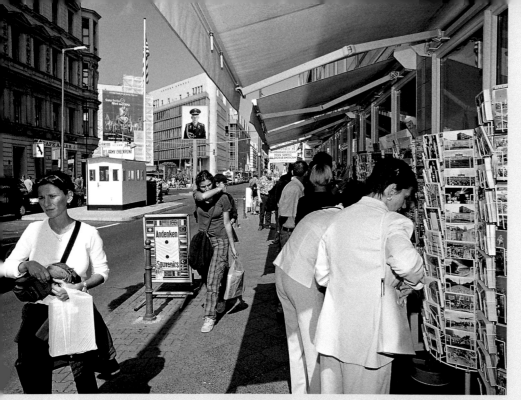

teams are out and about in Berlin filming a new crime thriller for the TV or a big-time movie for the silver screen. And during the international Berlinale film festival each February cineastes from all over the world again focus on Potsdamer Platz, eagerly waiting to see who will hoover up a Golden Bear this time round.

THE MOST BEAUTIFUL GENT'S TOILET IN BERLIN

The sole remnant of the old Potsdamer Platz is the Weinhaus Huth building, accompanied by a few trees which once lined the old Reichstraße 1 running from Königsberg to Aachen. Conductor of the Berlin Philharmonic Wilhelm Furtwängler

Above:
This is as good a place as any to get your postcards and souvenirs: Checkpoint Charlie on Friedrichstraße, the border crossing for Allied troops stationed in Berlin until 1989/90.

Right:
Reminders of a dark chapter in Germany's history. The excavated foundations and cellars of what was the Prinz-Albrecht-Palais were used by the Gestapo, the SS and their henchmen for their terrible deeds during the Nazi period, instilling the fear of death into the local populace. The chambers are now part of the Topography of Terror exhibition.

Centre right:
The flag's flying – the president's in. Schloss Bellevue in Tiergarten is the official residence of Germany's head of state. This is also where most of the country's important guests are wined and dined.

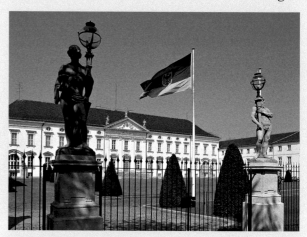

The modern Imax cinema with its 3-D screenings and the two multiplexes, Cinestar and Cinemaxx, provide the other 100-odd picture houses in town with some very stiff competition. Discerning film freaks are catered for by the Stiftung Deutsche Kinemathek and the Kino Arsenal, who in turn are supported in their endeavours by the new film museum with its fascinating exhibits. Here robes and make-up utensils once belonging to Marlene Dietrich are on display, as is the original contract stating Romy Schneider's fee for her role as Sissi; Gerd "Goldfinger" Fröbe can be pursued through the Bond film of the same name and monsters from diverse science fiction and fantasy movies can be gawked at in miniature – all rounded off with the scenes and stills from the relevant films, of course. Incidentally, the crew at the film museum needn't worry where the next paraphernalia is going to come from; every day between 40 and 50 production

and the young president of the Prussian Council of State, Konrad Adenauer, used to dine at the tavern in the 1920s, and in later years a certain Alois Hitler, a half-brother of the Führer, was employed as a waiter here.

The listed sections of what was once the Grand Hotel Esplanade, where Emperor William II met with his gentlemen associates, have now been integrated into the glass showcase of the Sony Center like some nostalgic museum piece. To this end the two storeys of the Kaisersaal weighing 1,300 metric tonnes were "translocated", a highly complicated undertaking which involved hydraulically manoeuvring the edifice 200 ft (60 m) from its original site to the new location. A different procedure was applied to the breakfast room; this was dismantled into 500 pieces, stored and then reassembled like a jigsaw in its new position. Even the little room the emperor

sought at his convenience was saved from the old Esplanade Hotel, promoting one local newspaper to herald it as the most beautiful gent's toilet in Berlin. Above it, stacked one on top of the other on an elaborate system of supports, are the 134 up-to-the-minute luxury apartments of the Esplanade Residence whose well-heeled inhabitants are protected from unwanted visitors by short-circuit cameras and an officious bouncer-cum-concierge.

GÂTEAU-MAKERS EXTRA-ORDINAIRE RE-ESTABLISHED

Another creation of the Sony Center is the re-established Josty café, home of gâteau-makers

Even if the new Potsdamer Platz of Renzo Piano, Heinz Kollhoff and Helmut Jahn and co, with its idiosyncratic, effervescent architectural melange, fails to recapture the flair of yesteryear, it has become an effervescent centre of urban society – despite the critics. This is primarily due to the fact that the Platz is a colourful mixture; besides the culture it may have posh ice-cream parlours, exclusive jewellers and expensive restaurants but it also has common-or-garden chain stores, supermarkets and discount warehouses (down in the Arkaden basement). Clients brandishing gold cards are just as well catered for as rucksack- and carrier bag-humping bargain hunters, ensuring that the gigantic amount of cash invested in Potsdamer Platz will at some stage be

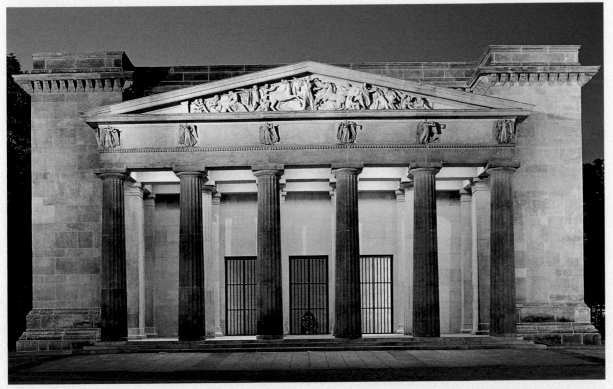

The strong neo-classical lines of the Neue Wache on Unter den Linden, built between 1816 and 1818 by Karl Friedrich Schinkel as a guardhouse for the royal watch. During the GDR period East German soldiers goose-stepped past the pillars. Today the building is a national memorial to the victims of war and tyranny.

extraordinaire. Once the favourite meeting place of the imperial capital's cultural elite, this is where artist Adolph von Menzel had his afternoon nap, where Fontane came and went and where the Else Lasker-Schüler literary circle hung out, thrown out of the chic Café des Westens because they didn't spend enough on food and drink. In tune with the more cosmopolitan atmosphere of the Esplanade, the revamped Josty now serves carpaccio, cappuccino and cocktails alongside its more traditional fare – not that anybody seems to mind.

recovered. debis alone has built to the tune of 2 billion euros, Sony has forked out almost one billion and Metro founder Otto Beisheim is not far behind with the 500 million spent on bricks and mortar for exclusive city apartments and a five-star hotel on Lenné-Dreieck. Completed in 2003, his building project is akin to the Rockefeller Center in New York, albeit on a slightly smaller, Berlin-sized scale.

As if that wasn't enough for boomtown Berlin. North of Potsdamer Platz the construction of the

21

Lehrter Bahnhof continues which – much to the chagrin of the Berliners – is going to be their new main station. The huge glass roof of the future rail junction is finished but not a single Intercity has yet stopped here. At the moment only the S-Bahn is up and running; once fully functional, 240,000 travellers are predicted to pass through the station on its busiest days.

NEVER-ENDING BALLET OF CRANES

Due east of Potsdamer Platz is the octagon of Leipziger Platz where the game of monopoly is still in full swing. A small city quarter is to be erected here with a maximum height of 120 ft (36 m), the greatest elevation permitted by the all-powerful director of construction for the senate, Hans Stimmann. The first buildings, such as the Mosse Palais, are now in use; high up above the muddy excavations, rickety scaffolding and bare masonry the Berlin ballet of cranes still dances, once even under the baton of Daniel Barenboim as an alternative to his indoor programme at the Staatsoper Unter den Linden. The state opera house competes with two others, the Deutsche Oper Berlin and the Komische Oper, for custom, often with the same work; three different productions of "The Magic Flute" are currently being staged, for example. Overkill, surely, you might think. Not so. Mozart's smash hit is as popular as ever, with opera-goers just as keen to sit out performances of Wagner's "Ring" cycle.

The bottoms on the plush seats of the opera house may, however, not be so keen to endure Berlin's 21st-century version of "The Ride of the Valkyries". At the yearly Love Parade lorry-loads of loud speakers and lovebirds, bellybuttons showing and backsides swaying, boom and bop their way along the Straße des 17. Juni between Ernst-Reuter-Platz and the Brandenburg Gate, then dismounting and heading for the clubs in Kreuzberg, Prenzlauer Berg and Friedrichshain for a night to end all nights. Cash tills have never rung so cheerfully, which is why almost all of the local politicians in the Red Town Hall and the House of Representatives (in the old Prussian parliament building) are keen to jump on the Love Parade bandwagon. The mood then swings from carnival à la Rio to kids' birthday party to pep-pill beano. This growing commercialisation of the Techno procession and the gradually waning trend in excessive numbers of beats per minute, however, has lead to a slight drop in enthusiasm among ravers since the mid-1990s; nevertheless, those out for fun, fun, fun are still guaranteed to get their kicks en route. The second great open-air event of the year is New Year's Eve at the Brandenburg Gate. About a

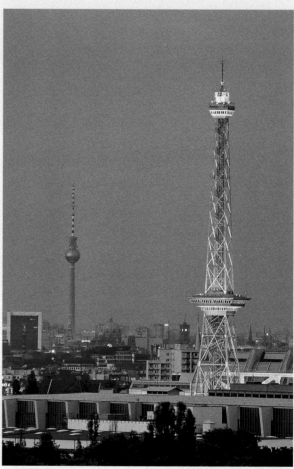

million people converge underneath the arches clutching bottles of champagne to herald the coming of the new. Both born-and-bred and would-be Berliners believe in amusement en masse. At weekends the locals prefer to do their circuit of the Grunewaldsee in the company of their fellow citizens rather than trundle in solitude along deserted footpaths through the Düppler or Köpenicker forests.

Culture is a different matter entirely. Whether mass movements or individualist avant-garde,

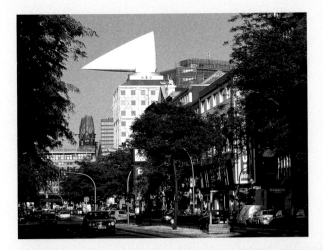

SILVERY ARCHITECTURE MEETS PRUSSIAN BAROQUE

Investing in the allegedly not-so-lucrative sector of the arts can prove fruitful, as the Jewish Museum on the Lindenstraße in Kreuzberg eloquently demonstrates. Opened in the autumn of 2001, the building is made up of two very contrasting elements; left is the yellow plaster of the Prussian baroque, within whose walls Romantic ETA Hoffmann once studied court records, right the silver bolt of architectural

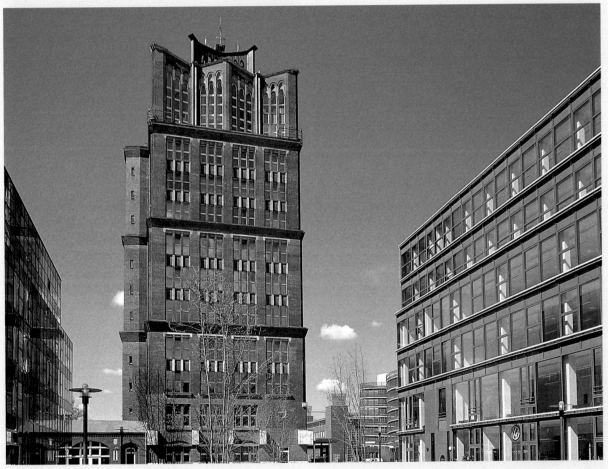

Top left:
High up above the Kantstraße in Charlottenburg gleams the triangular sail of the Kantdreieck. The building was designed by star architect Josef Paul Kleihues. In the background on the left you can just about make out the blunt steeple of the Kaiser Wilhelm Memorial Church.

Left:
The Borsigturm in Reinickendorf, were locomotives were once built and repaired, rises up into the heavens like an industrial cathedral spire. With the days of heavy industry long gone, the complex is now devoted to the service industry with offices and a shopping mall.

both are equally represented in Berlin. Indeed, the abundance of performances – from experimental theatre to mainstream opera – is so great that the city's desperately hard-up council of the arts is barely able to do it justice and has been forced to go begging to the government. Responsibility for the Stiftung Preußischer Kulturbesitz (including museum island), the Berlin Festival (under whose auspices the Berlinale, Festwochen and Theatertreffen fall) and the new Jewish Museum has since been successfully delegated to the State Ministry of the Arts in the chancellery.

lightening fashioned by Daniel Libeskind, whose form resembles a burst Star of David and slit windows the streets of Berlin from whence the Jews were deported during the Third Reich. Within the space of a year over 750,000 people visited the exhibition on almost two thousand years of German-Jewish history.

Special exhibitions, concerts, readings and discussions are held in the older part of the building, with the Libeskind construction illustrating the many cultural aspects common to both the

German and Jewish community. The Axis of Continuity beginning in the basement becomes a many-facetted zigzag through the upper floors, full of astonishing discoveries and interspersed with pensive voids representing the holes left by the Holocaust. The Axis of Exile and the Axis of the Holocaust, two sloping corridors with few exhibits, lead off the Axis of Continuity. One ends in the Garden of Exile with its 49 concrete stelae, a possible pre-emption of Peter Eisenman's Holocaust Memorial planned for the 19,000 square metres (ca. 204,500 square feet) of empty ground

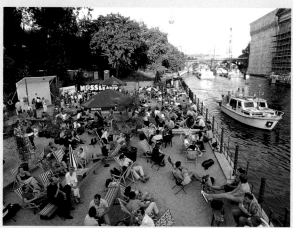

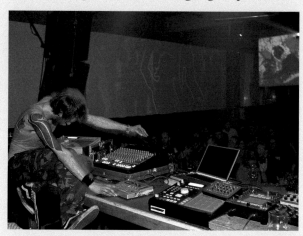

near the Brandenburg Gate. The other terminates in the frightening, dimly lit Holocaust Tower. Hardly surprisingly the museum stirs emotions, providing visitors with a wealth of experience no less important than the items on display. "Good architecture", claims Daniel Libeskind, "creates new freedoms, inviting us to speculate and ponder new forms of being."

It's often the simplest exhibits which tell the most moving stories, poignantly symbolising the fate of the individual. The carefully ironed and folded towel, for example, which a woman gave her child going into exile while she herself had to stay behind, a fated victim of the genocide, speaks louder than words. The towel was never used; the son kept it in pristine condition in memory of his beloved mother.

BERLIN, HOME TO THE STARS

Berlin's reinstatement as the capital of Germany has done little to change daily life. Economically the city has indeed profited from the influx of lobbyists, journalists, functionaries and diplomats drawn to Berlin by the blazing fire of politics like moths to a flame, yet little of this has filtered through to the Stalinist wedding-cake Karl-Marx-Allee in Friedrichshain or the suburban backwater of Friedrichshagen. Only in the restaurants left and right of Unter den Linden or around Schinkel's old theatre on Gendarmenmarkt do you occasionally catch a glimpse of a famous face from the TV newsroom. Despite this, those writing for the ever longer gossip columns of Berlin's dailies would have us believe that the city is home to the stars.

On closer inspection the discerning reader will observe that it's always the same names which crop up – particularly that of a certain hairdresser who is frequently quoted when the colour of the chancellor's hair is deemed all-important. Another prominent and glamorous contact, especially at society parties, is a lady with the esteemed title of Maja von Hohenzollern. An aristocrat by marriage alone, sharp tongues maintain that for a price – like other actors or sports personalities who shall remain nameless – Ms von Hohenzollern can be booked through events agencies to "spontaneously" appear at gala dinners, fashion shows and award ceremonies. How does that song in "Cabaret" go again? Wasn't it "Money makes the world go round…"

All in all, it's best to rise above such tittle-tattle. There's plenty of opportunity to do so – literally. There's the Grunewaldturm, the clock tower of

the Olympic Stadium, the television tower or Funkturm (or Langer Lulatsch to the locals), the Teufelsberg, 25 million cubic metres (880 million cubic feet) of rubble piled up from the last war, the Siegessäule or victory column and the television tower on Alexanderplatz, also known as St Walter after its architect Walter Ulbricht and the cross beamed onto the dome of the restaurant in sunlight.

NEW LANDMARK OF BERLIN

The most popular climb is to go over the heads of Germany's parliamentarians in the Reichstag. Lord Norman Foster's glass dome high up above the chamber has become the new landmark of Berlin. Those making the gentle ascent to the summit are inadvertently following advice given by former mayor of Berlin Ernst Reuter in a moving speech during the Berlin Blockade: "People of the world, look at this city." Tourists in the know come late in the evening to enjoy the sea of light beneath them, for during the day they have to exercise a virtue which before 1989 was more commonly practised in the east of the city: queuing.

Once at the top, most are rendered speechless by the breathtaking panorama spread out at their feet. Berliners might utter a cheery "Mustn't grumble" – an expression which in Athens on the Spree indicates complete satisfaction. This is rare; the indigenous population has lots to moan about, if not rises in taxes or other such unpopular matters of state then the new Federal Chancellery, sarcastically known as the "Kohlosseum" after the man who commissioned it, former chancellor of Germany Helmut Kohl.

The big chief and his treasured aquarium were too late to move into the edifice fashioned by architectural team Axel Schultes and Charlotte Frank, however; the first tenant was his successor Gerhard Schröder. In lieu of an aquarium Schröder had a 90-ton metal sculpture entitled – not surprisingly – Berlin erected by Basque artist Eduadro Chillida in the courtyard of the mighty

monstrosity which even the New York Times found a touch too pompous. The two entwining rusty claws of Chillida's work represent unity; sceptics claim it's really a case of you scratch my back, I'll scratch yours, or, in the German idiom, of "one hand washing the other". That's Berlin in a nutshell, really; anything representing the interests of the state is immediately ridiculed. On Unter den Linden Old Fritz (Frederick II the Great), sitting contentedly astride his horse, seems to find this amusing. Despite his warlike stance, his lips bear the faintest trace of a smile.

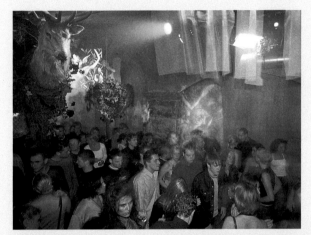

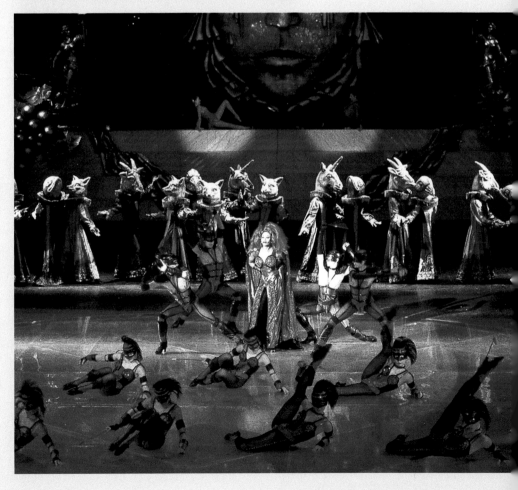

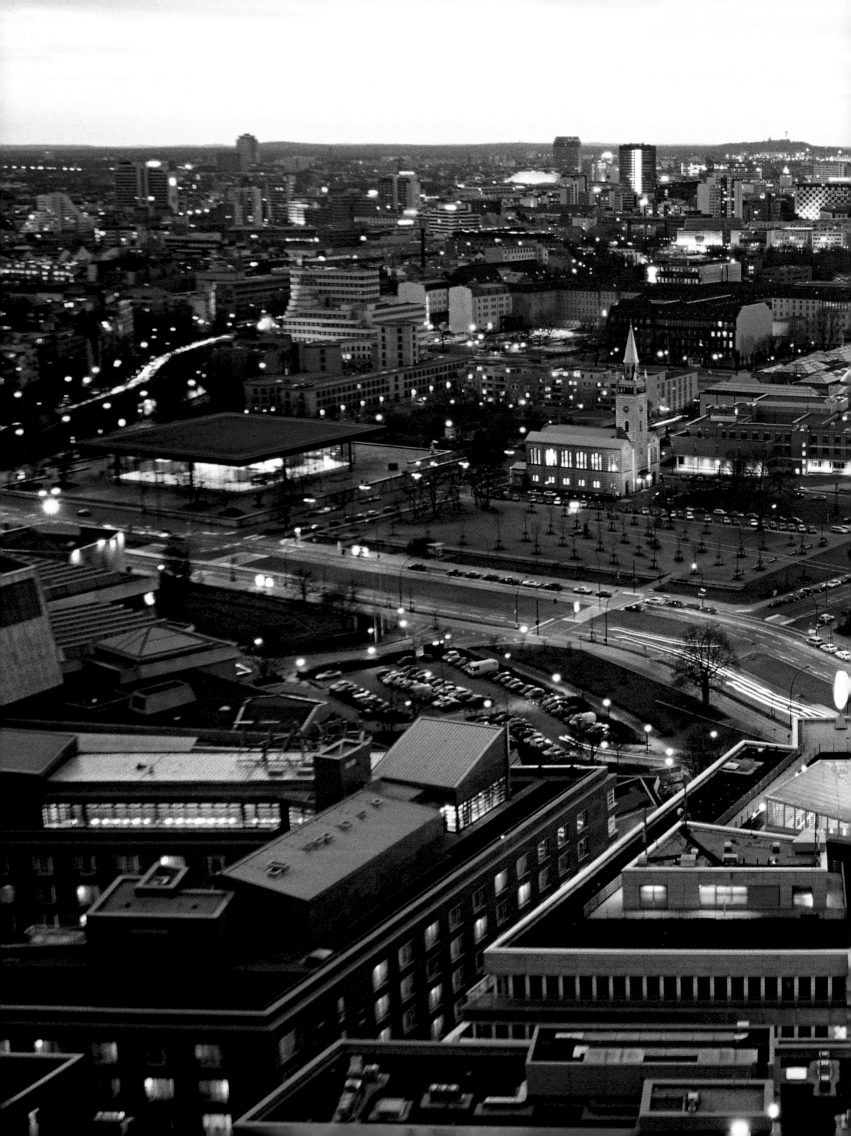

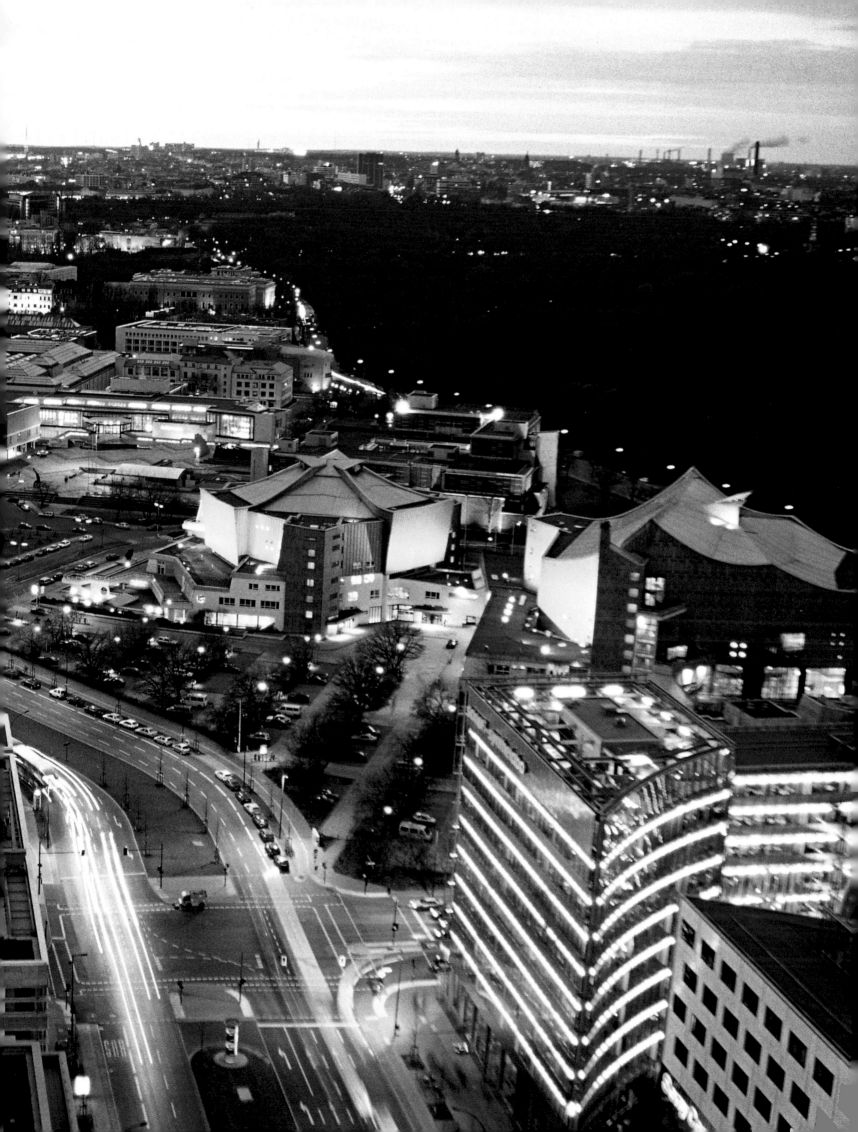

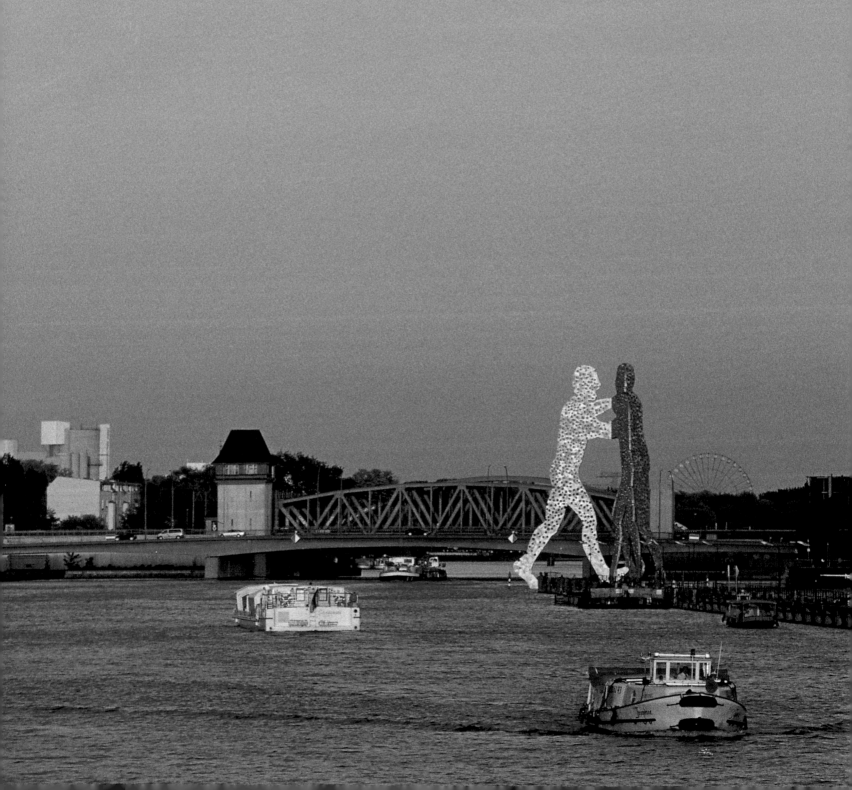

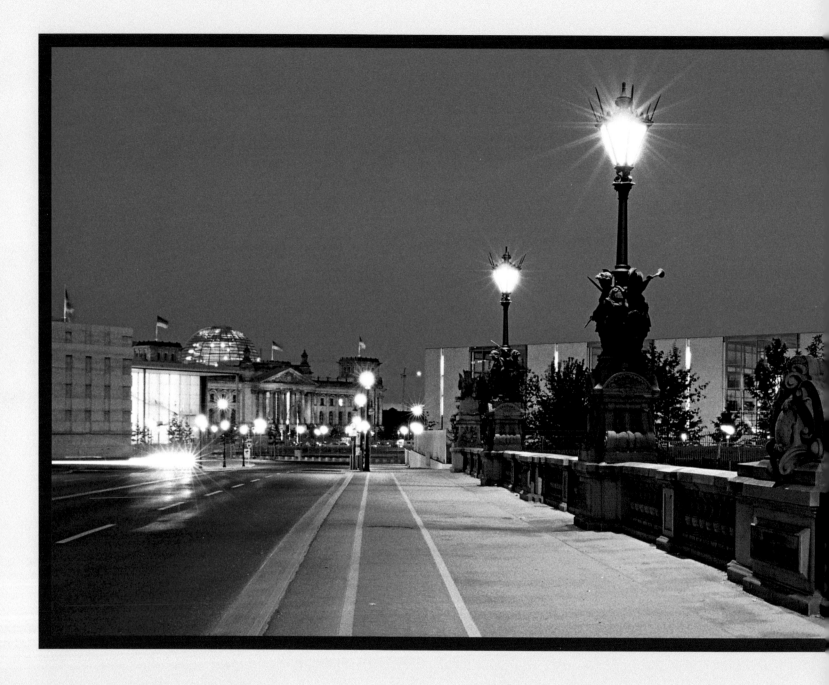

TOUTING FOR CUSTOM — BERLIN'S THREE CITY CENTRES

Dark red underneath and mustard yellow on top, with a thin black line in the middle, Berlin's "S-Bahnzüge", the trains of its city railway, are still painted in the traditional colours. The same goes for the carriages of the Ringbahn, a 37-kilometre (23-mile) circuit of track running through the heart of the city. Shaped like a dog's head, at the bottom end of the Kurfürsten-damm the muzzle slurps water from the Halen-see. The nose sniffs around in hidden corners of Schloss Charlottenburg's park, the hair on the back of the neck brushes against Lichtenberg Station. The ears are tuned in to the alternative scene on Schönhauser Allee. And where the jaw is, regional flights still speed along the runway

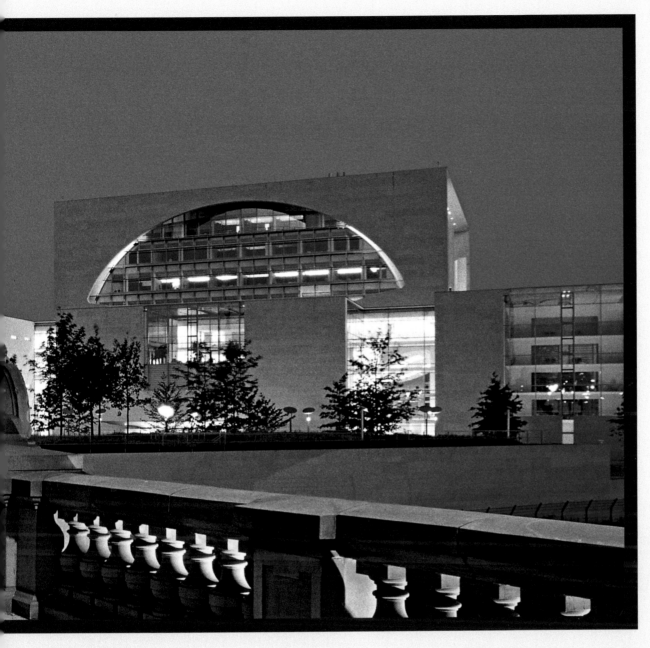

Page 28/29:
The Treptowers on the banks of the Spree have been leased by a leading insurance agency. Beside them Jonathan Borofsky's metal Molecule Men stride across the water.

Moltkebrücke and the "washing machine" of the Federal Chancellery, so called because of its orb and cube design. Others call it the Kohlosseum after ex-Chancellor Helmut Kohl who was destined to move in here before he lost the election to political rival Gerhard Schröder of the left-of-centre SPD.

of Tempelhof Airport – just. For as soon as Schönefeld is ready to be reopened as an major international terminal, Tempelhof City is to be shut down.

Completed in 1877 as a link between Berlin's various terminus stations, the dog's head was cleaved in two by the building of the Wall in 1961, remaining so for 41 years. The last derelict section between Westhafen and Gesundbrunnen was finally reopened in the summer of 2002 – amid much to-do and soapbox philosophising about further steps being made towards total reunification. After one-and-a-half circuits the trains of the S41 and S42, travelling in oppo-site directions, leave the Ringbahn so that you have to change trains if you want to clock up all 27 stations in just 63 minutes.

Within the Ring lies the core of Berlin, much of it still the "Gründerzeit stone Berlin" described by Werner Hegemann in his legendary book from 1930 on the "largest city of tenement houses in the world." Beyond it is the protective belt of suburbs which are also part of the city. Greater Berlin as we know it today wasn't officially created until 1920, from an amalgam of towns and 59 rural communities which had grown into one another to form a tangled whole.

CITY-WEST, CITY-OST AND POTSDAMER PLATZ

As a result Berlin has not one but three city centres, easily dwarfing most of Germany's other urban conglomerations. Berliners go to City-West if they want to shop on the Kurfürsten-damm, go to the Zoo, Gedächtniskirche (Kaiser Wilhelm Memorial Church), Tauentzienstraße or Wittenbergplatz. They talk about City-Ost or the "old city centre" when they mean the area between Alexanderplatz, Friedrichstraße, Unter den Linden and the Brandenburg Gate. Between these two poles is the once desolate and now infamous Potsdamer Platz, a city within a city and the third nucleus of Berlin erected over the past ten years to the tune of four billion euros.

The main recreation area within the Ringbahn is the Tiergarten with its zoo, boasting the biggest variety of animals in captivity in the world, and

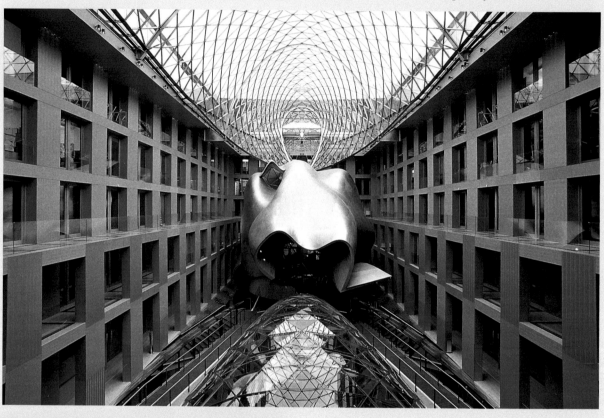

Right:
Modern money box: view of the atrium of Frank O Gehry's bank on the south side of Pariser Platz.

Below:
During the International Film Festival in February the musical theatre on Pots-damer Platz becomes the grand Berlinale-Palast, where stars and jury eagerly await the opening of those sparkly envelopes and the awarding of the coveted Golden Bears.

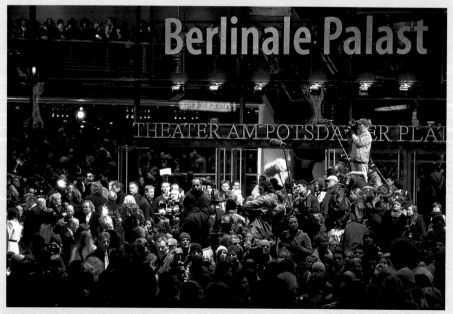

the Kulturforum, which includes the golden ship of the (west) state library and the philharmonic Pentagon of "Zirkus Karajan", now conducted by Sir Simon Rattle. Around the edge of the Tiergarten the old diplomatic quarter has been rejuvenated by spanking new office blocks hous-ing various foreign representatives. Japan and Italy have refurbished their monumental palaces, built here during the Nazi period, and the Scan-dinavians and Mexico pay tasteful homage to the avant-garde with their new embassies on Klingelhöferstraße.

Thanks to the historic buildings still lining the elegant boulevard of Unter den Linden and Gendarmenmarkt and to the huge amount of

money pumped into this area City-Ost has much improved over the past decade.

The old heart of Berlin isn't merely a political focal point (and consequently the subject of much media interest); it has now also become a centre for society and the arts. The humming epicentre of youth and student culture has moved from Kreuzberg and Wilhelmsdorf in the west to Oranienburger Straße and Prenzlauer Berg in the east. With its island of museums,

than along the Friedrichstraße, which manages a mere 5,000 in the same space of time. With new developments on Kranzlereck and Kudamm-Eck and the Zoo-Fenster project, the west is making a valiant attempt to break the monopoly of City-East. Yet still the investments continue.

In the next few years Alexanderplatz is not only to have a brand-new mega shopping mall which will beat even the gigantic KaDeWe in sales area, but also a collection of monumental skyscrapers

Below:
The banks of the River Spree in Moabit are home to Germany's Ministry of Internal Affairs. The offices don't belong to the government, however; they were erected by a pizza chef-cum-big time investor.

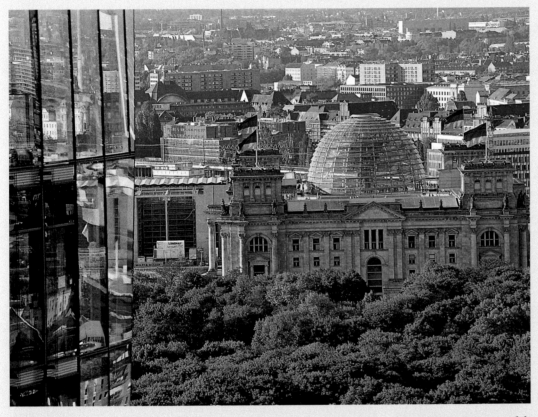

Staatsoper, Komische Oper, Deutsches Theater, Maxim Gorki Theater, Berliner Ensemble and Volksbühne, not to mention the lighter entertainment of the Friedrichstadtpalast, high culture in Mitte holds more trump cards than City-West.

THE NEW BERLIN ALEXANDERPLATZ

In return, what was formerly West Berlin insists that it still has a higher turnover than the Friedrichstraße and Potsdamer Platz. Marketing experts reckon that more than 7,000 pedestrians stroll along the Kurfürstendamm within an hour (with the Tauentzienstraße clocking up 10,000)

constructed from plans presented by Hans Kollhoff in 1993. His aim was to completely redesign the Berlin skyline, adding a good dozen high rises up to 150 metres (490 feet) tall. There'll probably not be quite that many, although contracts have already been signed and sealed for four projects. Ca. four billion euros are estimated to have been deposited on Alexanderplatz by 2013. In Alfred Döblin's bestseller "Berlin Alexanderplatz" such an enormous amount would have rendered small-time criminal Franz Biberkopf absolutely speechless.

Above left:
Flying the flag. Paul Wallot's infamous Reichstag was remodelled by Lord Norman Foster in such a way that the scars and gashes in Germany's history have remained visible as a reminder to future generations – such as the Cyrillic script carved into the walls by the Red Army. Left is a section of a high-rise facade on Potsdamer Platz.

Below and right:

From 1961 to 1989 the symbol of a city divided, today the symbol of reunification: the Brandenburg Gate. Built by Carl Gotthard Langhans in 1791, it was modelled on the Propylaea at the Acropolis in Athens, which is one of the reasons why Berlin is known as "Athens on the Spree".

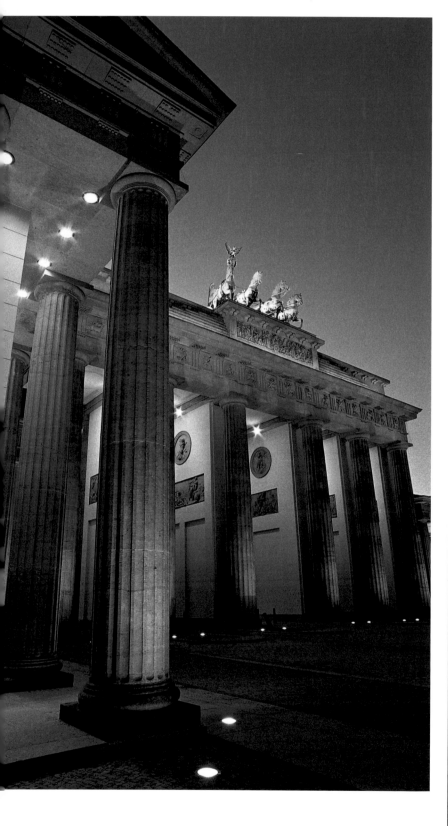

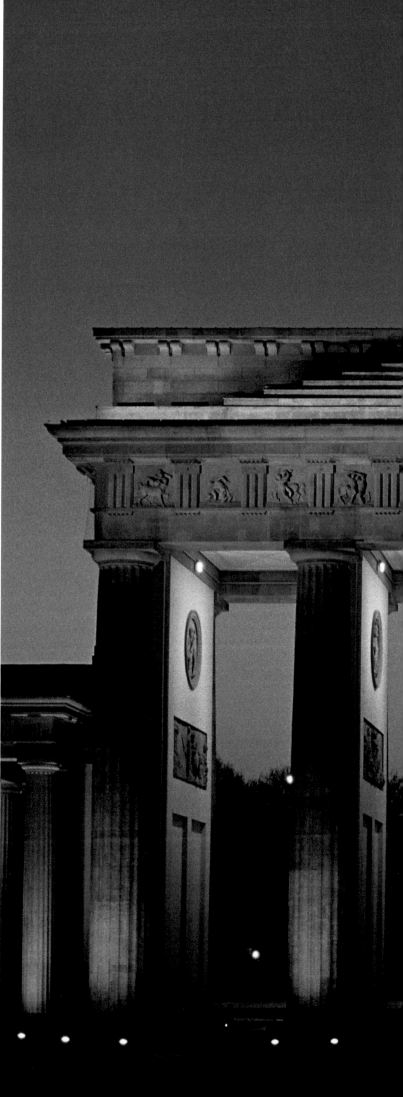

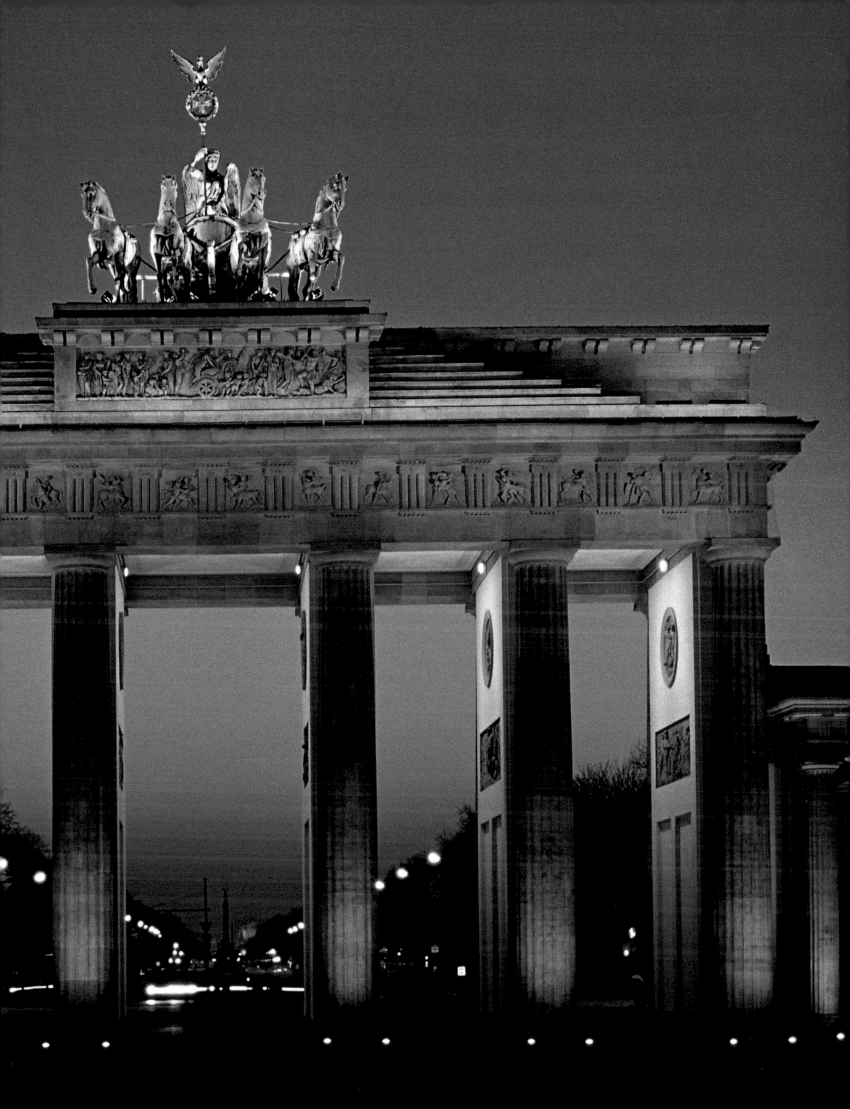

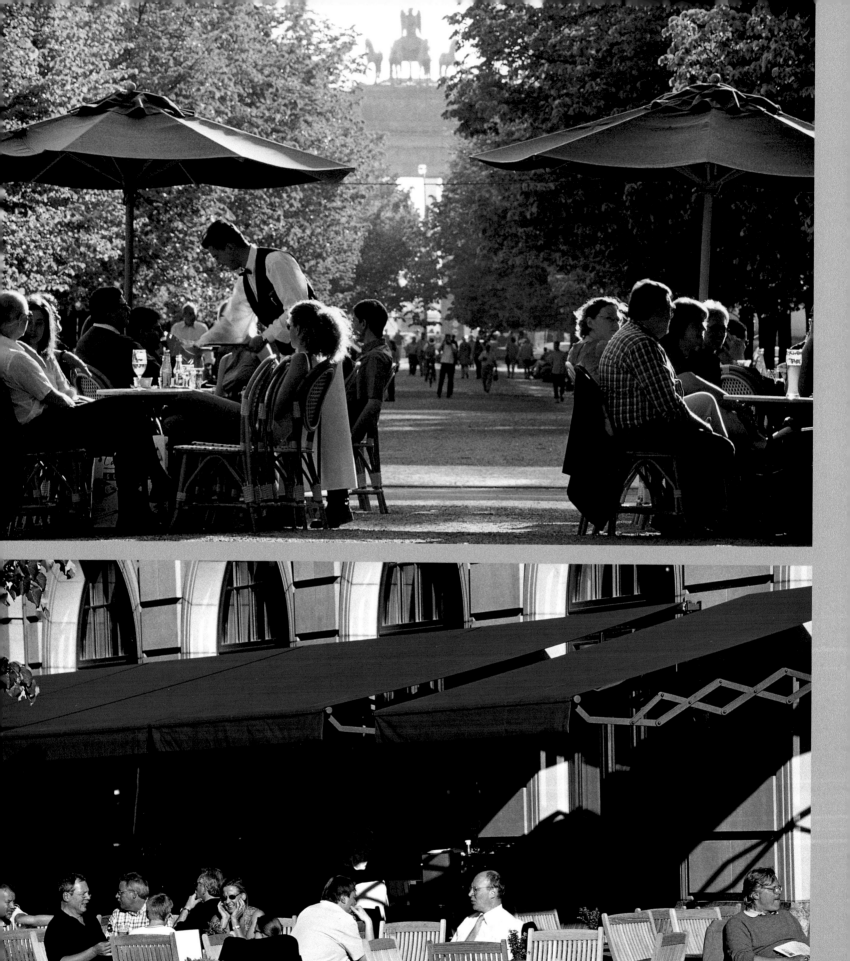

Left:
Drinks served on the lush
green central reservation of
Unter den Linden seem to
be particularly refreshing.

Below:
The auspicious halls of the Russian Embassy
are palatial in size. The land was bought in
1837 by Tsar Nikolaus I, who had soil from
Russia especially carted in for the construc-
tion work which began in 1840. Following
the Second World War this was the first set
of buildings on Unter den Linden to be
scheduled for restoration.

Below:
Hotel Adlon thrives on its
former glory, pulling the stars
of the silver screen, ageing
aristocrats and the nouveau
riche. This is the favourite
abode of would-bes, has-
beens and stars of the
moment – provided they
have the necessary cash.

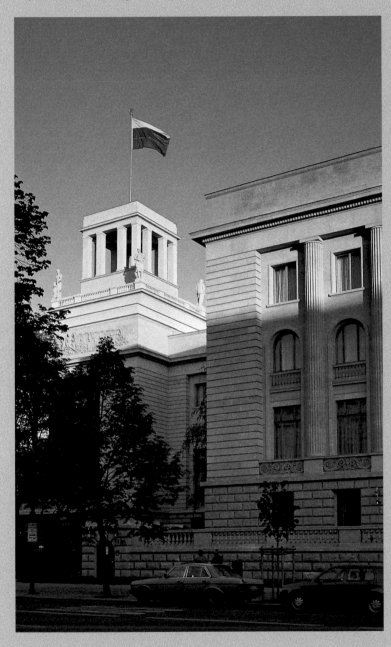

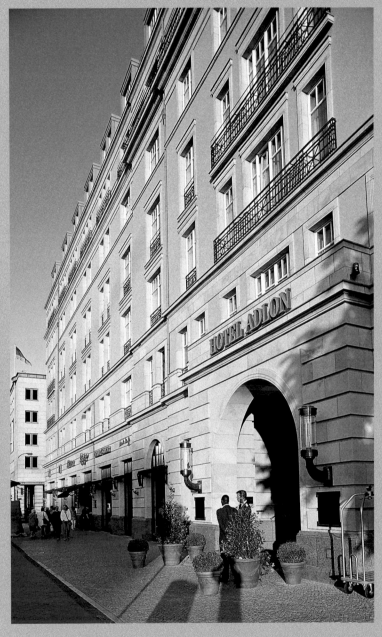

Left:
Even such personalities of
renown as Michael Jackson
have stayed here at the Hotel
Adlon on Unter den Linden.
Financed by a real estate
fund, it's now to be extended.

GERMANY'S MOST FAMOUS CUL-DE-SAC
THE BRANDEN-BURG GATE

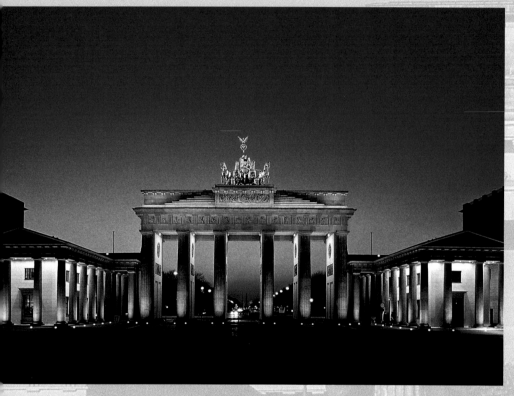

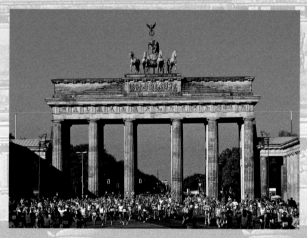

Above:
The symbol of Berlin in the magical evening light: the Brandenburg Gate with its five archways, with the central arch once reserved exclusively for the carriages of the royal family.

Above right:
The Brandenburg Gate is a popular backdrop for state visits and the Berlin Marathon and the Berlin motif for all kinds of promotional material.

It's official. Now that the elaborate restoration of the Brandenburg Gate has been completed (work was finished in 2002), Berlin's local landmark plus Pariser Platz in front of it are strictly taboo for the city's yellow double-deckers and various denominations of taxi. If you want the republican thrill of passing underneath the middle arch, you have to resort to your own two feet or peddle power (of the unmotorised kind). During the reign of the House of Hohenzollern only the emperor's royal barouche was allowed to pass through the city gate. Thank goodness those days are long gone.

The fact that the magnificent Unter den Linden boulevard has now become the most famous cul-de-sac in the world – thanks to the pedestrianisation of the Gate – doesn't seem to bother anyone. The majority in Berlin have welcomed the decision to ban all traffic from their city showpiece. A quick glance in any wallet or purse demonstrates just how dear this symbol of a country divided is in the hearts of the Germans. Since the introduction of the euro the Brandenburg Gate has adorned Germany's 10, 20 and 50 cent pieces, gleaming bronze in gentle imitation of the soft yellowish grey of the restored sandstone.

BERLINS PROPYLAEA-AS SPOILS OF WAR

Built between 1788 and 1791 from plans by Carl Gotthard Langhans, the Brandenburg Gate was the first neo-classical edifice to be erected in the Prussian capital. It was modelled on the Propylaea at the Acropolis. Gottfried Schadow added his decorative Quadriga, fashioned in copper, in 1794. The statue is known locally as the "return coach" or "coach of retribution" (Retourkutsche).

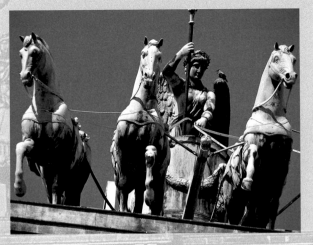

cession under the Gate, prompting ageing Jewish Impressionist and president of the Academy Max Liebermann, then resident on Pariser Platz, to remark that that no amount of food could replenish what he felt like throwing up. A "critical reconstruction" of the original Haus Liebermann north of the archway was erected after the fall of the Wall. The same goes for Haus Sommer to the south and the luxury Hotel Adlon opposite. The banks and embassies which have since sprung up nearby have also felt bound to tradition, emulating the proportions and stone facade of their

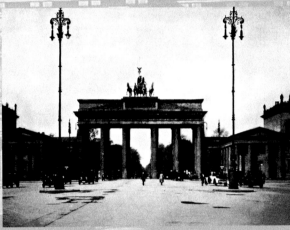

In 1806 Napoleon whisked Schadow's chariot and rider off to Paris as spoils of war to provide the horses he pilfered from St Mark's in Venice with a little company. Eight years later, after a new chapter had begun in the annals of history, Blücher reharnessed the quartet and restored the historic monument to its rightful place. The group atop the Brandenburg Gate today is a copy; during the advance of the Red Army towards the Reichstag and the Führer's bunker the original was so badly damaged that only a single horsy head survived. This is now on display at the city museum (Stadtmuseum).

A HISTORIC PLACE – PARISER PLATZ

Historic events such as this have taken place time and again underneath the Brandenburg Gate. Here in 1914 young recruits marched off to the trenches of the First World War with a courageous "hurrah" on their lips; in 1933 Hitler celebrated the dawn of his "thousand-year empire" (which lasted just twelve) with a torch-lit pro-

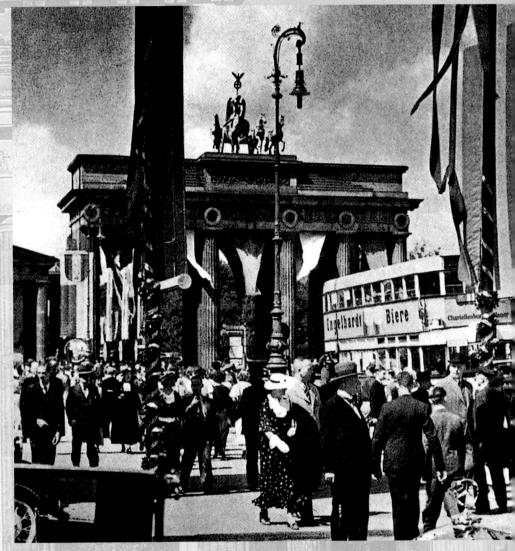

historic neighbour without denying their contemporary roots. Only the new Academy of the Arts building designed by Günther Behnisch sheds a very different architectural light on the otherwise subtle ensemble. Pariser Platz doesn't seem that bothered by this contradiction in terms. After all, this isn't exactly the first time it's had to let history take its course…

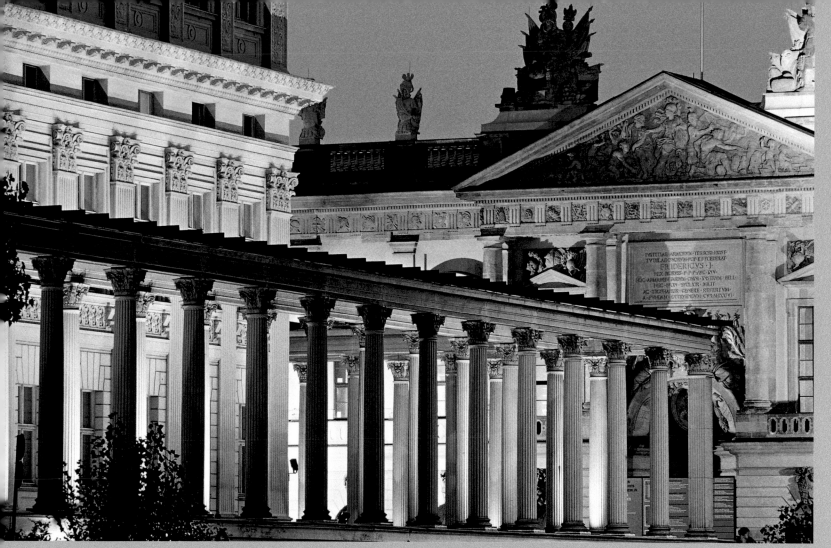

Above:
Unter den Linden is one magnificent edifice after another. Hidden behind the pillars of the Kronprinzen-palais (the residence of Prussia's crown princes) is the old baroque arsenal which now houses the Deutsches Historisches Museum.

Right:
Statue of Frederick II on horseback, otherwise known as "Old Fritz", riding through the ages on his favourite steed Conde. The monument was designed by Christian Daniel Rauch in 1851. Behind the statue is the old imperial palace of Kaiser Wilhelm on Bebelplatz.

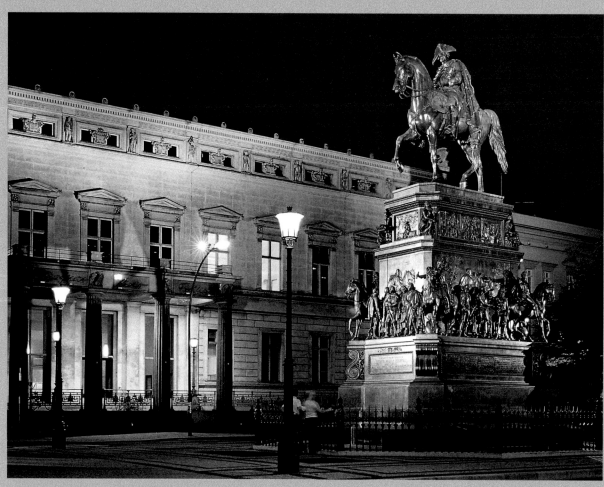

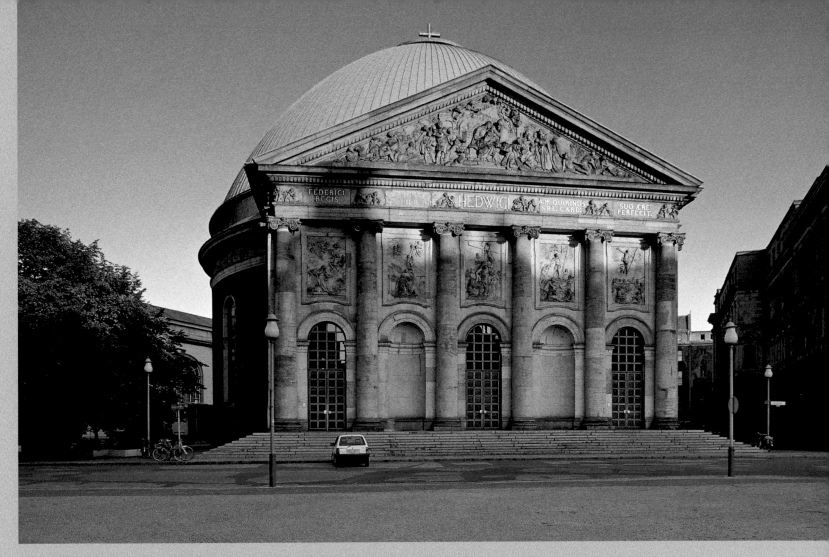

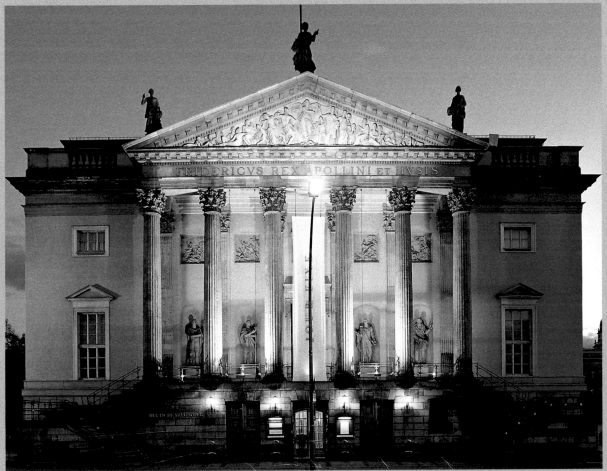

Above:
None other than Frederick II provided the initial plans for St Hedwig's Cathedral, entrusting the construction to Georg Wenzeslaus von Knobelsdorff. The interior of the chief place of worship for Berlin's Catholic community was refurbished between 1952 and 1961.

Left:
At the Deutsche Staatsoper Daniel Barenboim is Master of Music. Also built by Knobelsdorff, the building is part of the Forum Fridericianum complex. Weber's "Freischütz" was premiered here in 1821; 100 years later a mixed audience witnessed the first showing of Alban Berg's "Wozzeck".

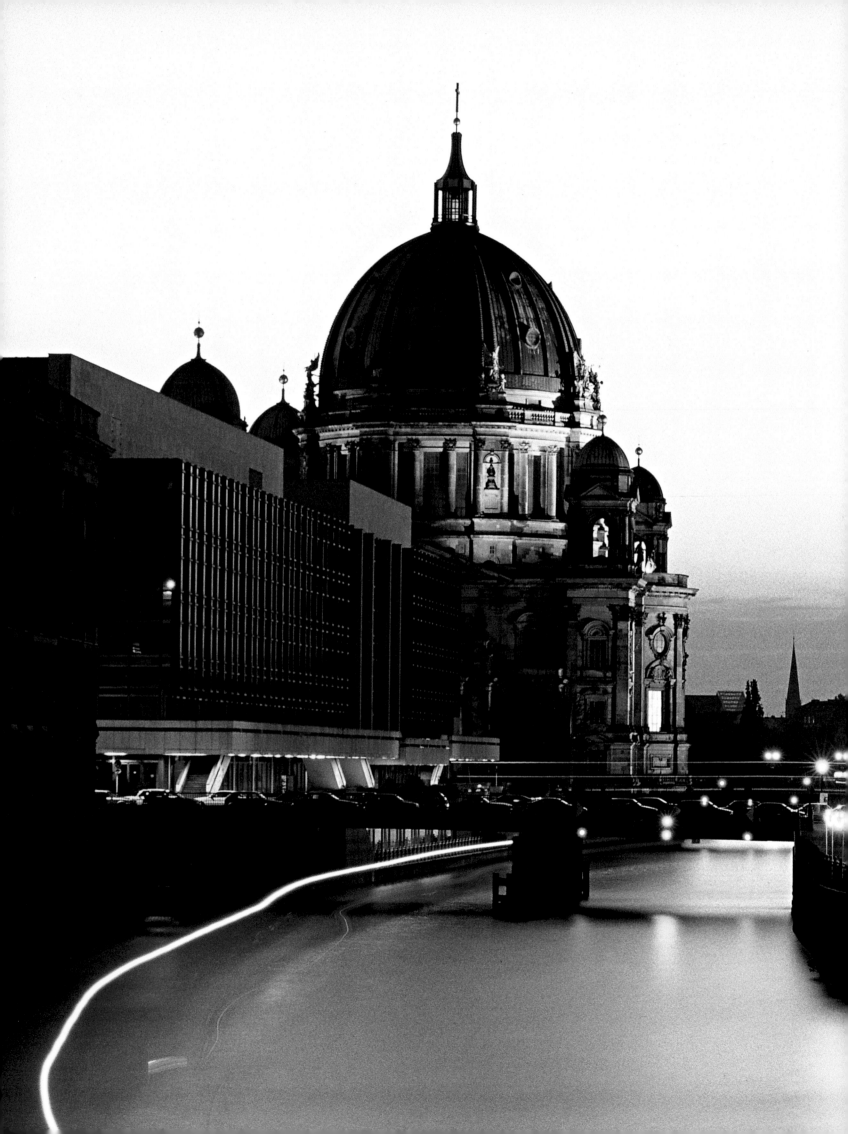

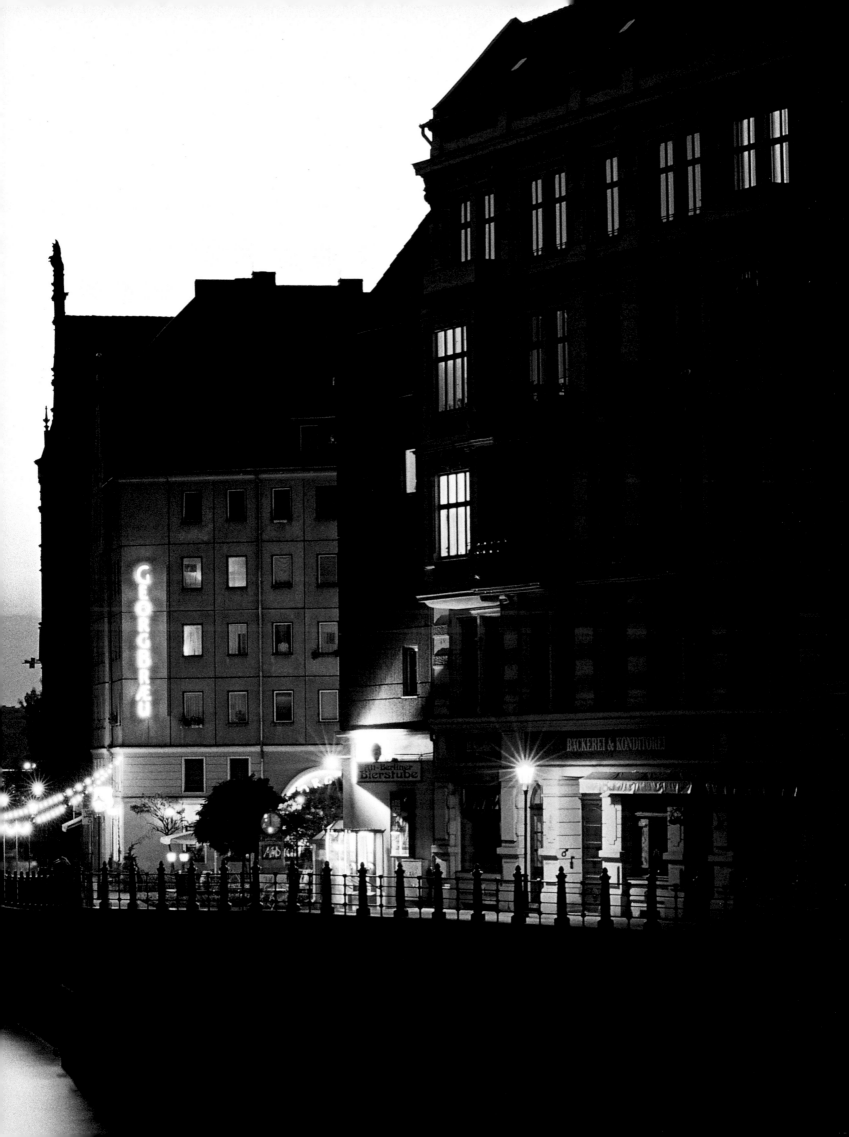

Page 42/43:
Berlin Cathedral (left), erected between 1894 and 1905 by Julius Raschdorff, and the Nikolaiviertel on the opposite bank of the river, reconstructed in 1987 to celebrate 750 years of Berlin and emulate the narrow streets and alleyways of the medieval city.

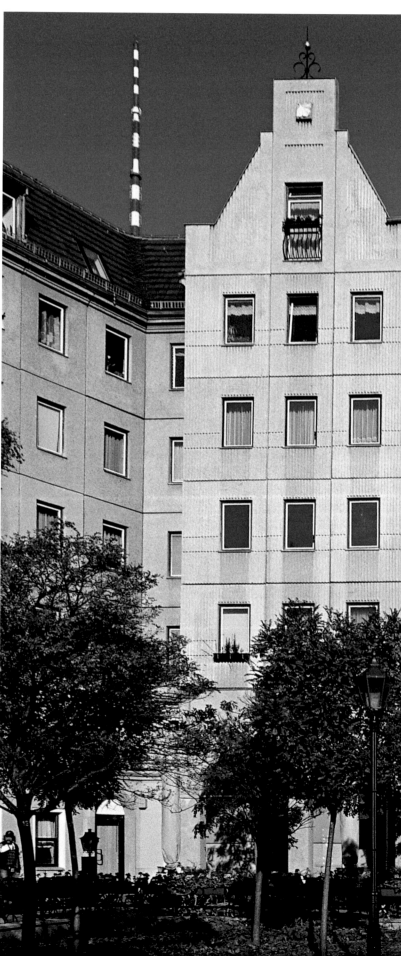

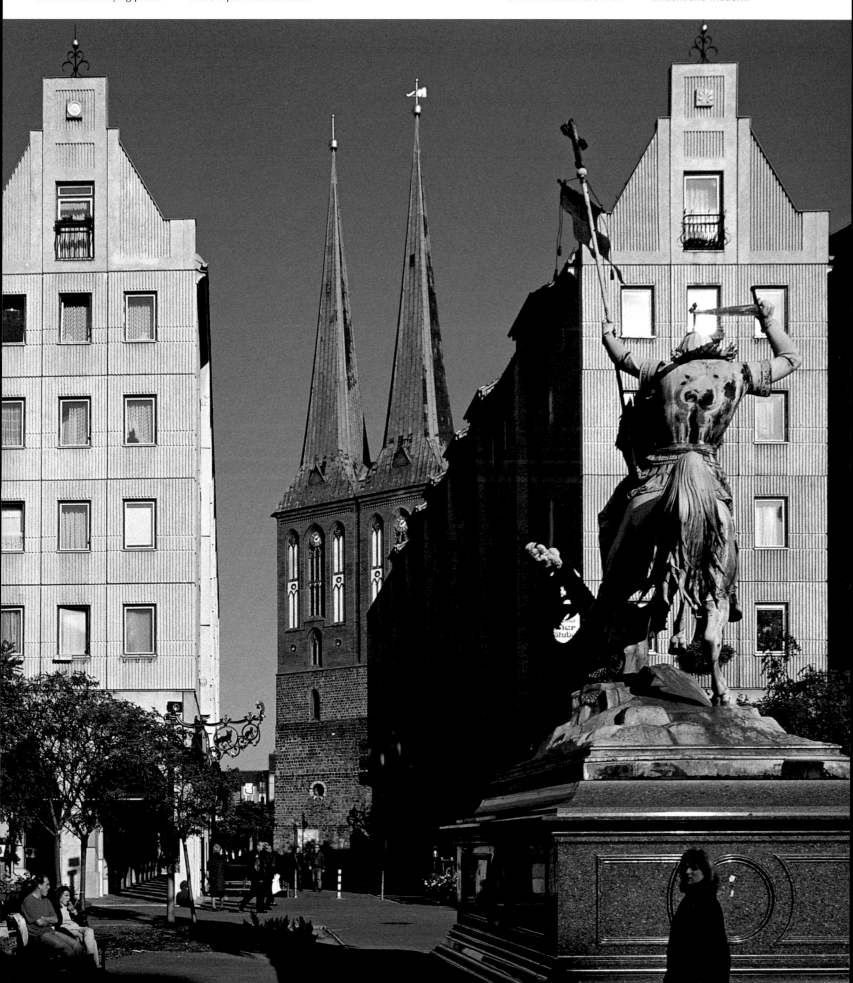

Right page:
The Rotes Rathaus, fronted
by Reinhold Begas's Neptun-
brunnen (1891) which ori-
ginally stood outside the old
Hohenzollern palace. The Red
Town Hall isn't named after
the socialist politics made
here by the GDR's powers
that be, nor because the
mayor of Berlin spends much
of his time here wondering
how to get the city accounts
out of the red, but quite
simply after the material the
neo-Renaissance building is
made of – red brick.

Above and below right:
Services are no longer held
in the Nikolaikirche; today
it's used for concerts and
exhibitions. Parts of it date
back to 1230, with the Gothic
brick hall built in c. 1470.
The church is the oldest
sacred building in Berlin.

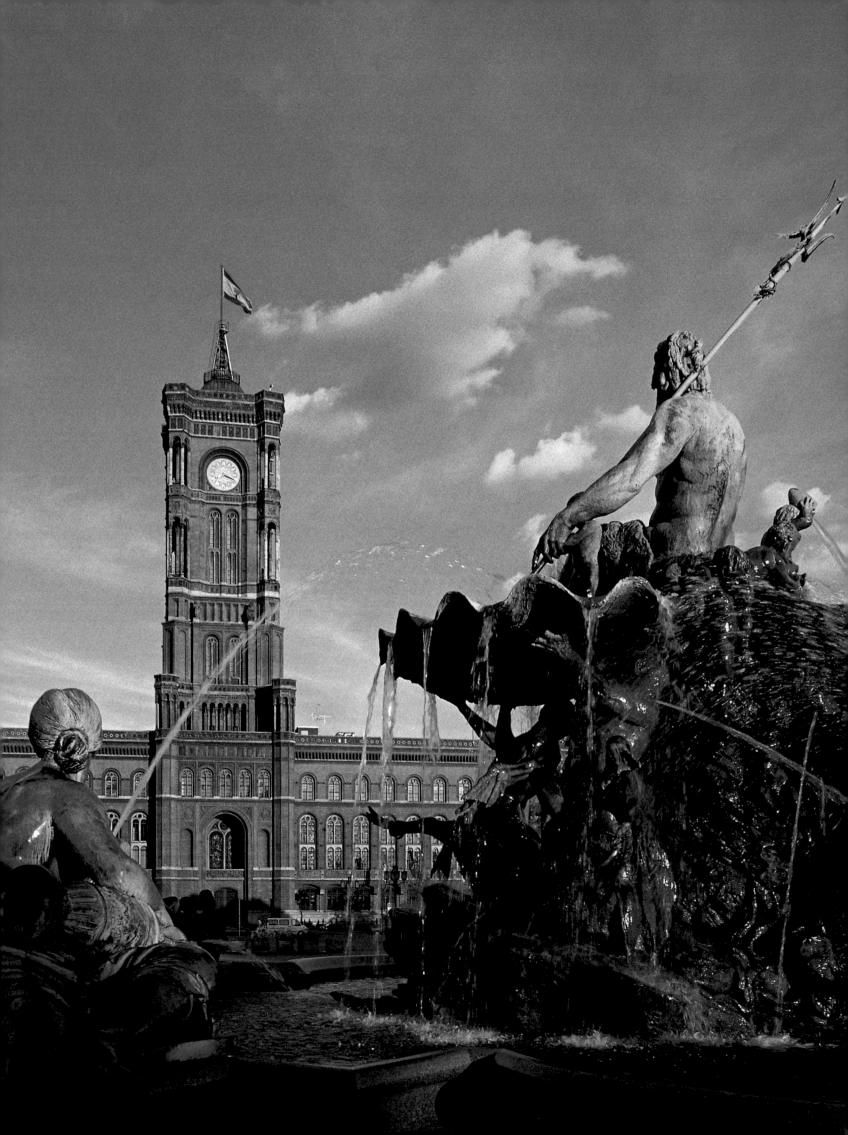

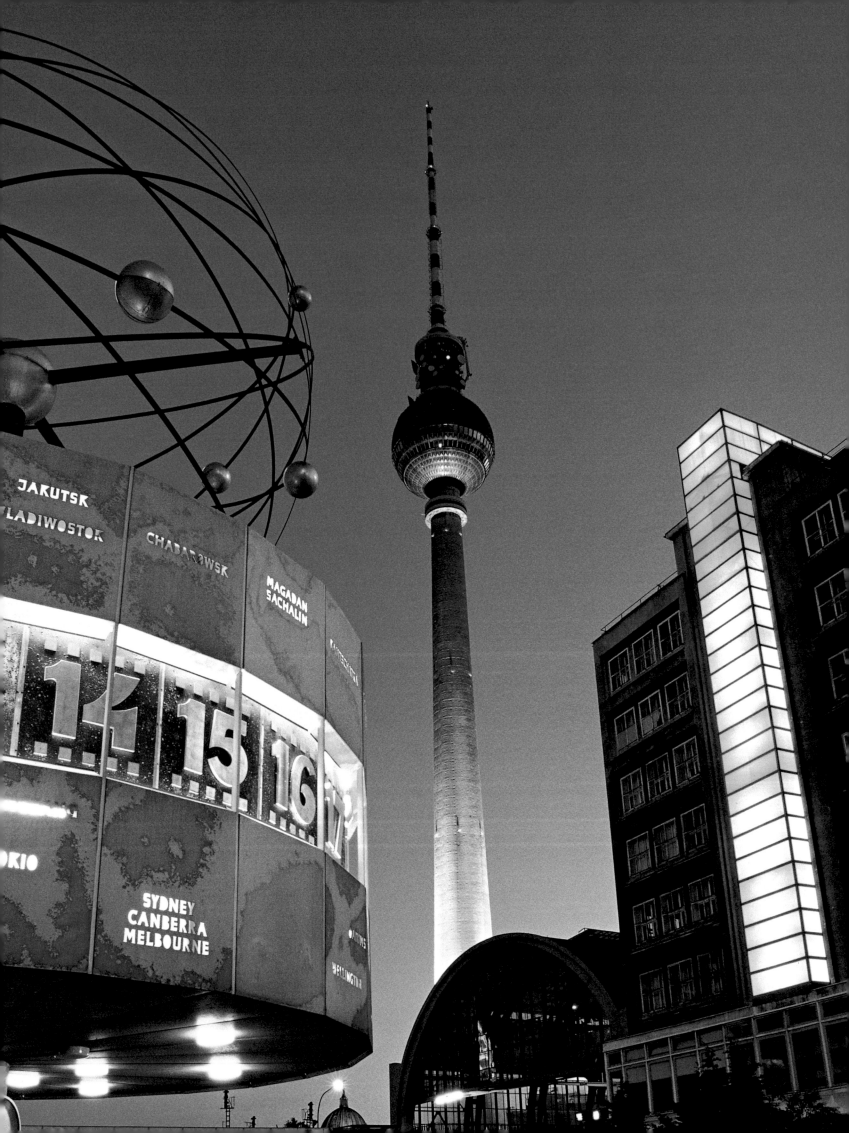

Left:
For whom the bell tolls: the world clock on Alexanderplatz keeps time for all continents of the globe. In the 1980s it inspired Eberhard Hilscher to write his fascinating yet sadly now obsolete novel of development. The square was also the focus of Alfred Döblin's famous work from 1929, "Berlin Alexanderplatz", where the hero of the novel is the city itself.

Below:
The Alexanderplatz skyline is still dominated by its high-rise hotel and the giddy 365 metres (ca. 1,200 feet) of the television tower. This could all change, when Hans Kollhoff's plans for his new skyscrapers are put into action.

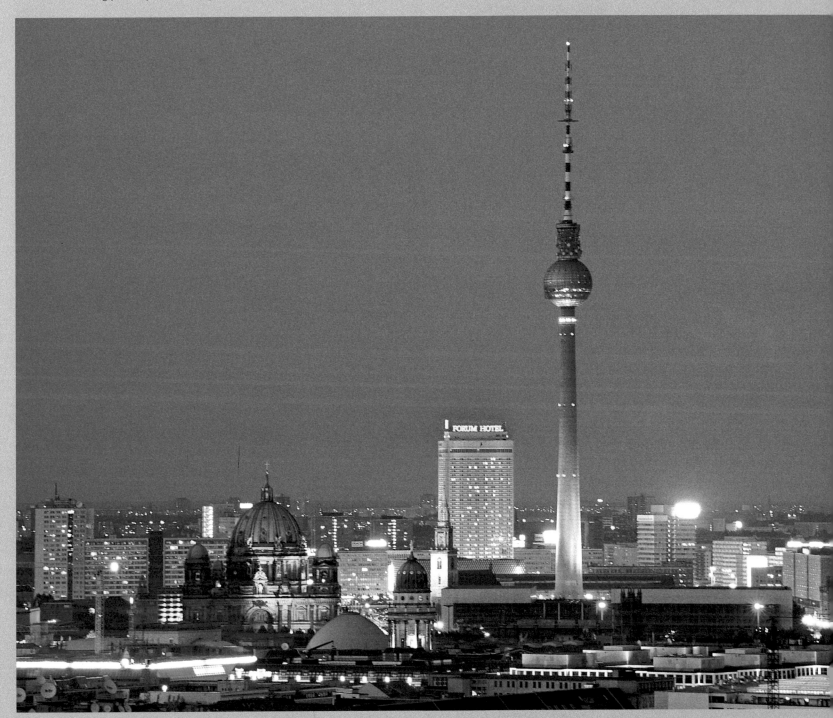

Right:
The new Foreign Office on Werderscher Markt. Despite its generous proportions the old federal bank building, which once housed the central committee of the SED, wasn't big enough for the administrative machinery of the new tenants, calling for this wing to be built.

Below:
Christmas on Gendarmenmarkt with Schinkel's old Schauspielhaus and the Deutscher Dom, the twin of the French Cathedral. The German house of worship was consecrated just three years after its French counterpart to balance the architectural harmony of the square. It now houses the "Questions on Germany History" exhibition.

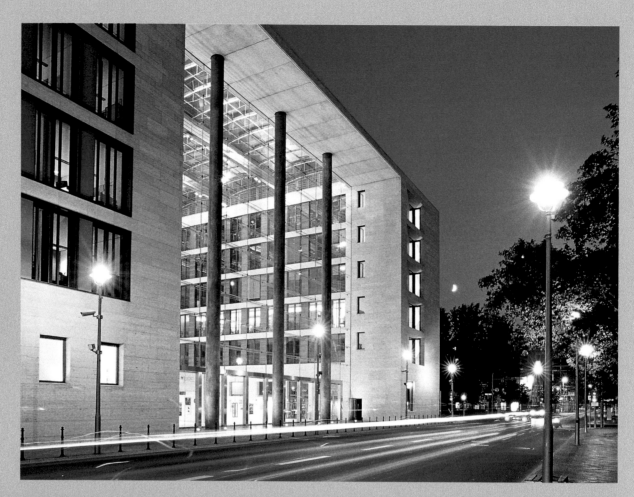

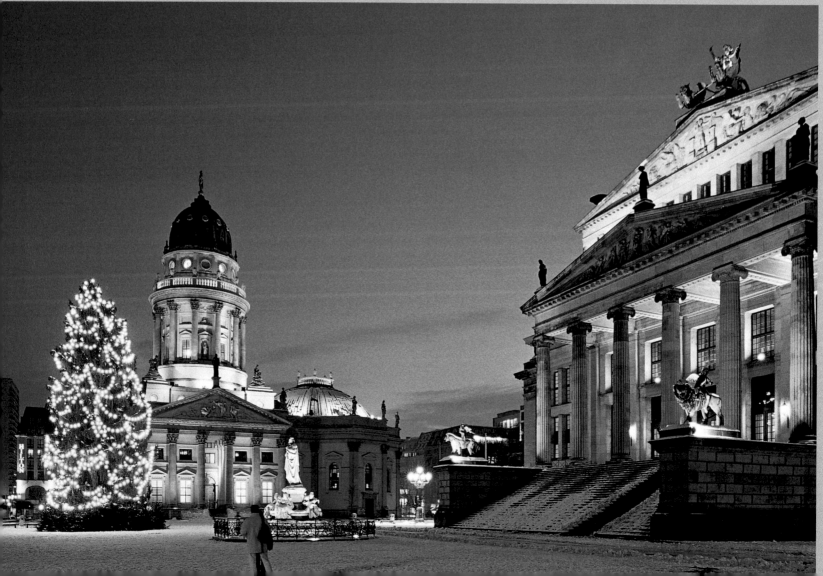

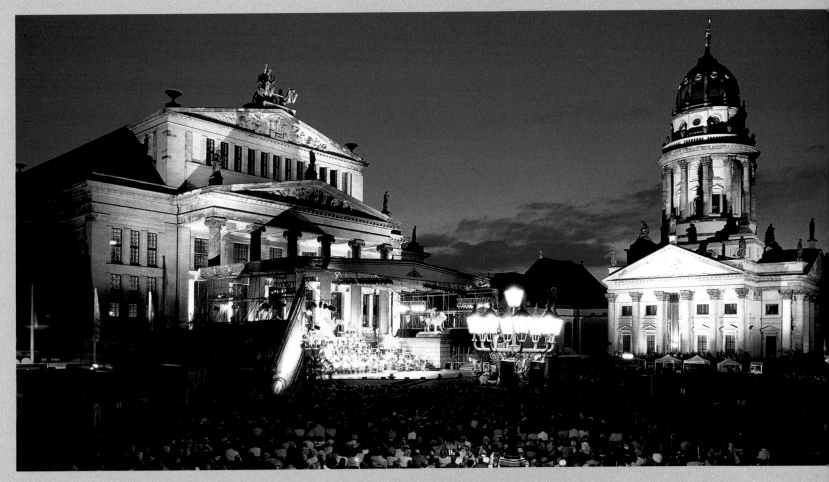

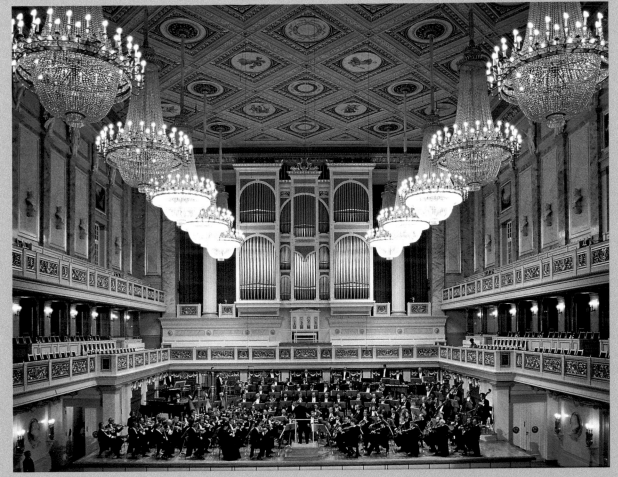

Above:
Standing on another corner of the Gendarmenmarkt and looking at the theatre and Französischer Dom. The church – known as the French Cathedral – was built between 1701 and 1705 to serve Berlin's Huguenot community. During the summer months the elegant ensemble acts as a backdrop for the grand Classic Open Air festival.

Left:
The Schauspielhaus, the theatre whose boards Gustaf Gründgens once trod, is now used as a concert hall. The building was designed by Friedrich Schinkel and erected between 1818 and 1821 in place of the old national theatre which burnt down in 1817.

THE BIG DEBATE – PARTIAL RECONSTRUCTION OF THE OLD HOHENZOLLERN PALACE

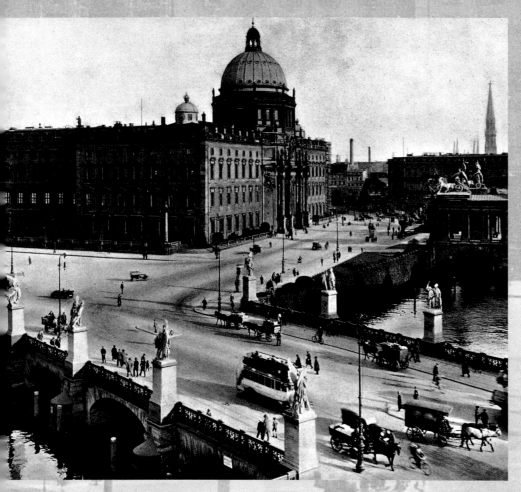

Berlin's old Hohenzollern palace or Stadtschloss in 1925, bombed during the Second World War and finally dynamited in 1950. In front of it is the Schloss-brücke with statues by Schinkel.

dynamited in 1950; the feudal relic didn't quite fit in with the socialist ideology of the GDR and was 'removed' to make way for a huge parade ground. Head of state Walter Ulbricht personally ordered its destruction. All that remained was Portal IV and the balcony from which Karl Liebknecht proclaimed the "Free Socialist Republic" in 1918. In the 1960s the ruin was integrated into the Staatsratsgebäude or GDR state council building like some wartime booty; the building later temporarily housed the Federal Chancellery and since 2002 has accommodated a private business school. Some of the decorative sculptures were also saved; these now collect dust in the vaults of the Bode Museum.

There has been much discussion as to the reconstruction of the imperial palace since the Reunification of Germany. Historians, architects, town planners, politicians and also a large section of the indigenous population have added their twopence worth to the big debate. Erecting a one-to-one copy of the palace, built between 1443 and 1716, would be practically impossible. The creation of a new building emanating the cube of the original palace has thus been proposed, flanked on three sides and on Schlüter-Hof by a replica of the baroque facade largely designed by architects to the emperor Andreas Schlüter and Eosander von Göthe. In July 2002 German parliament voiced its support for the experts' suggested plans. The structure of the east facade remains to be clarified and it has yet to be decided whether the Palast der Republik, Erich Honecker's 'Lamp Shop', now devoid of its asbestos covering, should make way for the new

Looking down into the excavated hole, the city's loss seems even greater. A few years ago archaeologists laid bare the jagged foundations of the old imperial palace on Schlossplatz, once the residence of the Hohenzollern. Although its damage from Allied air raids was much slighter than that to Schloss Charlottenburg, long since restored to its original splendour, the palace was

edifice once it has served its present purpose. The GDR's houses of parliament, constructed between 1974 and 1976, take up about half of the palace area.

To some the proposed undertaking smacks of the fairytale fabrications of Disney World; to others, such as palace advocate Wilhelm von Boddien, it's much more than a touch of urban plastic surgery. A partial reconstruction would reinstate the "gravitational centre" of the city. "One can clearly feel the phantom pain of a city

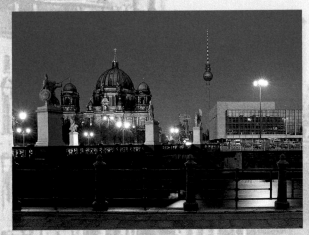

which has had its most significant building amputated", argues Boddien, who at the beginning of the 1990s pleaded his case by erecting an enormous scaffolding-and-plastic imitation of the severed limb.

Plans for the future use of the palace have already been made. If the Stiftung Preußischer Kulturbesitz had its way the ethnological exhibits from Dahlem would be transferred to the city centre, serving as an extension of the Museumsinsel on the other end of the old imperial gardens. There would also be room in the new construction for Humboldt University's scientific artefacts and for the treasures held at the national library. Before the first new foundations are laid, however, the question of money has to be clarified. It's estimated that the sum of between 750 million and one billion euros will be needed, with the government, the federal state of Berlin and/or private investors footing the bill. Never short of an idea, Wilhelm von Boddien suggests selling shares in the Schloss to raise the necessary capital…

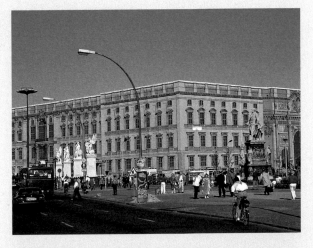

On printed plastic sheeting stretched onto 600 metric tons of heavy steel scaffolding, in 1993 advocates of the rebuilding of the Stadtschloss pleaded their case loud and long.

Left:
The Palast der Republik, erected on the site of the Stadtschloss, before the removal of its dangerous asbestos interior. "Erich's Lamp Shop" is possibly to be replaced by a new building sporting a copy of the baroque palace facade.

Far left:
The Berliner Dom, Schlossbrücke, TV tower and Palast der Republik, the historic centre of town at the heart of the palace debate.

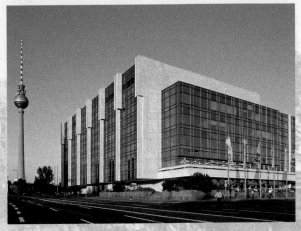

The temporary mock-up of the Hohenzollern residence was intended to illustrate just how important the building was (and again could be) to the old centre of Berlin.

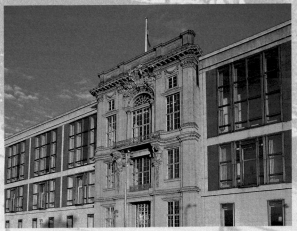

Portal IV of the old imperial palace was salvaged in honour of Karl Liebknecht, who on November 9 1918 proclaimed the "Free Socialist Republic of Germany" from its balcony. This relic of feudalism now adorns the Staatsratsgebäude or GDR state council building, constructed between 1961 and 1964.

Below and small photos on the right:
Friedrichstraße has blossomed beyond recognition since the erection of the Friedrichstadtpassagen with Quartier 206, an absolute paradise for shopaholics. At first customers were cautious, put off by the hammering and drilling which went on for ten years; since its completion, the complex has boomed and is now a hot consumer favourite.

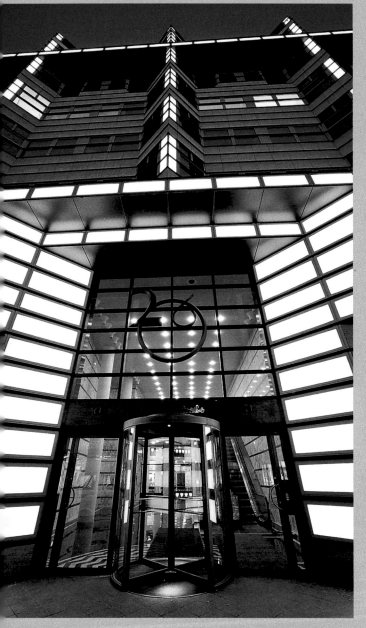

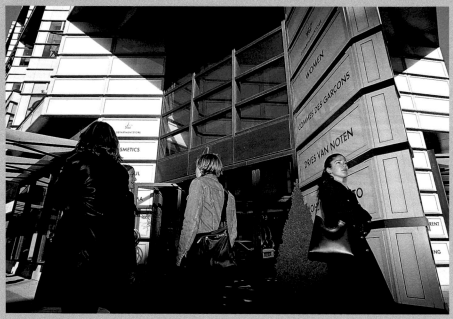

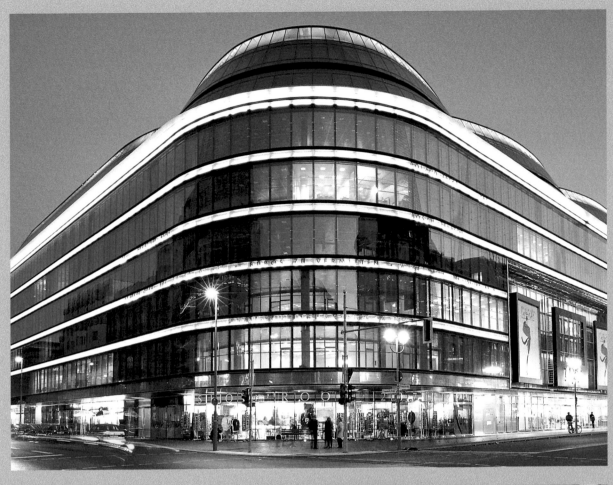

The flair and noblesse of the Parisian boutique slap bang in the middle of Berlin: Jean Nouvel's exclusive Galeries Lafayette on Friedrichstraße.

The new world of shopping on Friedrichstraße consists of three blocks of shops known as Quartier 205, 206 and 207. The bright lights and glass facades supersede the Kaisergalerie opened here in 1873, then the biggest retail and entertainment outlet in the world.

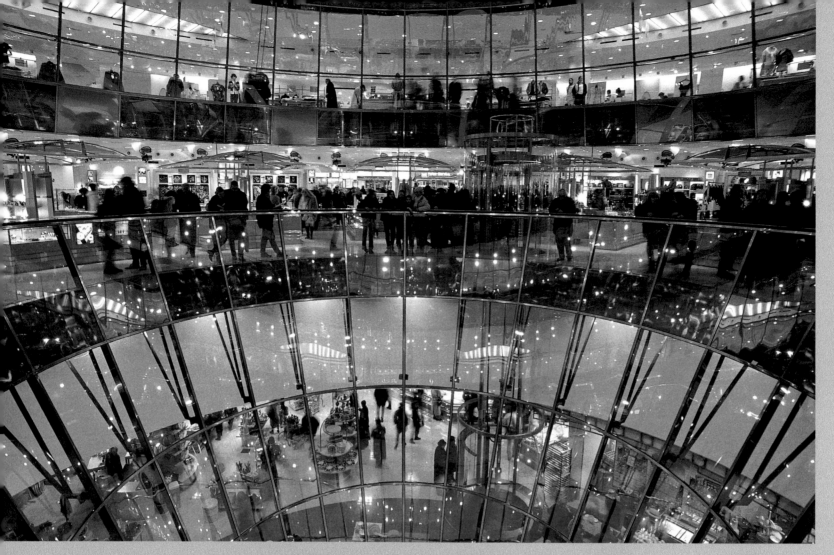

Above:
Consumption at its most spectacular. The glass funnel inside the Galeries Lafayette on Friedrichstraße opens out onto floors and floors of luxury goods and the latest fashions – a must for compulsive shoppers.

Right:
The Mediterranean meets Berlin-Mitte: the courtyard of Restaurant Guy on Jägerstraße.

Far right:
At the restaurant of the Westin Grand Hotel guests can enjoy sumptuous views out over Berlin while they dine.

Page 58/59:
Once a fortified barrier to the East, Allied border crossing Checkpoint Charlie on Friedrichstraße is now a busy junction, with Frank Thiel's American soldier the sole reminder of its complex past

Left:
During the GDR era specialists from the "capitalist West" were employed to work on the construction of the Westin Grand Hotel on the corner of Unter den Linden and Friedrichstraße. The hotel has changed hands several times since the fall of the Wall yet has retained its reputation as one of the most luxurious establishments in town.

Below:
Light, space and the finest materials give Quartier 206 in the Friedrichstadtpassage an exclusive allure, making shopping here an extremely pleasurable (if costly) experience.

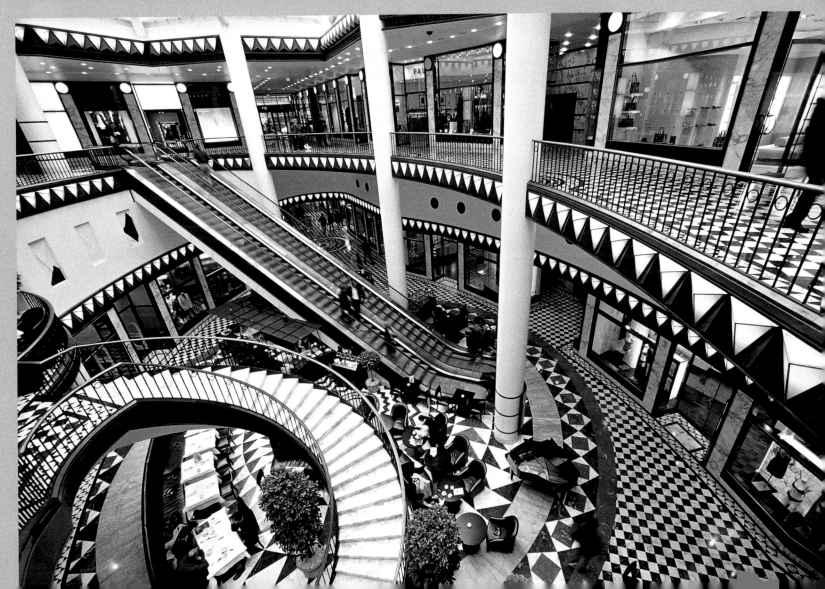

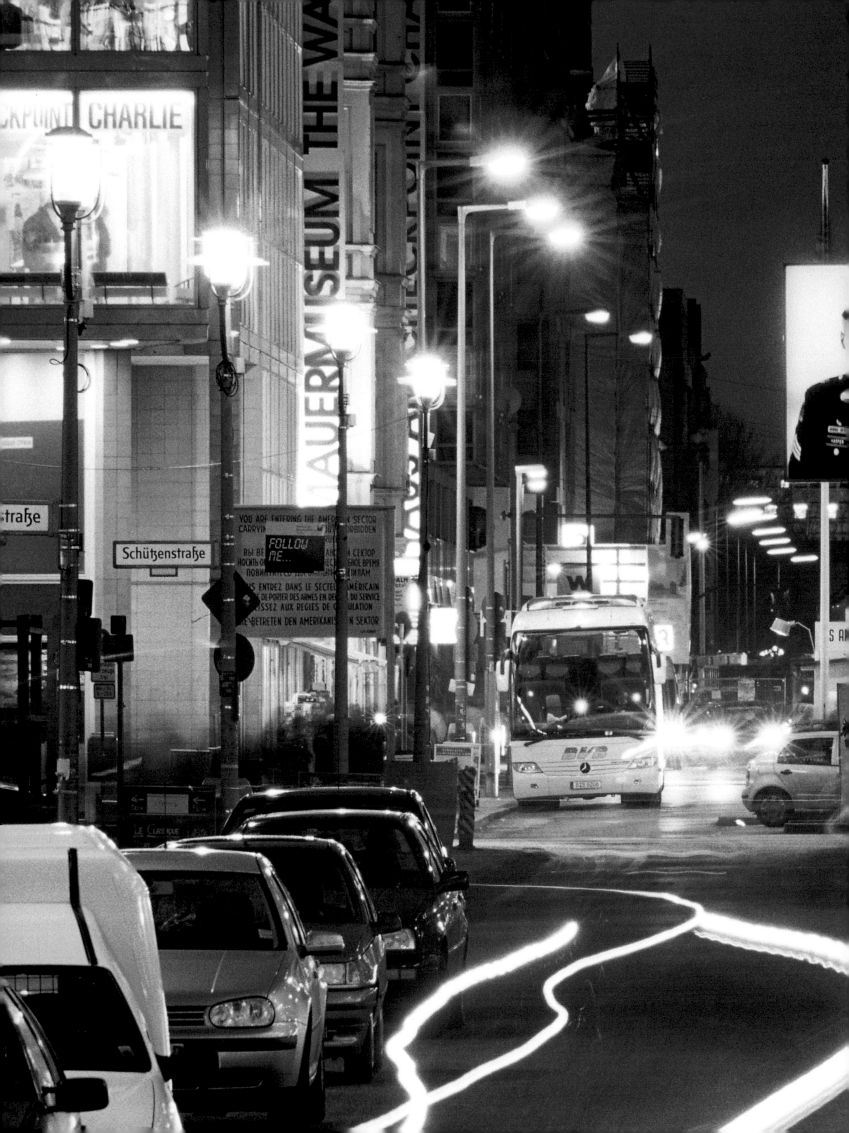

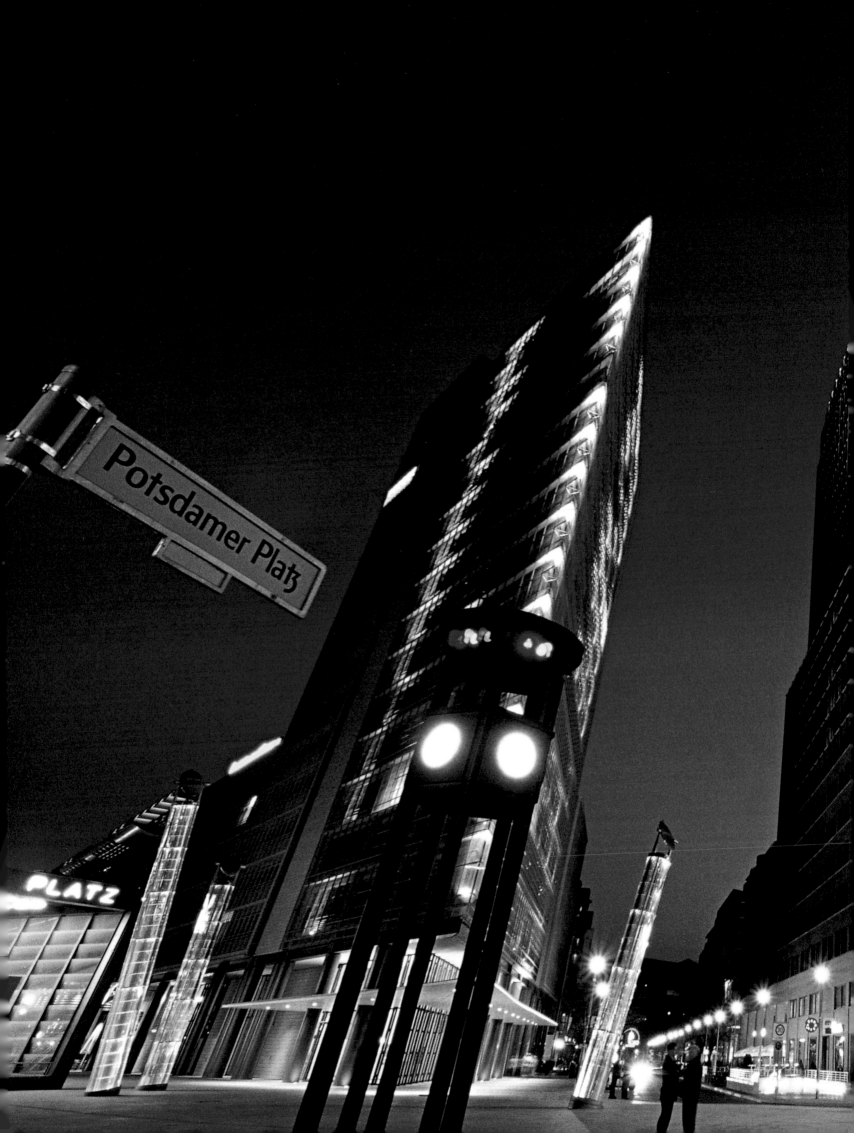

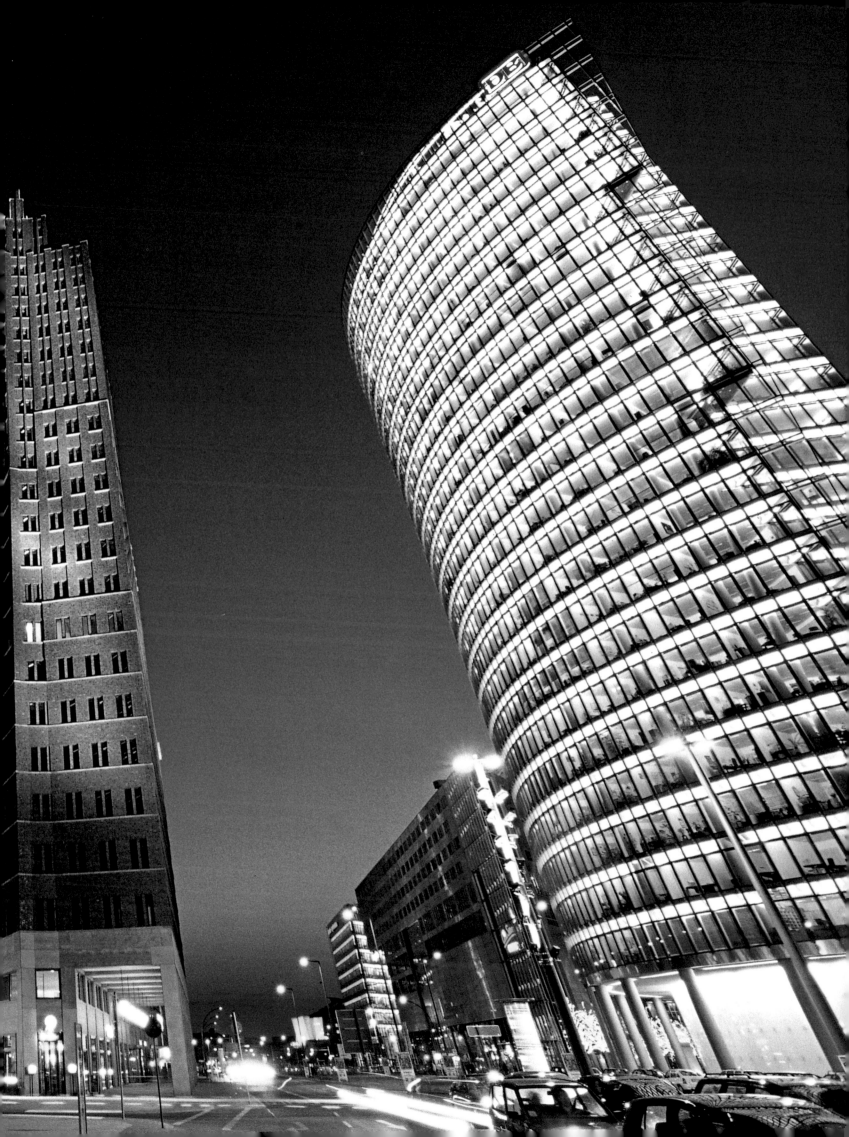

Page 60/61:
A holy trinity of skyscrapers looks benevolently down on the new Potsdamer Platz. Monumental architecture such as this is unusual for Berlin. In the foreground on the left stands a replica of the first traffic lights in Germany.

Art versus commerce; while Sir Simon Rattle furiously waves his baton at the Kammermusiksaal and Philharmonie (left), on Potsdamer Platz in the background big businessmen call the shots.

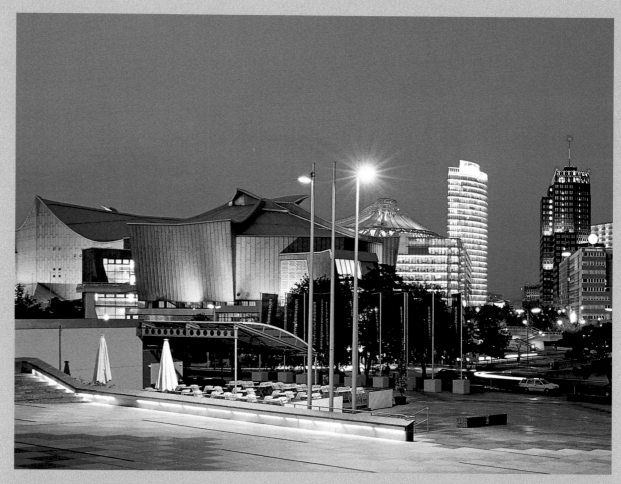

During the Berlinale film festival the musical theatre on Marlene-Dietrich-Platz, part of Potsdamer Platz, glitters with the bright lights of Hollywood. On the left in the background is the green cube on top of the debis building which marks the southern boundary of the new complex.

Right page:
The Potsdamer Platz Arkaden outside Kollhoff's Daimler-Chrysler-Haus is one big shopping mall, with sales outlets ranging from exclusive designer jeweller's to top-class restaurants to common-or-garden supermarkets.

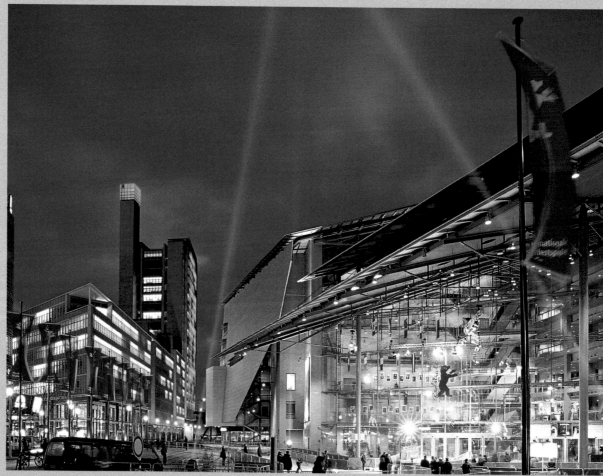

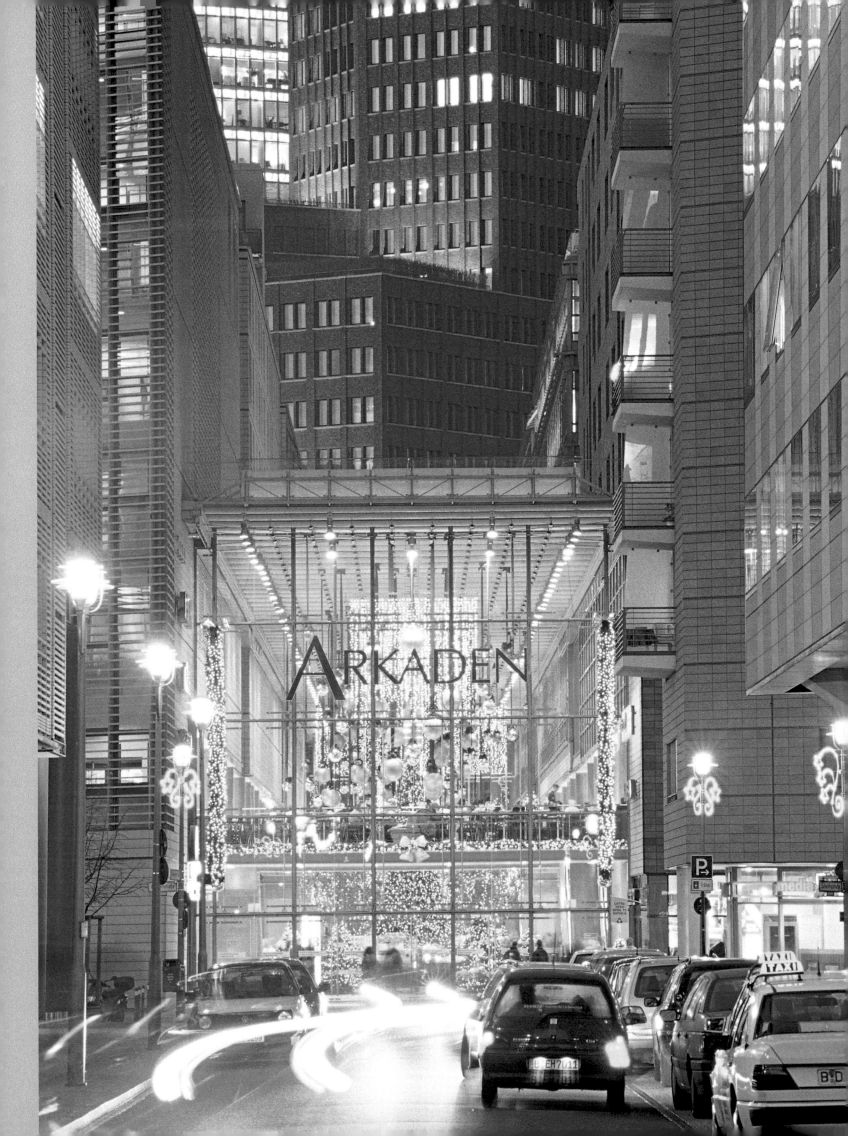

Below left and right:
The new Potsdamer Platz
offers a new perspective at
every turn, a mecca for fans
of modern architecture and
keen photographers.

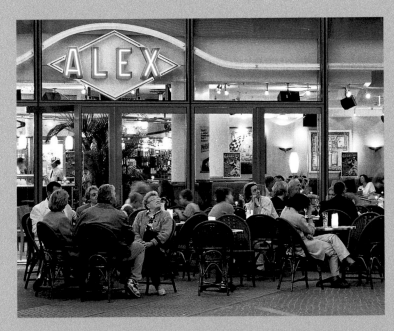

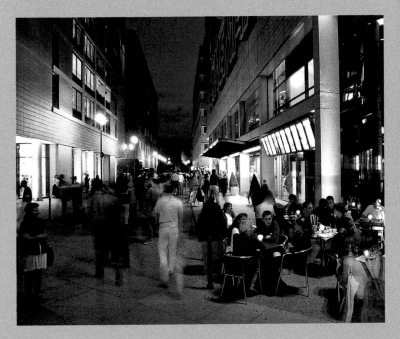

Left:
After a long day at the office or some hard shopping why not treat yourself to a slap-up meal at one of the many restaurants on Potsdamer Platz? Here punters relax at Alex in the Sony Center.

Centre left:
Bicycle pumps are totally superfluous here; these electric neon contraptions by Robert Rauschenberg decorate the front of Weinhaus Huth, the only intact remnant of the old Potsdamer Platz.

Left:
Restaurants, pubs and cinemas provide plenty of night-time entertainment on Potsdamer Platz, especially in the summer when the square is humming with activity.

Above:
Architectural studies on Potsdamer Platz, with dazzling glass and soft stone towers piercing the brilliant blue sky.

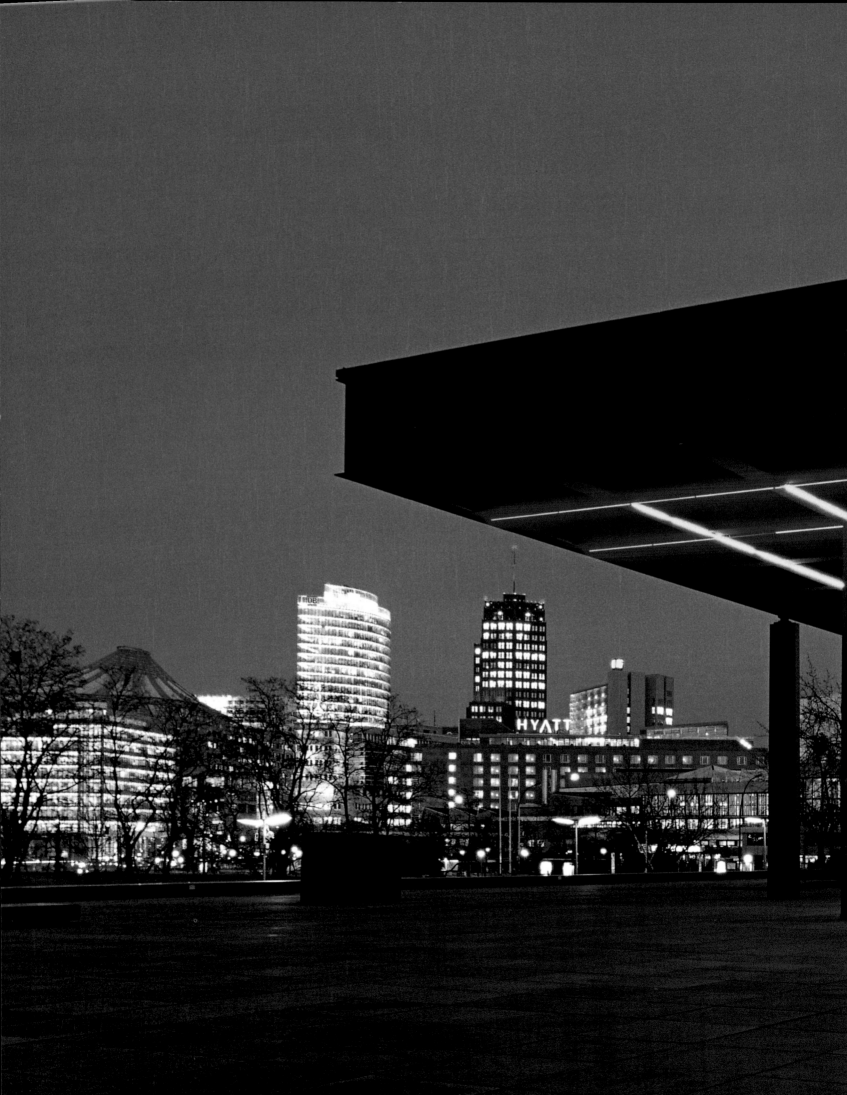

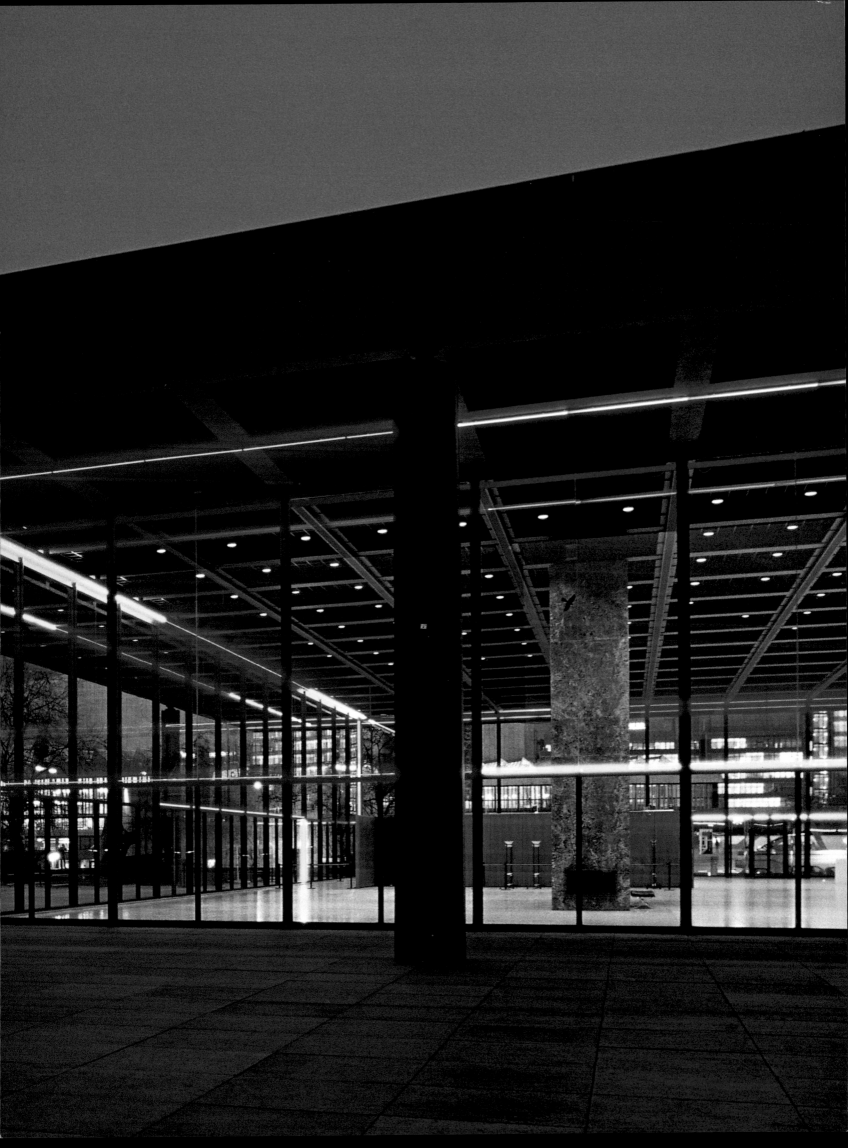

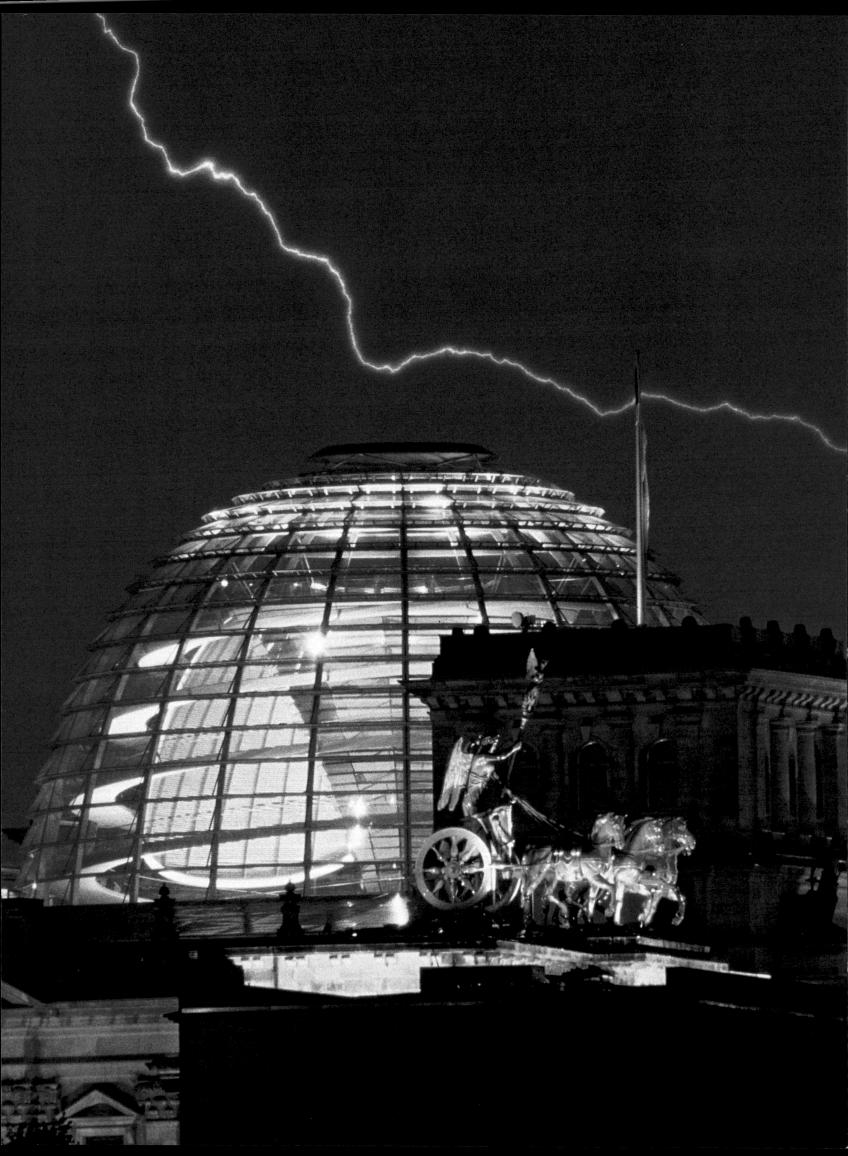

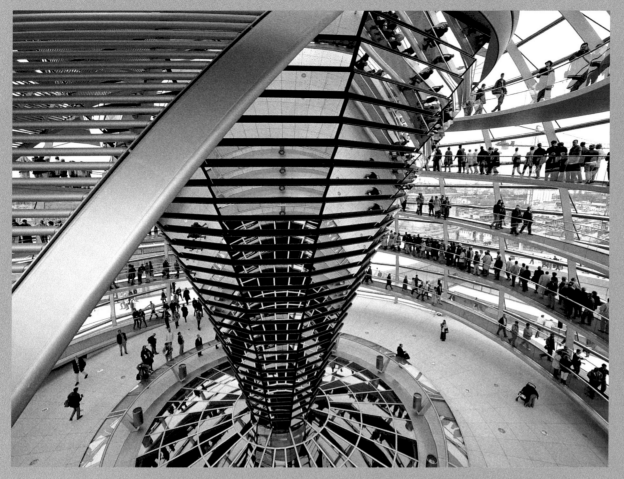

Page 66/67:
Pleasingly simple in its design, Mies van der Rohe's Neue Nationalgalerie was built in 1968 to house the city's collection of contemporary art. The light installation is by Keith Sonnier.

Left page:
Whatever the weather, the debates beneath Lord Norman Foster's glass dome at the Reichstag are often stormy, with thunderous applause reserved only for speakers of the same political persuasion. Equally wired, the Quadriga on top of the Brandenburg Gate demonstratively turns her back on the squabbling ministers and minions.

So that the divas and backbenchers of the German government retain some sort of contact with their electorate the dome of the Reichstag has been made accessible to the public. A mirrored funnel sheds light on the proceedings in the chamber below.

The chamber of the German government is scrutinised by the beady eyes of Germany's heraldic eagle. The parliamentarians convene in one of the most symbolic buildings of Germany's turbulent history.

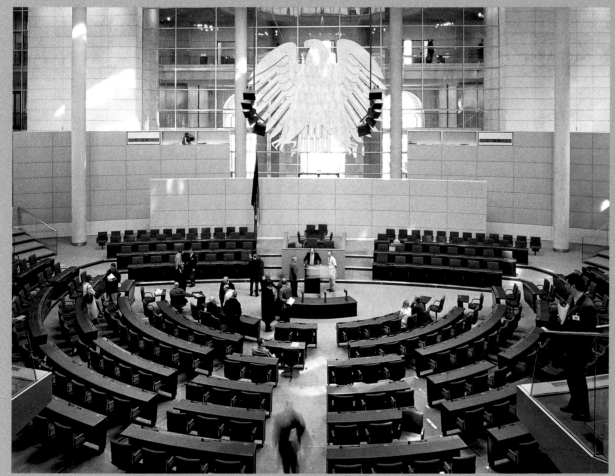

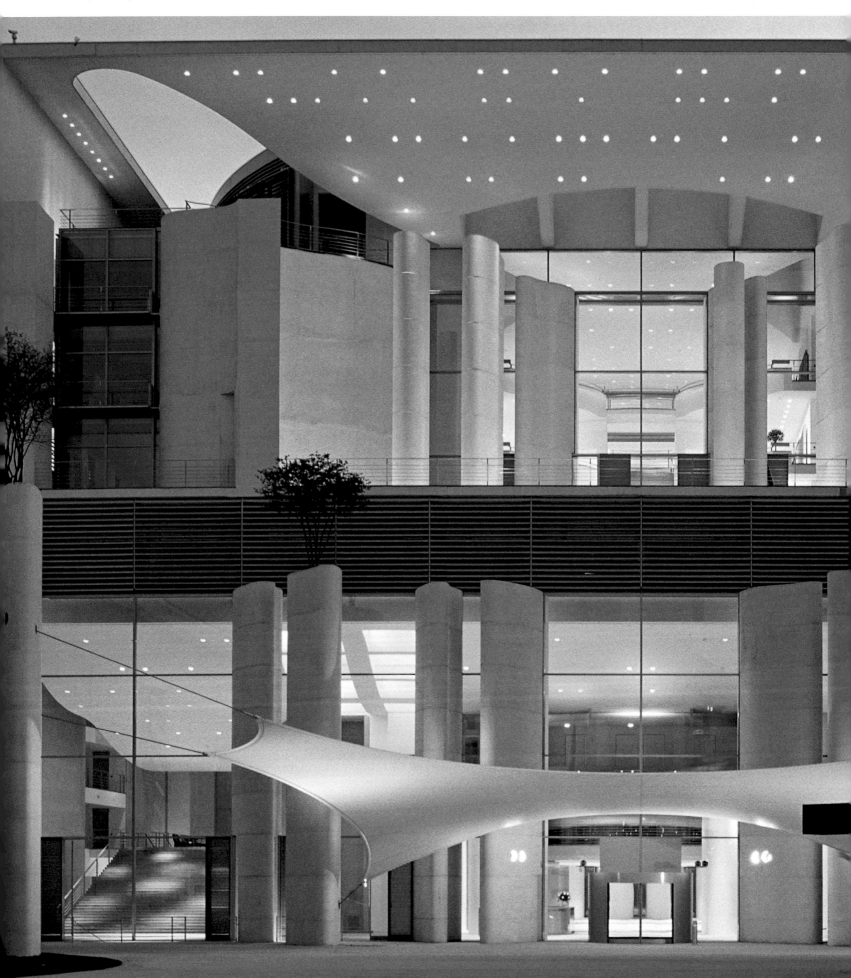

Below:
The new Federal Chancellery on Willy-Brandt-Straße, designed by Axel Schultes and Charlotte Frank. The nine-storey building, which critics find too clumsy, nevertheless has a certain airy appeal. In front of it lies the heavy metal sculpture by Basque artist Eduardo Chillida, aptly entitled "Berlin".

The bold interior of the new Federal Chancellery emulates the generous concrete exterior. Broad flights of stairs and curved balconies are accentuated by colourful walls and sculptures. The spacious lobbies are also used for press conferences. Present tenant Gerhard Schröder has recently abandoned his government villa in Dahlem in favour of an apartment very close to his new seat of office.

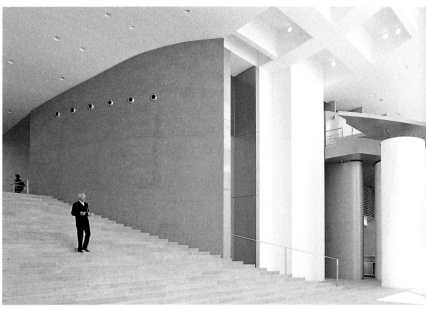

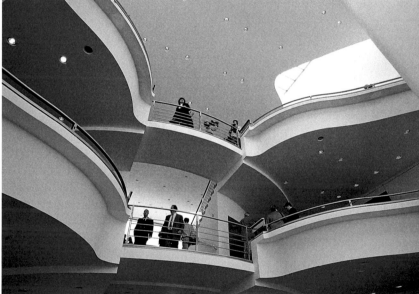

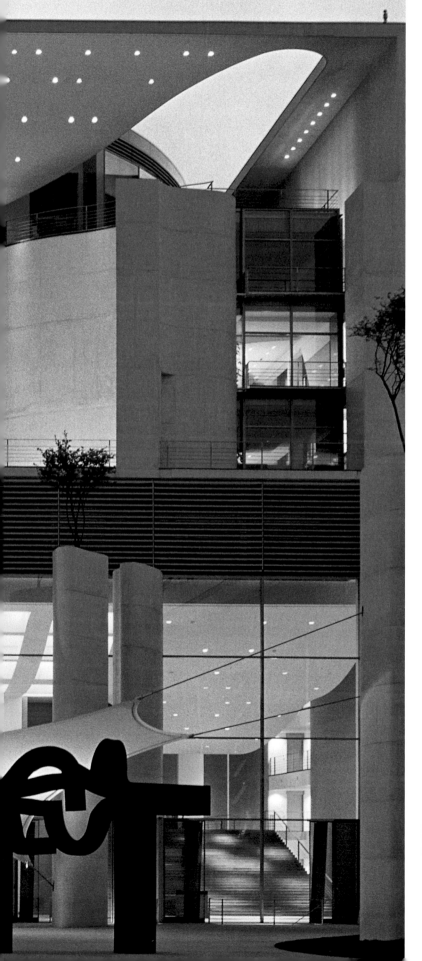

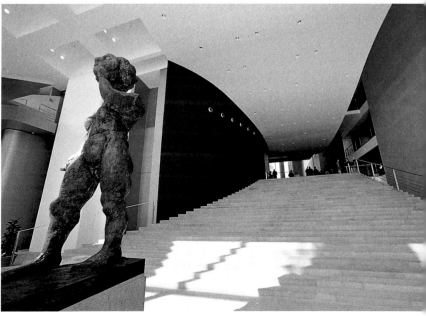

71

HISTORIC COLLECTION –
BERLIN'S ISLAND
OF MUSEUMS

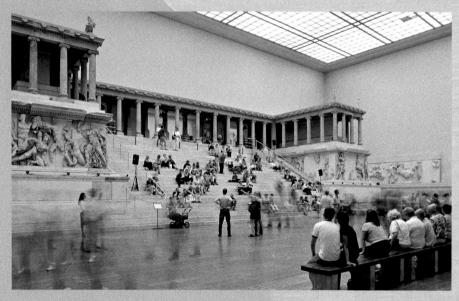

Above:
The main attraction at the Pergamon Museum on the Museumsinsel is the Pergamon Altar, brought to Berlin from Turkey in 1902.

Centre:
The neo-classical Pergamon Museum was built between 1912 and 1930 from plans by architects Alfred Messel and Ludwig Hoffmann. The entrance hall was added in 1982.

Going to Berlin's Museumsinsel or museum island is no different from visiting the Louvre in Paris or the museums of the Vatican in Rome; before you're let loose on the exhibits, you have to queue. The Alte Nationalgalerie in particular, now reopened following restoration, is a major draw with its incredibly extensive collection of works of art from the 19th century. The crowds at the Pergamon Museum – yet to be renovated – are similarly large. Year in, year out, over 600,000 flock to admire the magnificent array of architectural monuments from the ancient world. Together with Karl Friedrich Schinkel's Altes Museum, the bombed-out Neues Museum (still a war ruin) and the Bode Museum at the bow of the island, the buildings make up an impressive whole. Established over the course of one hundred years on an island in the River Spree in the middle of Berlin and propped up by 40,000 oak pillars rammed into marshy Ice-Age ground, the ensemble is due for a complete overhaul and

much-needed extension over the next ten years. The plans for this ambitious project have been masterminded by British architect David Chipperfield and other colleagues of renown.

The entire collection, documenting over 6,000 years of cultural history, is also to be reordered. Nefertiti at the museum of Egyptology in Charlottenburg has her bags packed and ready to go, eager to rejoin her relatives on the island where she resided before Berlin was bombed to oblivion during the Second World War. The relocation

of "the beautiful who has come", as the name Nefertiti can be roughly translated, is probably the most spectacular example of the cultural reunification of the Stiftung Preußischer Kulturbesitz, the organisation responsible for the preservation of Berlin's artistic treasures, torn apart by war and the division of East and West.

UNIVERSAL MUSEUM

As the pillars erected in the 19th century will no longer be able to support the growing museums,

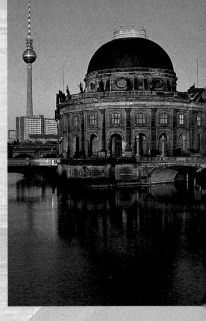

The current hype surrounding the Museumsinsel should not divert attention from the other collections managed by the Stiftung. At the Kulturforum there are Old Masters awaiting appreciation, with works of contemporary art at the Hamburger Bahnhof.

The Berggruen collection opposite Schloss Charlottenburg proudly presents the life and times of Picasso and at Mies van der Rohe's Neue Nationalgalerie there are plenty of other Modernist greats on display. If your interests

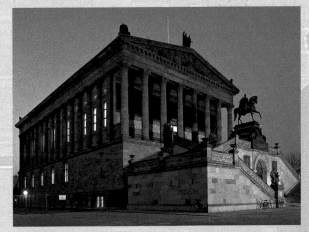

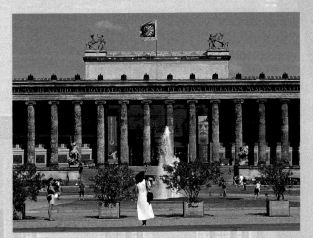

Above:
The Bode Museum on the bow of Berlin's island of museums is still scheduled for restoration. When reopened in 2006 the building will house the city's coin and sculpture collections and the Museum of Byzantine Art.

Above left:
Reopened in 2001 following extensive restoration, the Alte Nationalgalerie now exhibits the art of the 19th century. Visitors come here to marvel at the works of the great Romantics, such as Caspar David Friedrich, and to ponder Rodin's "Thinker".

Left:
It all started with the Altes Museum in the old palace gardens, completed in 1830. Karl Friedrich Schinkel called it "my best work".

engineers face a technical nightmare when it comes to transferring the load to the boggy ground. A billion euros have been provided to fund what is at the moment probably the biggest cultural building project in the world. The main aim is to link all five museums with an archaeological promenade, a historic trail which takes visitors on a tour of what will become largest universal museum complex worldwide. Museumgoers will, of course, be able to leave the convoy shuffling round the exhibits to ponder favourite items at leisure.

lie elsewhere, there are old aeroplanes and computers at the Deutsches Technikmuseum, dinosaur skeletons at the Naturkundemuseum (natural history), canons, rockets and old documents at the Deutsches Historisches Museum and the Luftwaffenmuseum (air force museum) in Gatow, "Jugendstil" or Art Nouveau at the Bröhan Museum and Stasi memorabilia at the Forschungs- und Gedenkstätte on Normannenstraße, not to mention Berlin's other 150 museums. In short, there's something for everyone.

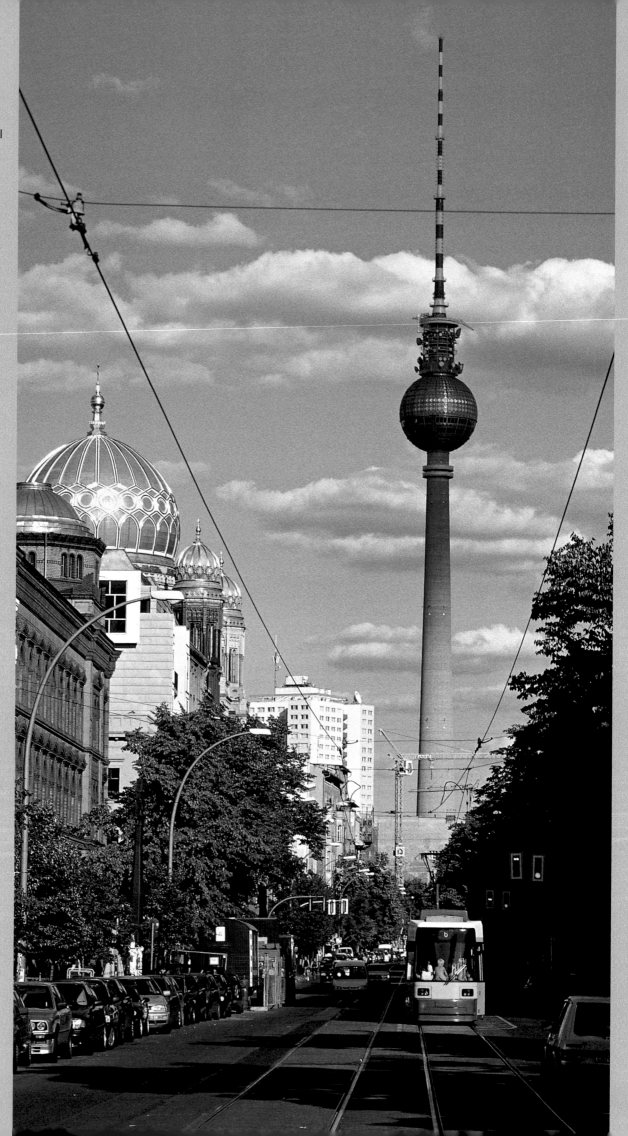

Right:
Its rather degenerate charm
has made Oranienburger
Straße a place of great appeal
to the young post-Wall gene-
ration who have also made
Mitte, Prenzlauer Berg and
Friedrichshain their own.
Oranienburger Straße is
dwarfed by the television
tower on Alexander Platz,
with the dome of the
synagogue to the left.

Right page:
There are pubs and cafés
galore in the Oranienburger
Straße area and the range is
vast. Here the punters bask
in the sun on the main drag
itself (top left) and soak up
the charm of Old Berlin on
Sophienstraße (bottom left);
the Große Hamburger Straße
is almost French with its out-
door bistros (top right) and
Hackescher Markt (bottom
right) has a Dutch flair with
its many coffee shops. The
Tanzwirtschaft Kaffee Burger
establishment on Torstraße
(centre left) even hosts liter-
ary evenings at their "den of
thieves" and has wild nights
of clubbing and "dacha
dance" at the Russian disco.

74

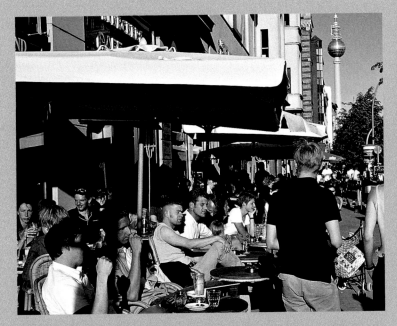

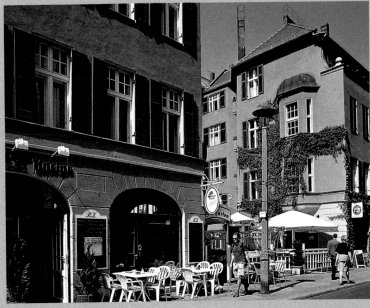

Below and right:
The Kulturbrauerei on Knaackstraße in Prenzlauer Berg was immortalised by Günter Grass in his novel "Ein weites Feld" (A Broad Field). The old brewery complex is now a buzzing centre of the arts, with restaurants and alternative culture in the form of readings, gigs, special club nights and experimental performances.

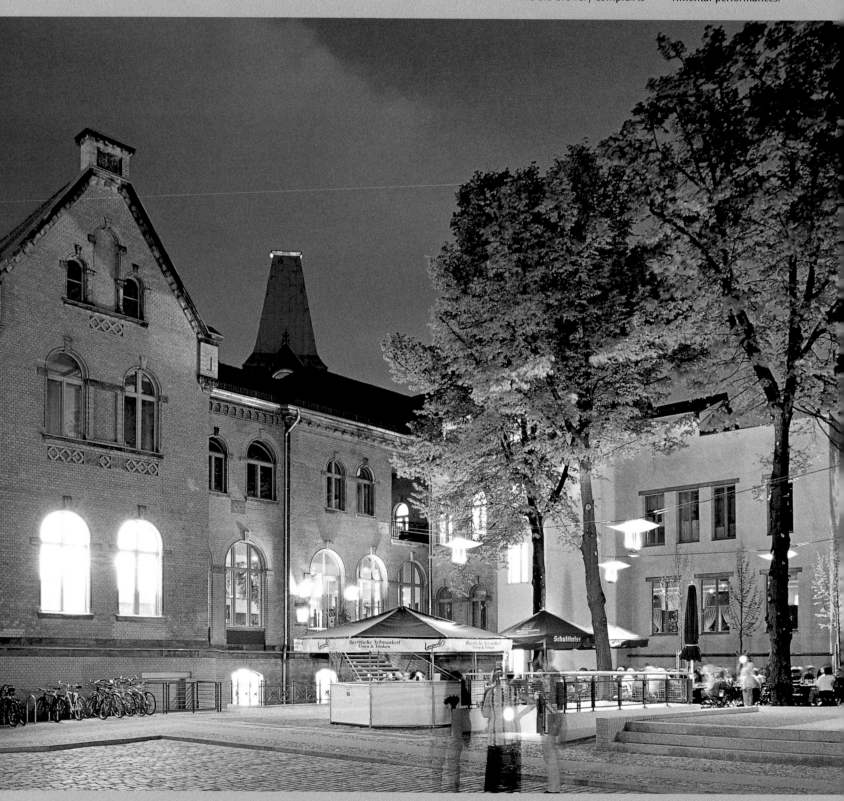

Right:
In the last few years the scene on Kollwitzplatz has boomed, with the young disciples of the early 1990s quickly becoming experienced entrepreneurs with a good head for business.

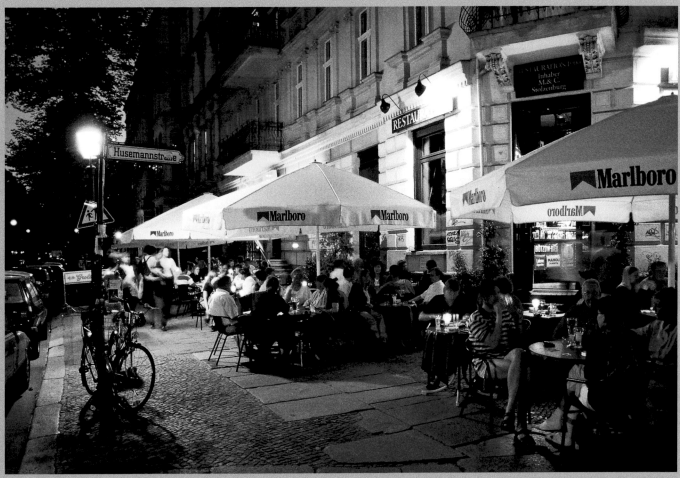

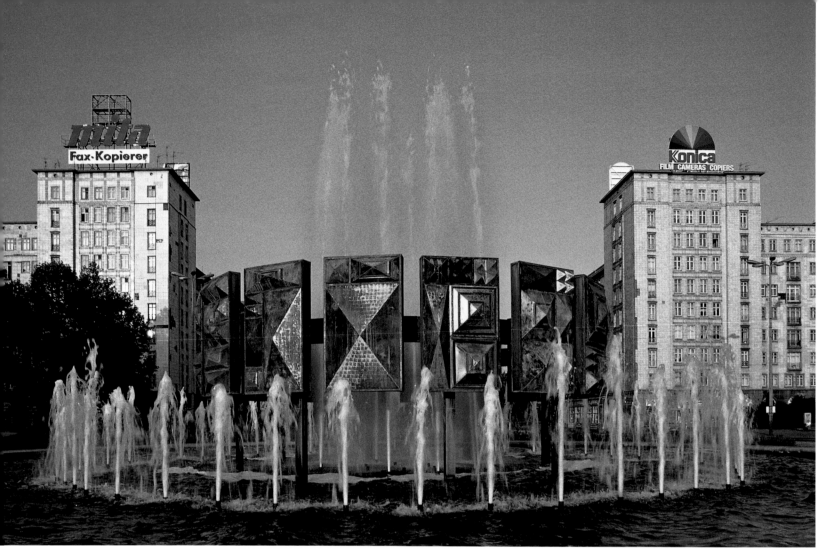

Above:
Straußberger Platz marks the beginning of the Stalinist Karl-Marx-Allee (formerly Stalin-Allee). The exaggerated "boulevard of the workers" with its colossal tower blocks and wide central thoroughfare was meant to be the ideological pendant of the "Western decadence" of the Kurfürstendamm.

Right:
Once the appeal of Prenzlauer Berg had waned Berlin's young trendsetters moved on to Simon-Dach-Straße in Friedrichshain.

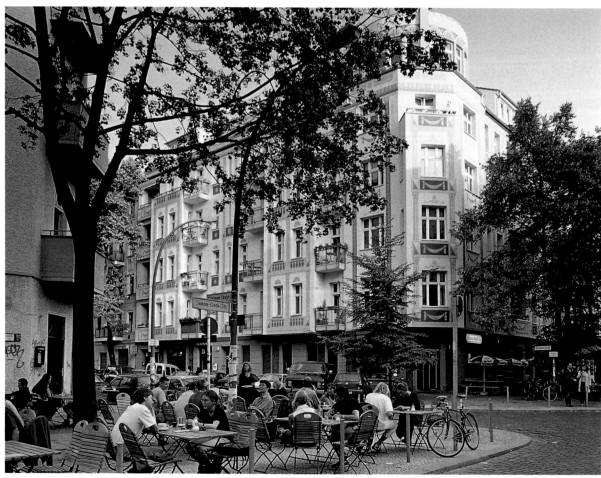

Left:
An alternative facade on Simon-Dach-Straße in Friedrichshain.

Below:
A little rough round the edges and rather unkempt, Schönhauser Allee has so far managed to avoid being tarted up like much of the rest of city, retaining much of its authentic East Berlin flair.

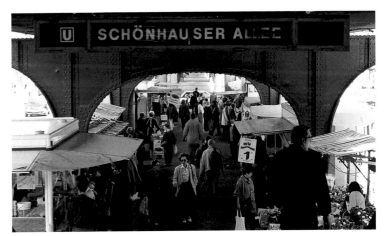

79

Frankfurter Allee has had
an elaborate facelift, with
spanking new offices and
shopping complexes – much
to the annoyance of the
area's long-established,
small-time traders.

The Ost-Bahnhof in Friedrichshain, one of the city's many S-Bahn, regional and main line stations. Once the super new city junction at Lehrter Stadtbahnhof has been finished (scheduled for 2006), things here, and at the infamous Bahnhof Zoo, should become a little quieter.

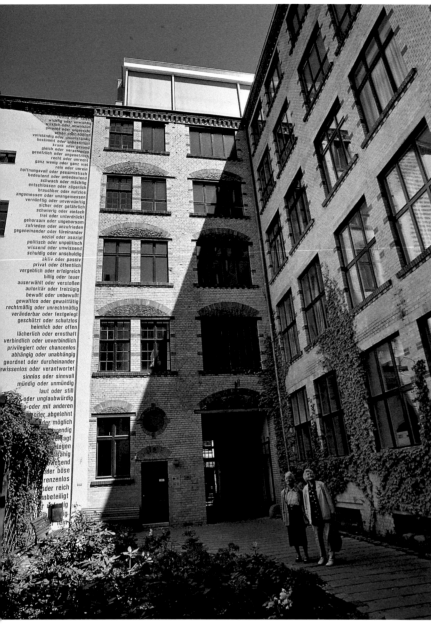

Above left:
With the Hackesche Höfe having met with such a positive response, renovation of the neighbouring Sophienhöfe and Gipshöfe has started in earnest.

Below left:
Living in the past: an inner courtyard from the last century on Albrechtstraße near Schiffbauerdamm.

Below:
The Heckmannhöfe between Oranienburger Straße and Auguststraße have lots of little shops selling everything from sweets to bridal gowns.

Cult meets culture. Above: the opening of an exhibition at a Galerie in the degenerately-charming Haus Schwarzenberg, Rosenthaler Straße 39, next-door to the Hackesche Höfe. Underneath it the preview of a Jeff Koons exhibition at the German Guggenheim Museum in Berlin at a branch of a major bank.

The fine arts and literature in close proximity; the above photo shows visitors admiring the newest exhibits at the Asian Fine Arts Gallery on Sophienstraße in Mitte, while others listen enthralled to a reading at Juliette's Literatursalon on Gormannstraße just around the corner.

Conceived by August Endell
in 1908, the Hackesche Höfe
on Hackescher Markt were
once the largest residential
and office complex in Europe.
The buildings are named
after an 18th-century mili-
tary governor of Berlin.

Sipping a cool beer on a
warm summer evening after
wandering around the Hacke-
sche Höfe. The many cafés
and restaurants outside the
Hackescher Markt S-Bahn
station are a great place to
sit and watch the world go by.

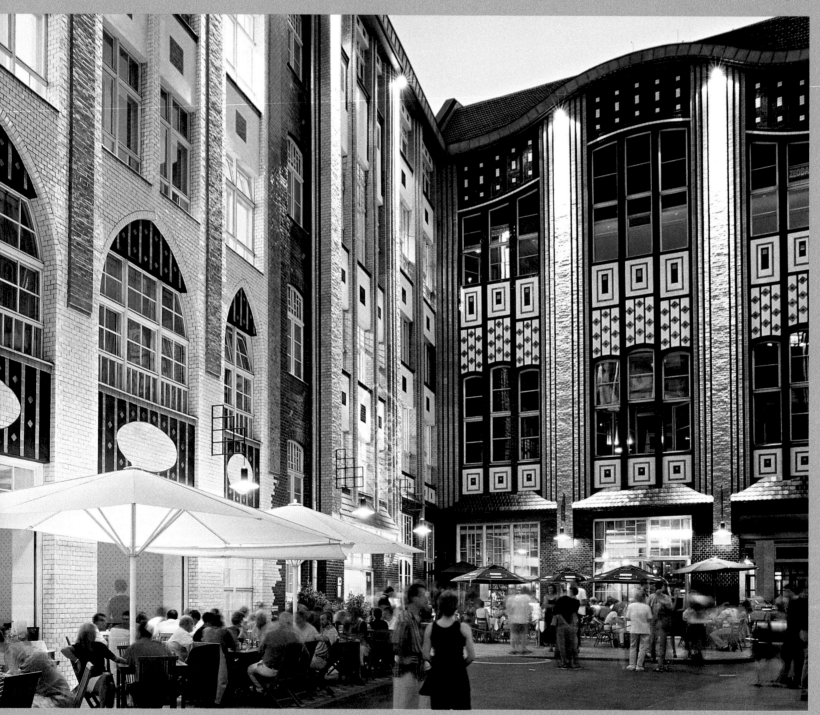

Right:
The imaginative and witty
performers at the Varieté
Chamäleon in the Hackesche
Höfe have earned the venue
an excellent reputation

nationwide. The audience
seems to greatly appreciate
the lack of unnecessary pomp
and glamour; shows are often
fully booked.

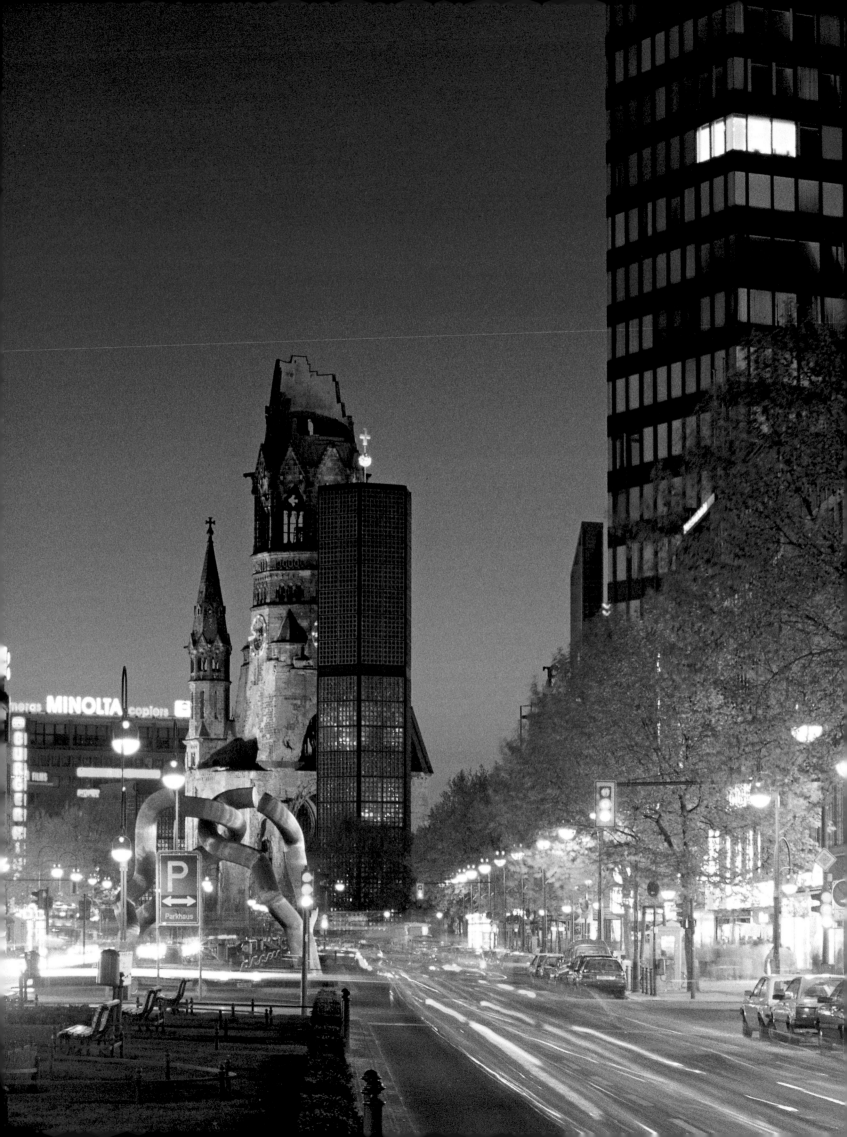

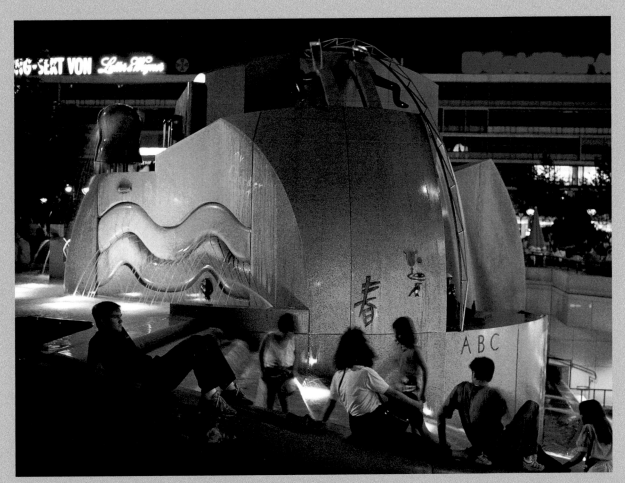

Left page:
The heart of City-West with the ruined Kaiser Wilhelm Memorial Church in the background, erected between 1891 and 1895 by Franz Schwechten. In front of it is the new steeple by Egon Eiermann from 1961, with part of the Europa-Center to the right.

Breitscheidplatz outside the Europa-Center is dominated by Joachim Schmettau's global clock, also known as the Flow of Time.

The entwined tentacles of the steel Berlin sculpture by couple Matschinsky and Denninghoff look like giant pieces of spaghetti, with the memorial church squatting in the background.

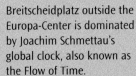

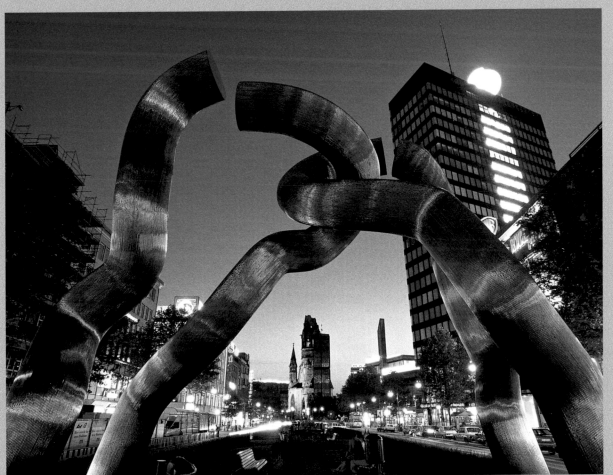

Page 90/91:
With so much money being invested in the east of the city, the west had to make a stand. The result was Helmut Jahn's new Kranzlereck, a glass iceberg cutting into the junction of Kantstraße and Kurfürstendamm. In front of it is the once glorious Café Kranzler building from the 1950s, now practically defunct and reduced to little more than a fashion store coffee shop.

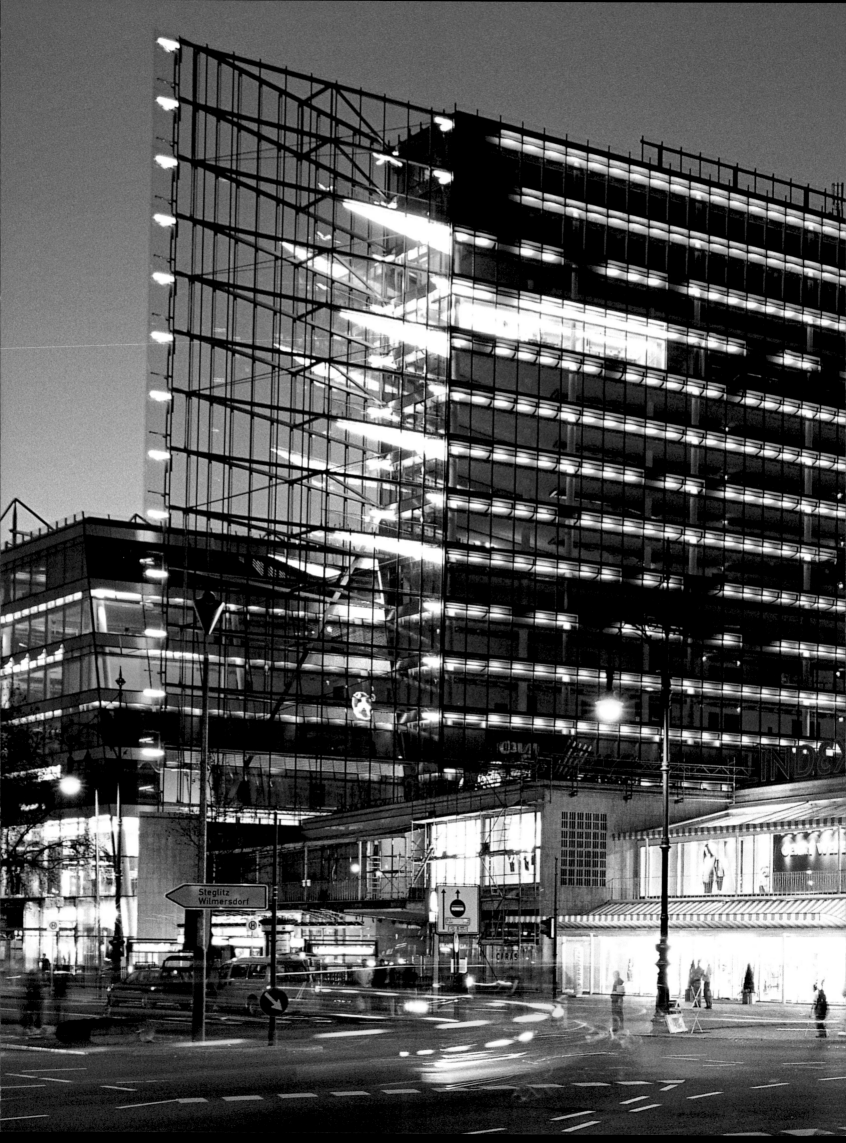

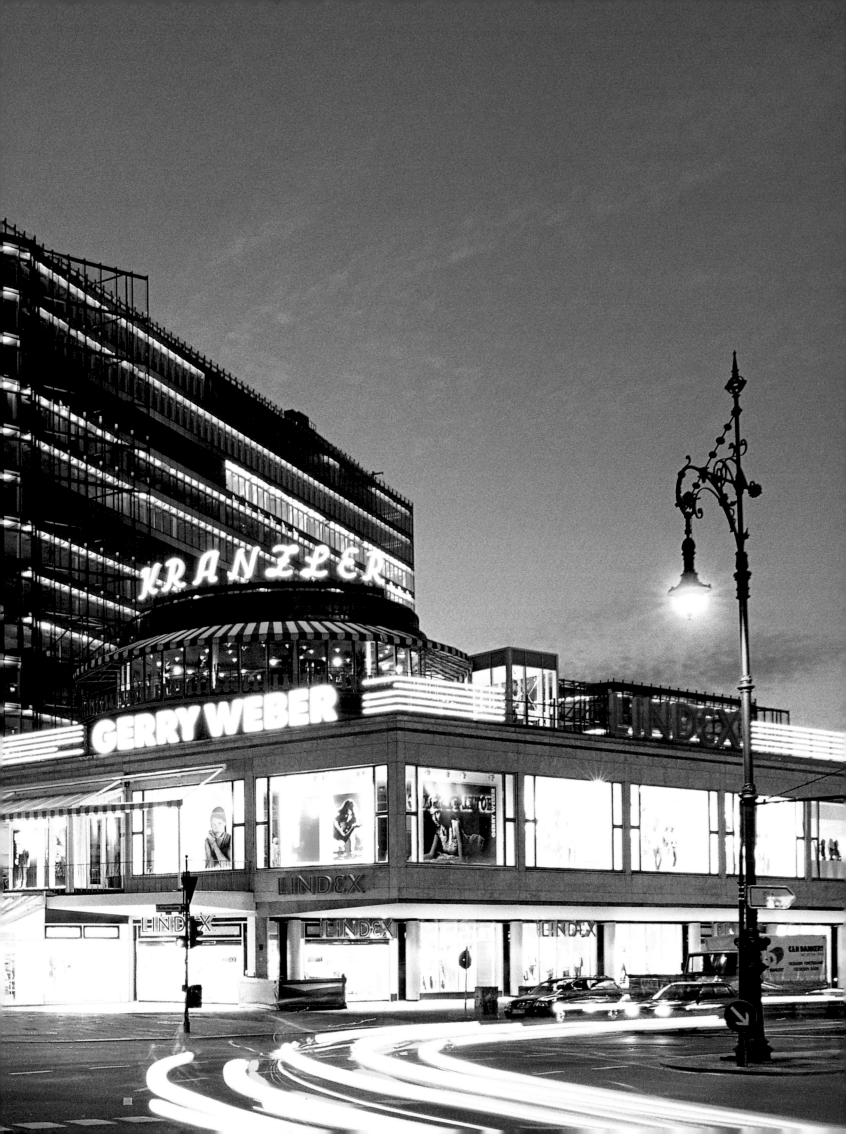

Proclaimed dead many times, the Kurfürstendamm lives on regardless. Once a bridleway running from Berlin to the Grunewald hunting lodge, today the boulevard is lined with posh shops and cafés touting for custom. At the first sign of sunshine the tables and chairs out on the pavement are packed with weary shoppers.

92

Small photos on the left:
"Gründerzeit" facades, busy
traffic under lush green
canopies and countless shops
and pavement cafés: all this –
and more – is Kudamm.

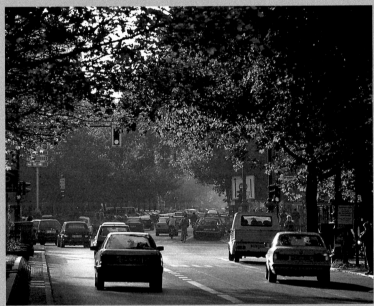

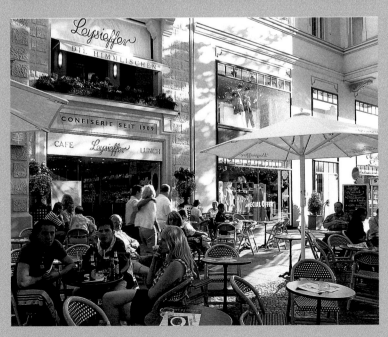

Above:
If you want to give your tired
feet a rest, there are open-
topped buses running sight-
seeing tours of the city. Don't
forget to duck the overhang-
ing branches on Kudamm.

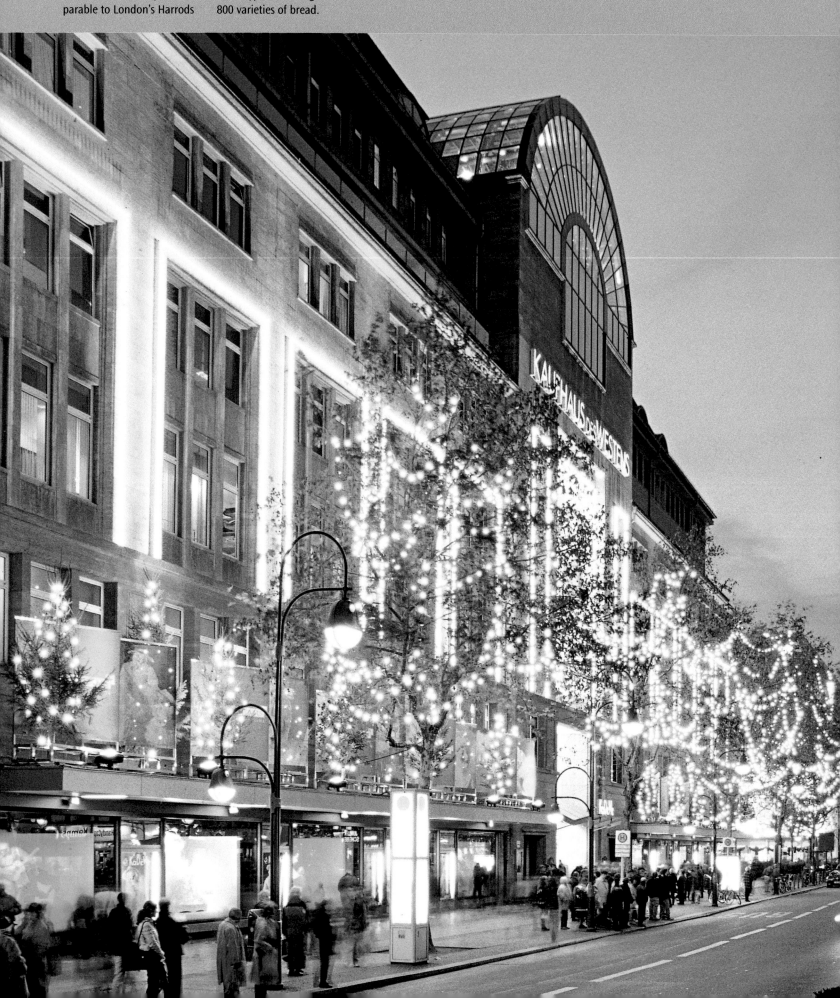

Below:
KaDeWe (Kaufhaus des Westens) on Tauentzienstraße is one of the biggest department stores in Europe, comparable to London's Harrods in size. Its most famous attribute is its food hall which sells 1,700 sorts of cheese, 1,000 types of sausage and 800 varieties of bread.

Small photos on the right:
Plenty for the discerning
customer: posh boutiques,
expensive jewellery stores
and exclusive art galleries
line the Kurfürstendamm and
its side streets.

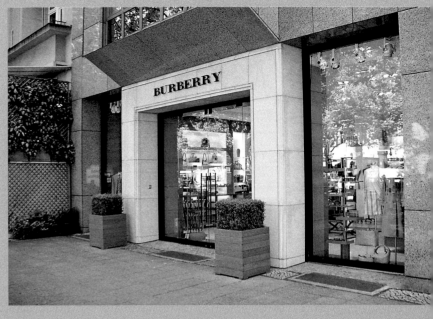

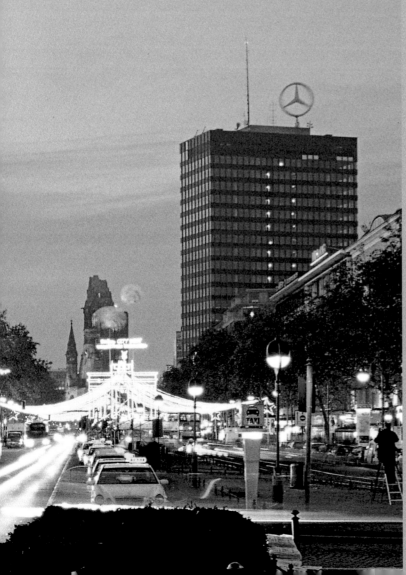

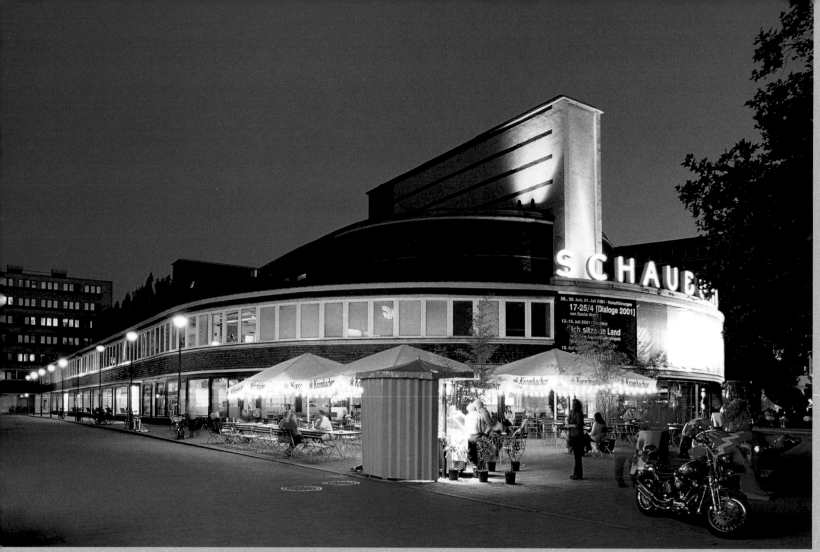

Above:
The Schaubühne on Lehniner Platz, run by Thomas Ostermeier and Sasha Waltz, resides in the refurbished Universum cinema built by Erich Mendelsohn.

Right:
The irrepressible Paris Bar on Kantstraße is still a hot favourite with the stars and critics of the music, theatre and film scene. German actor Otto Sander even has his own table, marked with a bronze plaque.

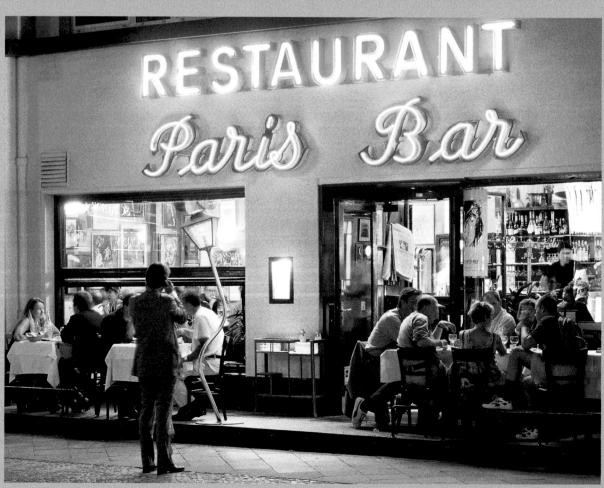

Above:
Design for the well-to-do is on sale at Stilwerk on Kantstraße, with extravagant furniture and accessoires for the discerning penthouse. Good taste costs good money; this is for holders of gold cards only…

Left:
"Bar jeder Vernunft", which literally translates as "bar any sense", is a tent of mirrors in the car park next to the Festspielhaus on Schaperstraße which stages cabaret and satire of the highest order.

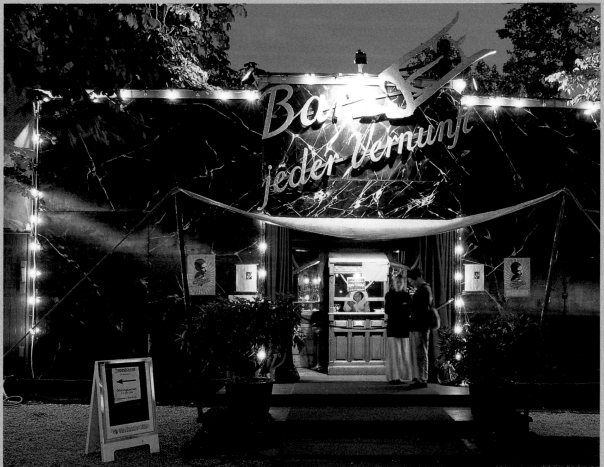

CURTAIN UP –
THEATRICAL GOINGS-ON
IN THE CITY OF BERLIN

Centre:
For over a decade now the performances at the Volksbühne have had rave reviews from all quarters. The theatre is also the main venue for trash theatre director Christoph Schlingensief, here with a scene from one of his own productions.

When the clock strikes midnight in the Dorotheenstadt cemetery, two ghostly figures rise from their graves. They glide silently along to the Berliner Ensemble a few streets away to hold their nightly vigil, checking whether their successor Claus Peymann is doing justice to the grand tradition of "their" playhouse. Firmly clamped between their ghostly jaws are two cigars. The spectres are dramatists Bertolt Brecht and Heiner Müller, their cigars as much part of their identity (Müller's tombstone even has its own ashtray) as the neon Berliner Ensemble (BE)

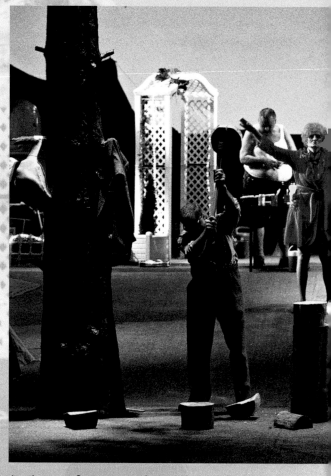

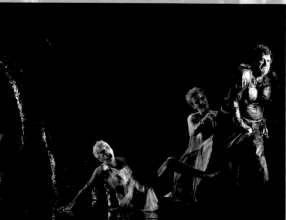

Above:
After the notorious flop of "The Hunchback of Notre-Dame" at the musical theatre on Potsdamer Platz, Andrew Lloyd Webber's all-time hit "Cats" was deemed a safer bet.

Above right:
Whenever Harry Kupfer's production of Richard Wagner's "Ring" is showing the Staatsoper on Unter den Linden is completely sold out. Here a scene from "The Rhinegold".

logo on the theatre roof, designed by one of Brecht's pupils Peter Palitzsch.

YOUNG STARS AND OLD HANDS

There's no cause for alarm, however, as business at the BE is positively booming. Night for night Thomas Bernhard, Peter Handke and George Tabori, and also the more traditional Shakespeare, Lessing and so forth fill the house, merrily competing with the Deutsches Theater

(DT) not far away, the second playhouse of renown in Berlin. Like the mischievously smiling statue of Brecht on Bertolt-Brecht-Platz outside the Ensemble, the bronze busts of Otto Brahm, Max Reinhardt, Heinz Hilpert and Wolfgang Langhoff in front of the DT and affiliated Kammerspiele ensure that only theatre of the highest quality is staged in these august surroundings. This involves present manager Bernd Wilms hiring such diverse directing talents as the American master of light and pictures Robert Wilson, young star Michael Thal-

heimer with his short and highly concentrated presentations and old hands Peter Zadek and Hans Neuenfels. It's not unusual to ring the ticket hotline a few days before a show and be disappointed to hear an apologetic "Sorry, sold out" on the other end.

REBEL WITH A CAUSE: THEATRE IN MITTE

The elegant sophistication of the Deutsches Theater is aggressively challenged by rebel with a

cause Frank Castorf at the Volksbühne on Rosa-Luxemburg-Platz in Mitte, his regular audience made up of bright young students from the trendy neighbouring district of Prenzlauer Berg. Castorf is heralded as a master of deconstruction and is famed for his satirical treatment of the nostalgia surrounding the GDR. This is embodied among other things by the illuminated blue "Ost" (east) stuck on top of the box-like theatre which, after being heavily bombed during the last war, has been reincarnated in geometric Art Nouveau and Stalinist pomp.

THE WORLD'S A STAGE

The last member of Berlin's top theatrical four is the Schaubühne on Lehniner Platz. Founded in 1962 as a student theatre on the Hallesches Ufer in Kreuzberg, it spiralled to fame shortly after Peter Stein took over in 1970. It prides itself on being a "contemporary theatre", as it did as its founding, where both drama and dance are given equal attention. Director Thomas Ostermeier confronts his audiences with the harsh

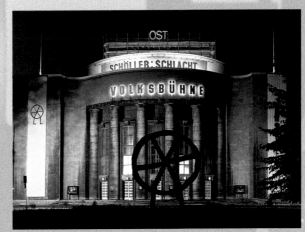

reality of social criticism, with choreographer Sasha Waltz preferring to appeal to the imagination with her vocabulary of movement, rich in colourful association.

This top-class quartet is accompanied by a large group of smaller theatres, among them the world-famous Grips theatre for children and teenagers, and an almost impenetrable number of experimental venues. Despite ongoing cuts in funding by the Berlin senate and the gaping cultural and political hole left by the closure of the Schiller Theatre in 1993, the world – in Berlin at least – is still a stage, providing inquisitive minds with some very unusual food for thought.

Top:
The decorative turn-of-the-century Theater des Westens on Kantstraße has recently been taken over by connoisseurs of the musical Stage Holding.

Above left:
Frank Castorf's Volksbühne on Rosa-Luxemburg-Platz. The blaring neon "Ost" on the roof and the rather anarchist sculpture in front of it indicate that you're in for an unconventional evening of wacky theatre.

Above:
One of the traditions at the Komische Oper, once run by Walter Felsenstein, is that everything is sung in German – even if Russian or Italian works are being staged.

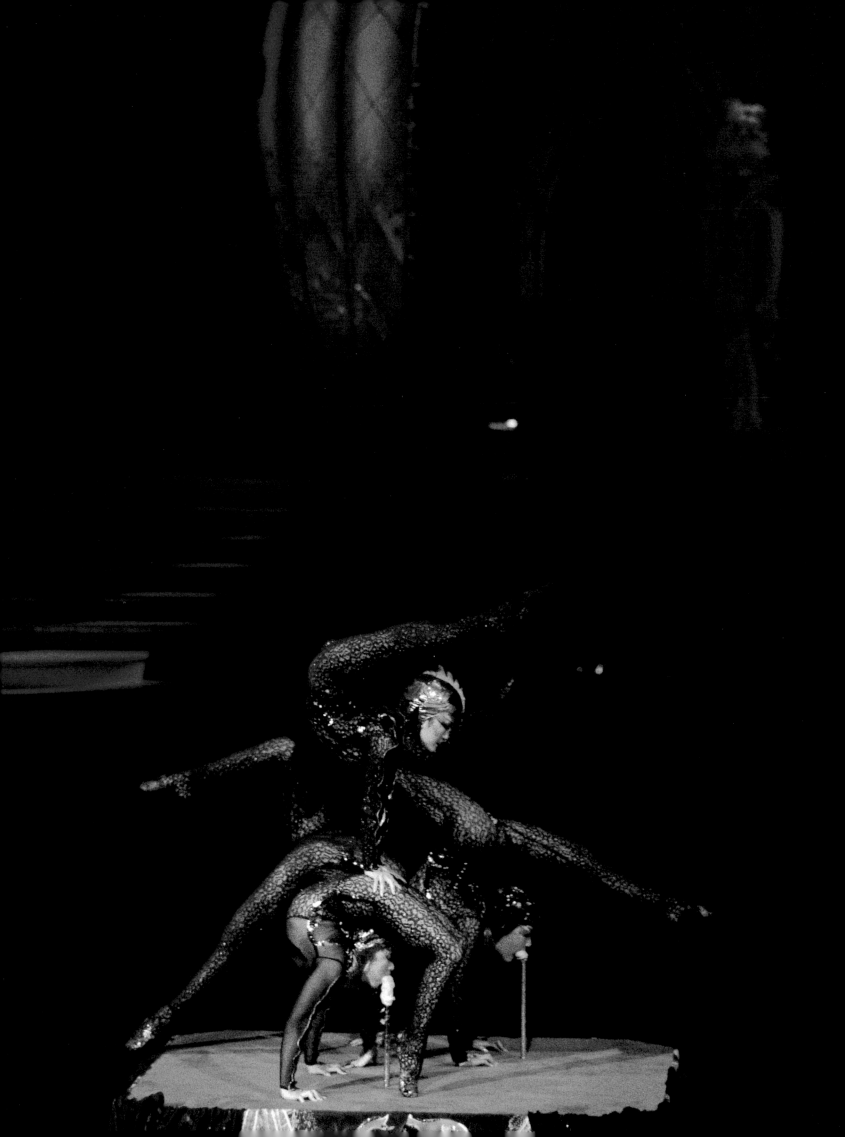

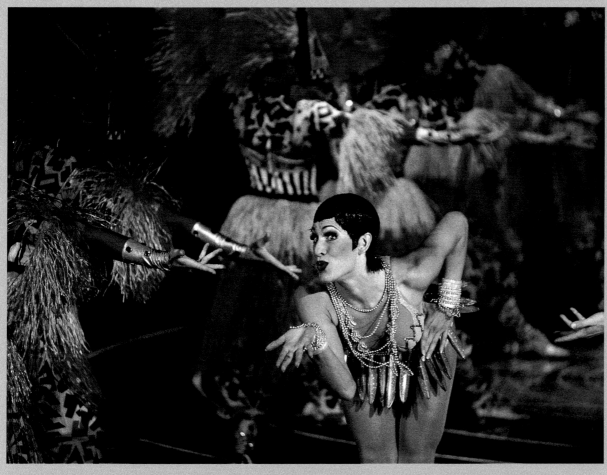

Friedrichstadtpalast, the review theatre managed by Alexander Iljinskij, has become a bastion of light entertainment. Although the titles, scanty costumes and lighting effects frequently change, the content, dramaturgy and fun factor of the shows are persistently similar. The highlight of any performance is the chorus line, which comes on kicking the 62 most shapely legs in Berlin to funky music and impressive laser lighting.

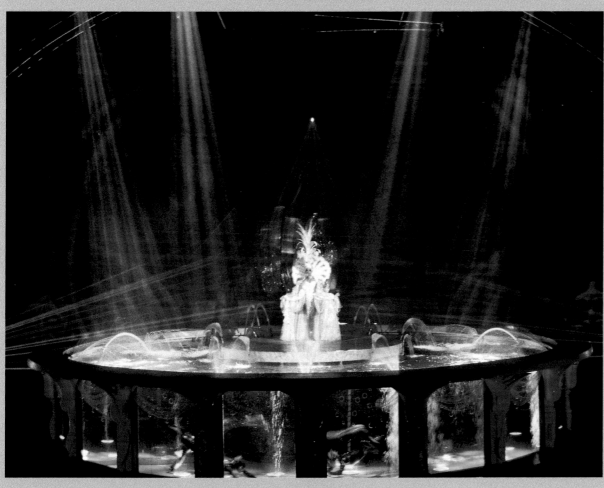

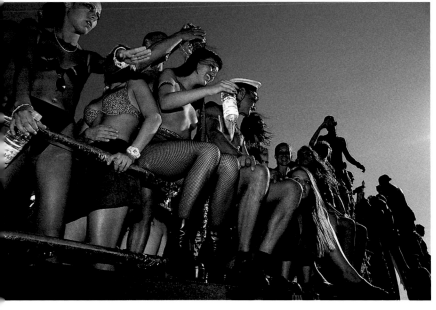
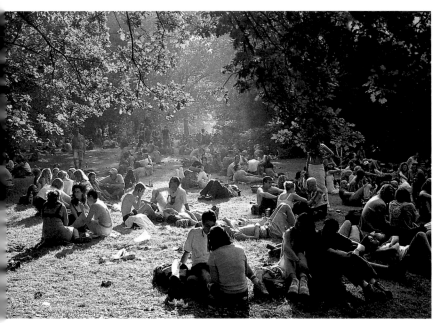

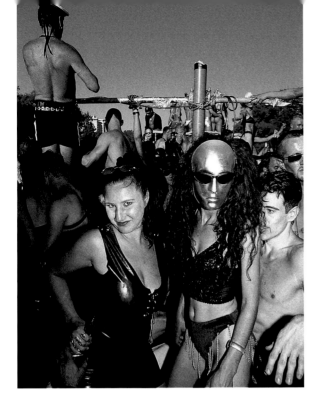

The yearly Love Parade is "the" happening for fans of acid house, techno and hundreds of beats per minute. At its peak at the middle/end of the 1990s over two million legs were estimated to have bopped their way along the Straße des 17. Juni between Ernst-Reuter-Platz and the Brandenburg Gate. Ravers in deliriously mad outfits, skimpy swimsuits and halter tops or even without anything on at all make the eyes of Berlin's retailers, restaurateurs and hoteliers gleam bright at the prospect of earning some quick euros. In the last few years the parade has run out of steam somewhat, with "only" several hundred thousand flocking to the open-air procession. This migrates to the clubs late at night, where those with plenty of puff still left bop until they drop the next morning.

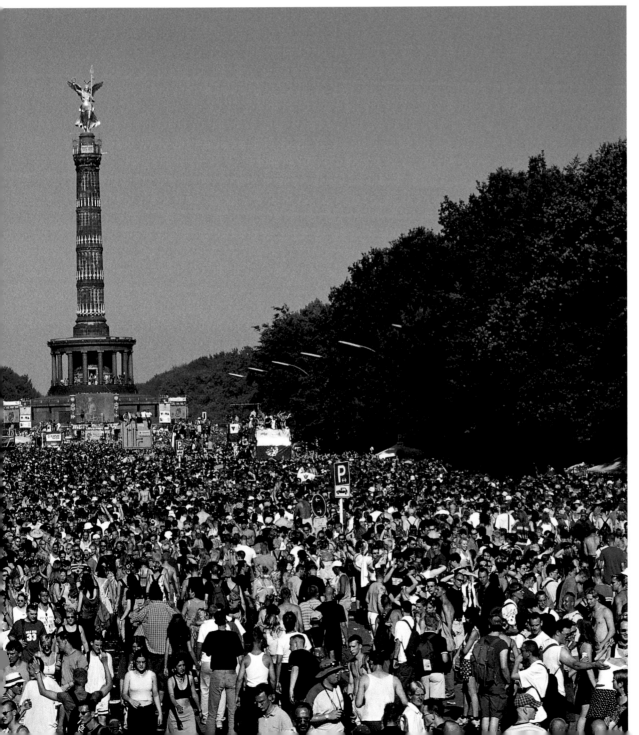

Above:
The autumnal Tiergarten, once the elector's game preserve west of the royal capital, is a haven of peace and quiet. In the early hours of the morning some of Germany's politicians can be spotted jogging off the effects of the night before.

Right:
What could be more romantic than a peaceful row along the Neuen See, right in the middle of the Tiergarten in the heart of the city.

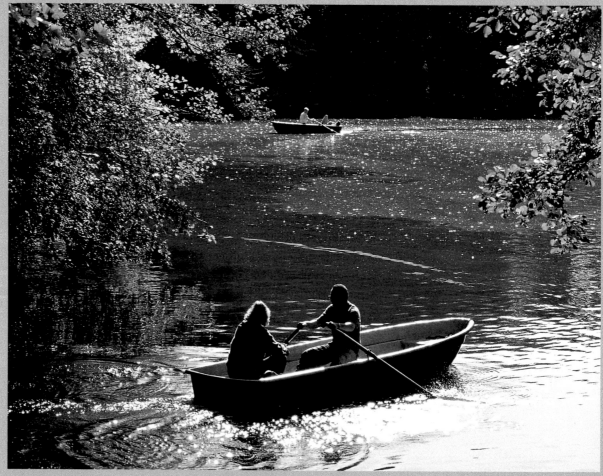

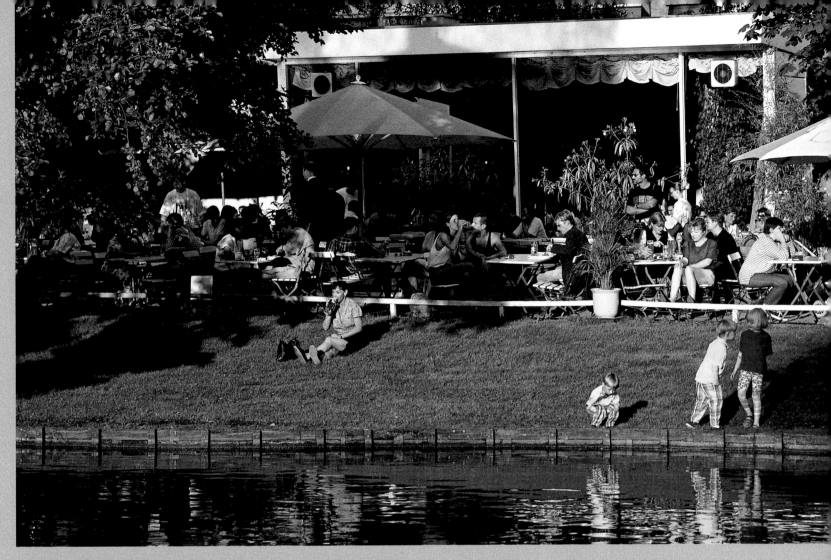

Above:
Tiergarten, at 200 hectares (490 acres) the biggest park in Berlin, has many fine restaurants, such as the Café am Neuen See. At the weekends the park goes multicultural when Berlin's Turkish community descends, armed with deckchairs, cool boxes and portable barbecues.

Left:
Taking a breather at the Löwenbrücke in Tiergarten, an English-style landscape garden which boasts 25 kilometres (15 miles) of trails and pathways.

Below:
Berlin has become something of a showcase for modern architecture. Here the embassies of Scandinavia share this pointed construction on Klingelhöferstraße.

Below:
The diplomats are back and keen to do justice to their countries both politically and architecturally. Here the Mexican Embassy, also on Klingelhöferstraße.

Right:
The ambassador of India works from this brick cube on Tiergartenstraße, with its unusual array of windows.

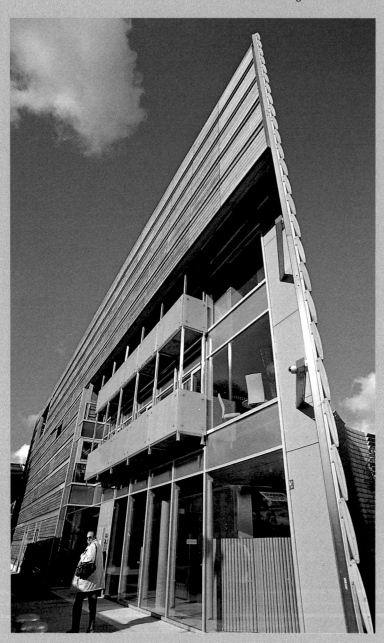

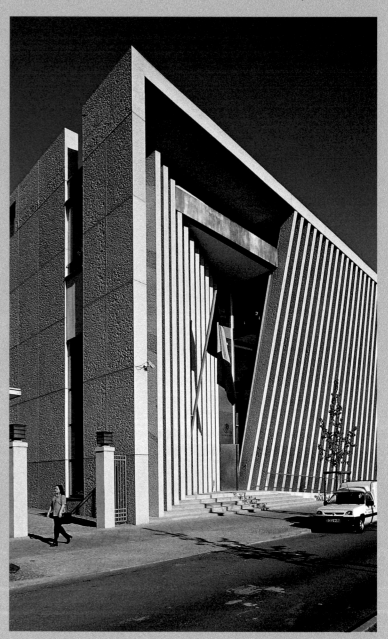

Right:
Tiergartenstraße is also where Austria's diplomats hold office in the pastel ensemble of their embassy.

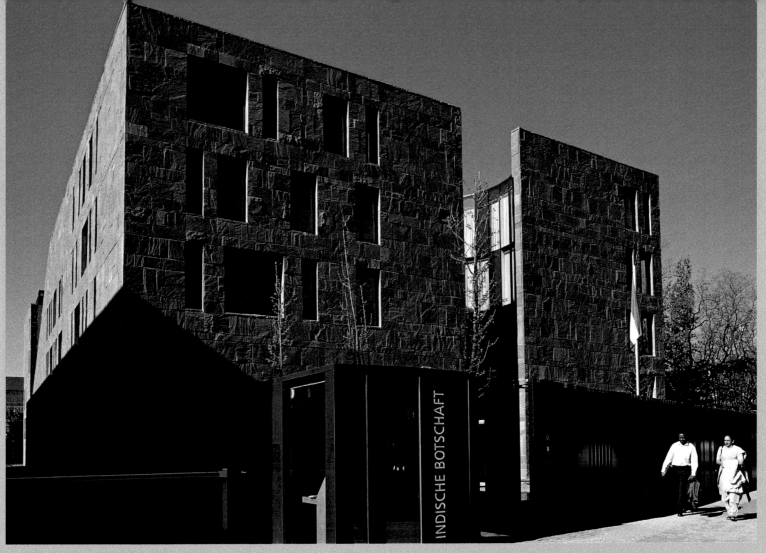

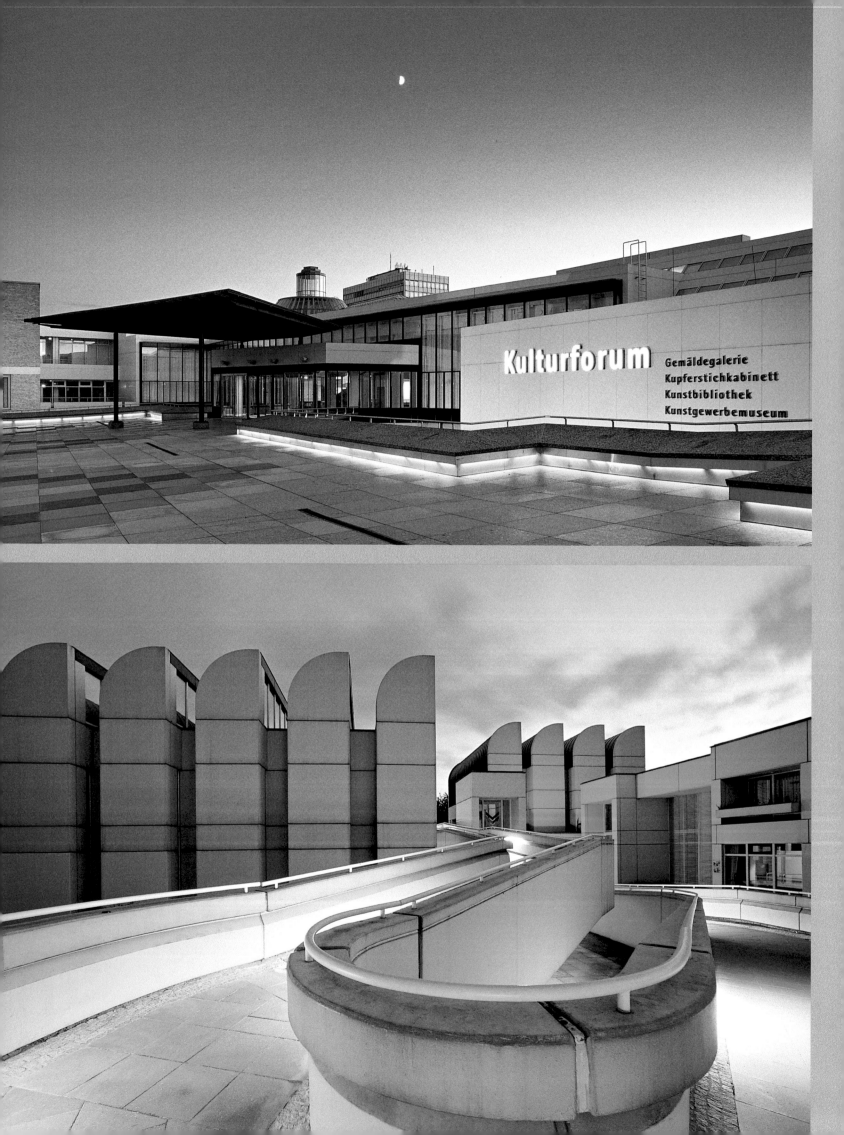

109

Schloss Charlottenburg, with its characteristic central tower, was built between 1700 and 1790 from plans by Johann Eosander Göthe and Wenzeslaus von Knobelsdorff. The upper baroque park was laid out by Simeon Godeau, with the northern section designed as an English garden by Peter Joseph Lenné. In the park stands the mausoleum erected for Queen Luise, who died in 1810.

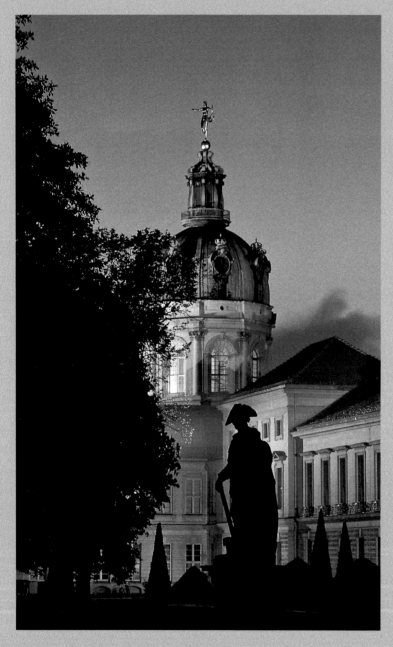

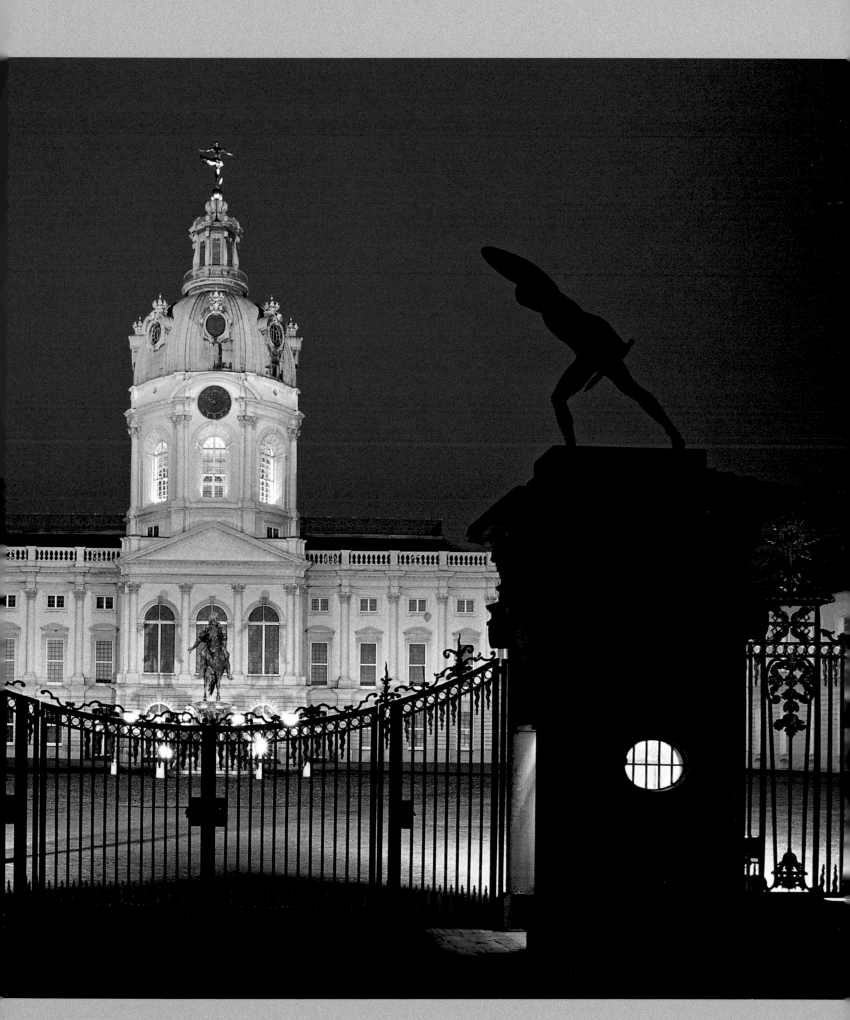

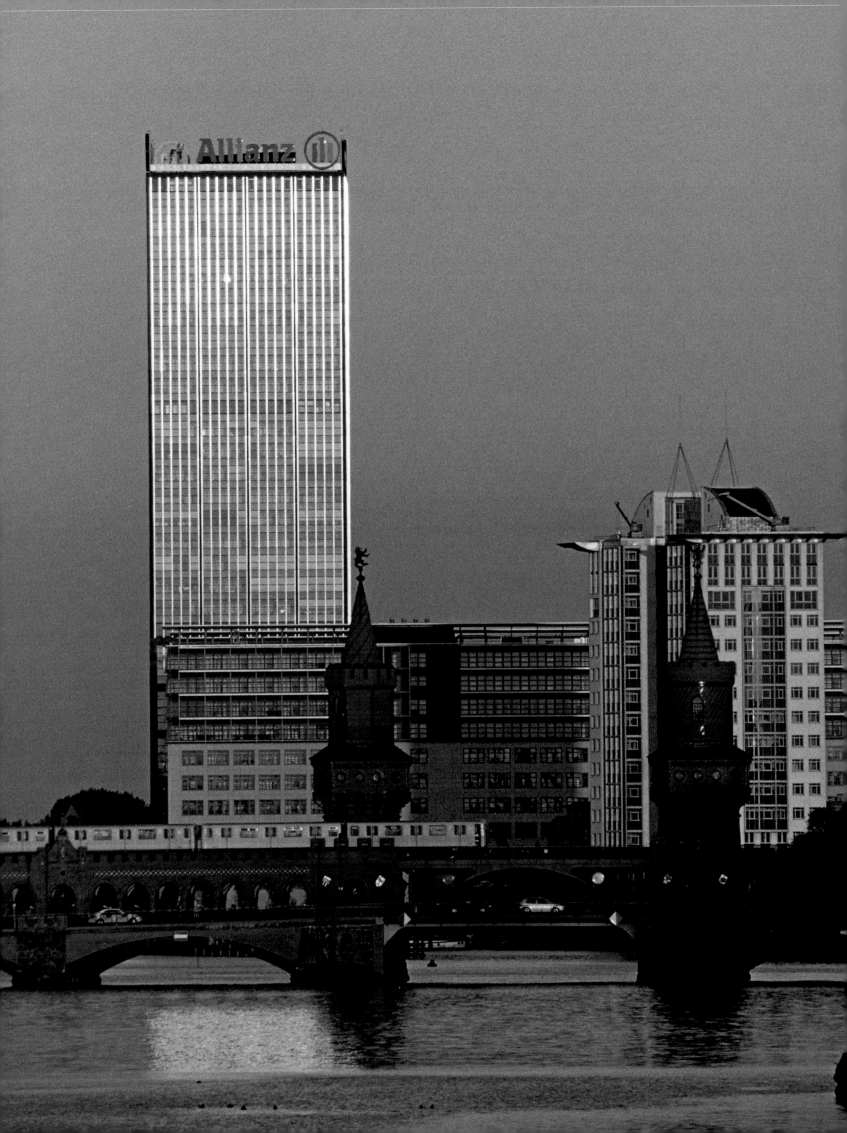

Left page:
The Treptowers defended by
the solid Oberbaumbrücke
which links Kreuzberg and
Friedrichshain across the
River Spree, here at almost
its widest point. Treptowers
is a word play on the nearby
district of Treptow.

During the GDR period
there was a checkpoint on
the Oberbaumbrücke shown
here. After the Reunification
the bridge, built in brick
from the Mark Brandenburg
by Otto Stahn between 1894
and 1896, was redesigned
by Santiago Calatrava.

Riddled with holes, Jonathan
Borofsky's huge metal Mole-
cule Men walk on the waters
of the River Spree.

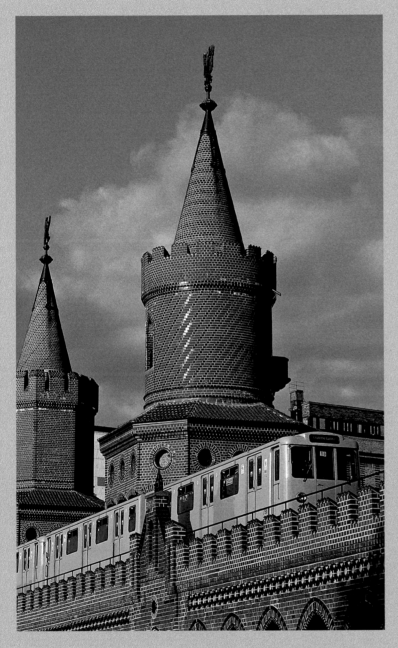

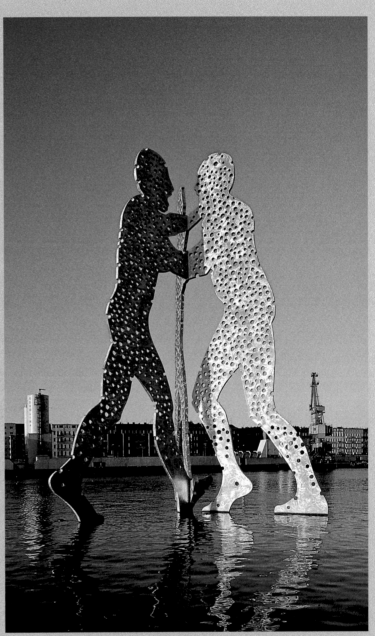

Page 114/115:
Two of Berlin's restaurants of
the moment: Freischwimmer
on converted houseboats
(left) and the Club der Visio-
näre, floating on a side arm
of the Spree at the eastern-
most tip of Kreuzberg.

THE "PROTECTIVE WALL AGAINST FASCISM" – THE MONSTROSITY OF THE
BERLIN WALL

Below:
Shortly after the Wall came down in 1989 a group of artists transformed a mile-long stretch of Wall near the Oberbaumbrücke into the East Side Gallery.

Up until November 1989/90 the following was *the* joke on everyone's lips. Now it's been forgotten, like almost everything else concerning the Berlin Wall. It went like this: the only place on earth where you can just go south is the North Pole. The only place on earth where you can just go north is the South Pole. And the

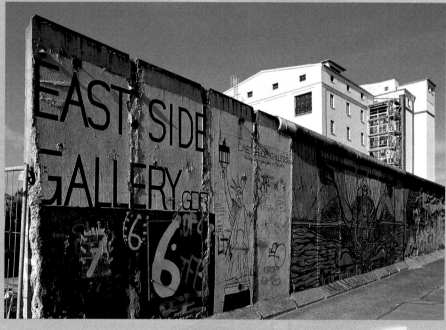

Right:
The mirror at the Wall memorial on Bernauer Straße between Wedding and Mitte is a sad reminder of the tragic scenes which took place here in 1961 when people made a last desperate dash for the West.

only place on earth which is surrounded by the East is West Berlin. People in the three Allied sectors of the city loved humour like this. Maybe they needed it to counteract the sad, hollow rituals which ruled their lives.

However dreadful the shootings along the 160 kilometres (100 miles) of "protective wall against fascism" were, however crippling the Wall proved to everyday life in Berlin, somehow people managed to cope, rearranging their lives to accommodate the monstrosity which

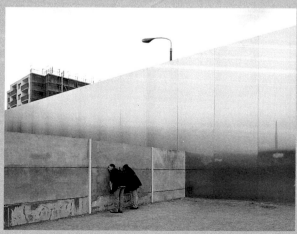

116

enclosed them. On both sides of it. Through the Four-Power Agreement of the 1970s, a good 10 years after the lightening erection of the Wall on 13 August 1961, West Berlin was able to adopt some kind of modus vivendi, cushioned by heavy subsidies from Bonn. The permanent confrontation between NATO and the Warsaw Pact within the city was indeed seen as threatening, but people tried to get on with their lives as best they could, lulled into a comforting sense of security by the much lauded "equilibrium of power".

All at once things changed. When on the evening of 9 November 1989 GDR politician Günther Schabowski announced an immediate freedom of movement between East and West at a press conference in the East, the night to end all nights fell over Berlin. A hastily produced supplement to the "Berliner Morgenpost" of 10 November printed the words of Berlin's mayor Walter Momper in big, dramatic letters: "Last night the German people were the happiest people on earth". Next to the headline was a picture of the Wall near the Brandenburg Gate onto which

hundreds had rapidly scrambled, drunk with a new-found sense of freedom. Now yellow with age in the city archives, the supplement is almost as obsolete as the 28 years of Wall. The old soviet boundary first fell prey to the "Wall woodpeckers", who chipped bits off it with a hammer and chisel, and then to the former GDR border guards, who brought in the heavies (pneumatic drills and bulldozers) to finish the job. Not much remains. There's the 1.3 kilometres (about a mile) of the East Side Gallery near the Oberbaumbrücke, smothered in artwork and graffiti, a few

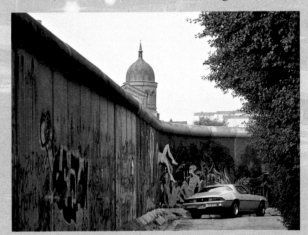

watchtowers (such as the one on Schlesischer Busch between Kreuzberg and Friedrichshain) and the remnant of concrete between the excavated cellars of the Gestapo at the "Topography of Terror" exhibition in Kreuzberg and the Ministry of Finance in Mitte, once Göring's old Imperial Air Ministry of the Third Reich. This was later the GDR's House of Ministries and after 1990 seat of the Treuhand administration charged with the privatisation of the national wealth of the GDR. At hardly any other place in Berlin is the city's history laid as bare as here on Niederkirchner Straße.

What has proved more resistant than the Wall itself, however, is the barrier in people's minds, a clear division between the mentalities of East and West. This phenomenon can be studied at length at the Museum at Checkpoint Charlie (Friedrichstraße), whose exhibits include various home-made means of escape, or at the documentation centre in Wedding opposite the Berlin Wall Memorial (on the corner of Bernauer Straße and Ackerstraße).

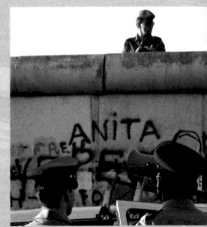

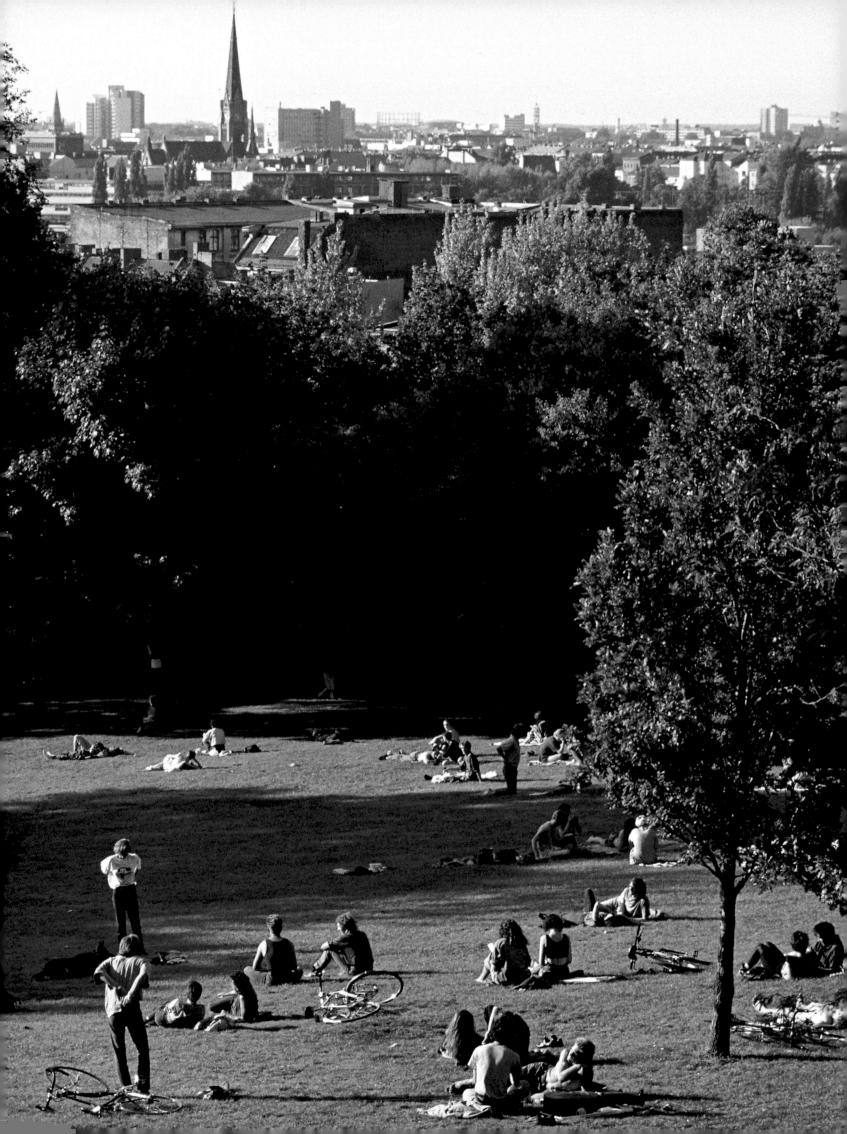

This unique town house on Landwehrkanal was produced for the international exhibition of building in 1987 by architects Hinrich and Imken Baller.

A rest is as good as a change; having a few lazy days off out on a floral, turn-of-the-century balcony in Kreuzberg.

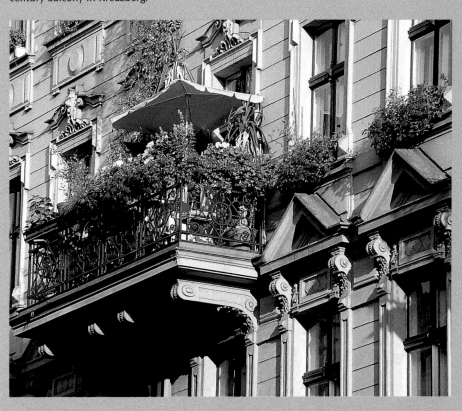

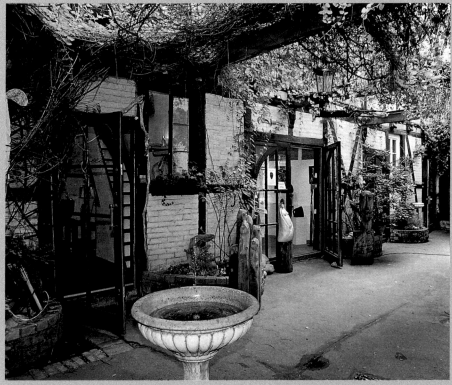

Left page:
Relaxing on the grass in Viktoriapark in Kreuzberg, where conditions are mild enough for vines to grow. Critics claim that the wine produced here is a "three-man vintage"; it's so terrible that the person drinking it has to be held down by two others.

The Kunstwerkhof tucked away in a courtyard on Solmsstraße is a manifestation of the great creative potential of the Bohemia of Kreuzberg.

A monument to the battles against Napoleon tops the artificial cascades built by Schinkel in Kreuzberg.

119

Below:
During the cultural revolu-
tion of the late 1960s Ludwig-
kirchplatz was to Wilmersdorf
what Kollwitz-Platz is to
Prenzlauer Berg and Simon-
Dach-Straße is to Friedrichs-
hain: the epicentre of the
student movement.

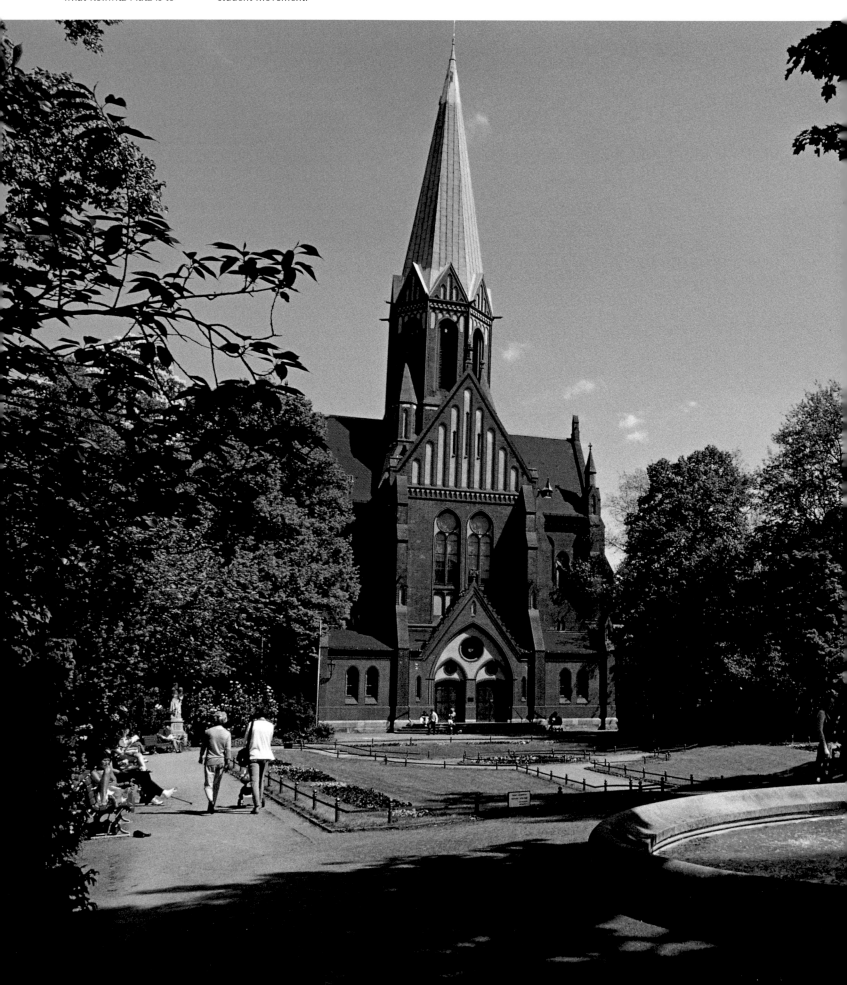

Small photos on the right:

Pomp and splendour on Fasanenstraße. These magnificent bourgeois residences from the "Gründerzeit" often have seven or more enormous rooms, with a separate set of stairs once used by the servants and an ancient bell-and-pulley system which used to summon the maid to the parlour with the tea. The Literaturhaus (centre), also on Fasanenstraße, has a charming garden café out the back.

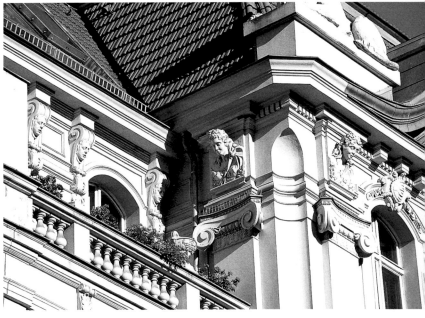

121

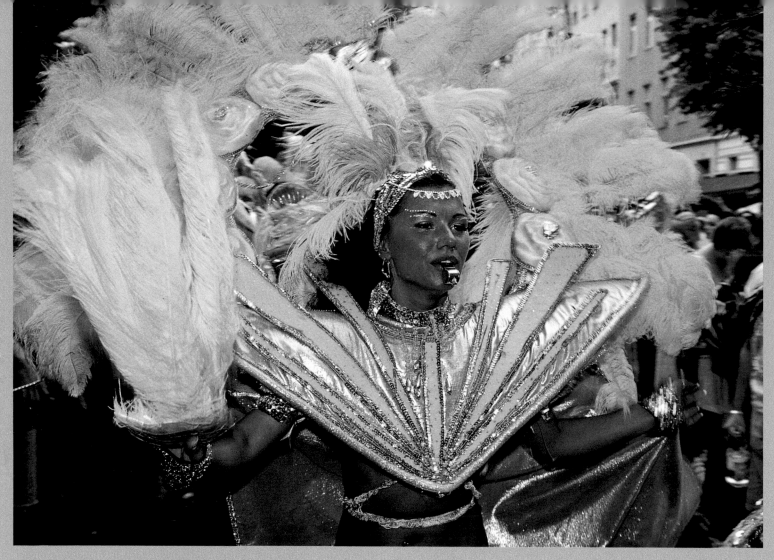

International, hip and extremely colourful, the Karneval der Kulturen in Kreuzberg is possibly the jolliest holiday parade in Berlin. Fans of ethno pop dance away to their heart's content among the multicultural floats and stands.

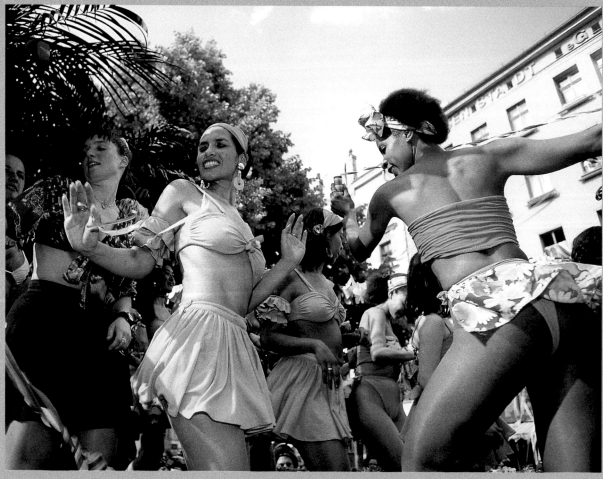

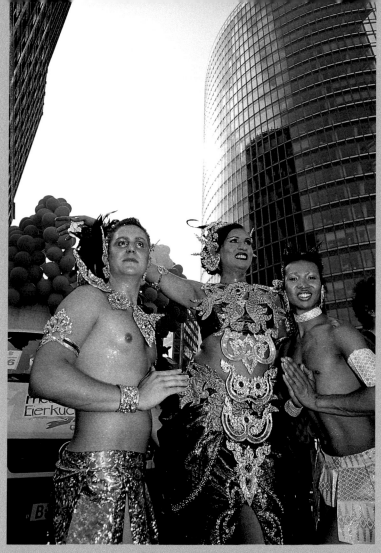

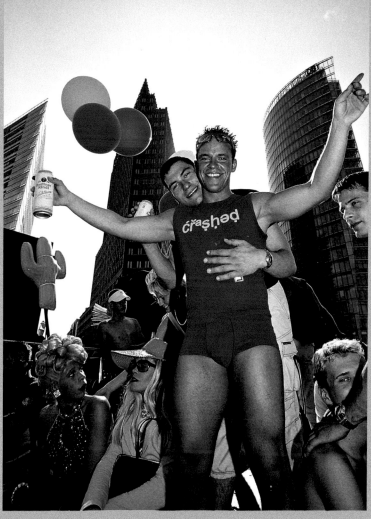

No less colourful and definitely bright and gay is Christopher Street Day in June, where the gay and lesbian community celebrate liberally and outrageously. Around half a million each year don their glad rags and take to the streets for the occasion.

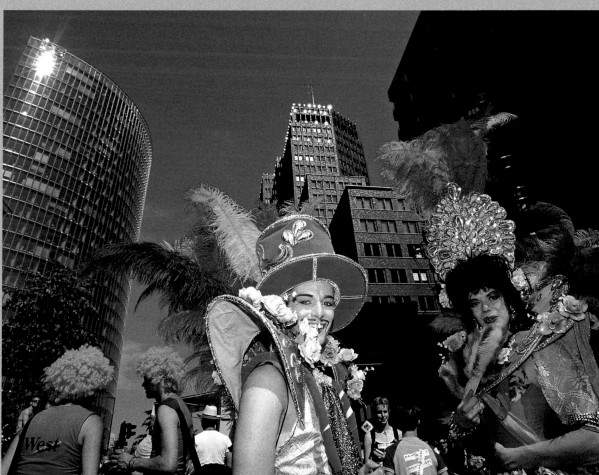

Below:
Bopping the night away at the KitKatClub, a hot favourite famous well beyond the boundaries of Berlin. Only those scantily clad are ad-mitted. The locations which are currently hip and cool are listed in the "Flyer" or the fortnightly "Tip" and "Zitty", the "Time Outs" of Berlin.

Top right:
The extremely popular Sage Club on Köpenicker Straße has three to four dance floors open Thursday night to Monday morning for the wild party animals of Berlin.

Centre right:
With its rough concrete pillars and light and video installa-tions, the Maria am Ufer club puts on a mixed programme of multimedia events, electro-nic music and live concerts.

Bottom right:
Like so many of today's in clubs, Polar TV on Heide- straße in Tiergarten is a mecca for house and techno fans. German director Bernd Eichinger has even been known to celebrate the odd film premiere here.

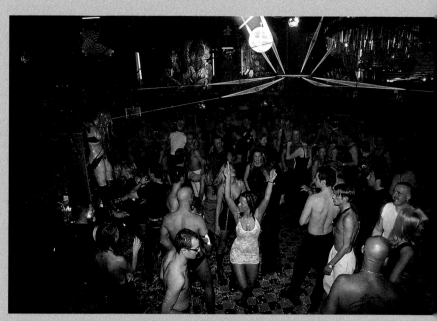

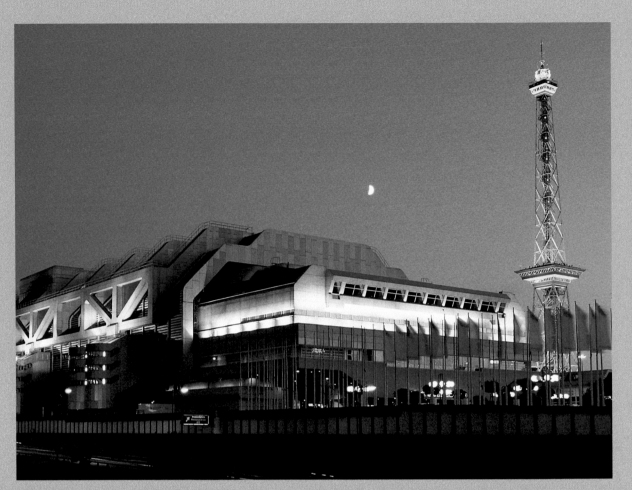

Right:
The International Congress Centre (ICC) at the Charlottenburg exhibition centre from the late 1970s is the Starship Enterprise of Berlin. The millions invested in it have failed to bear fruit and there are loud voices now calling for its demolition. This is, however, not likely to happen.

Below:
The new Tempodrom behind the ruined Anhalter Bahnhof has also hit the headlines with its debts and deficits. The multipurpose venue, reminiscent of Irene Moessinger's old Tempodrom tent, is used for concerts and party conferences.

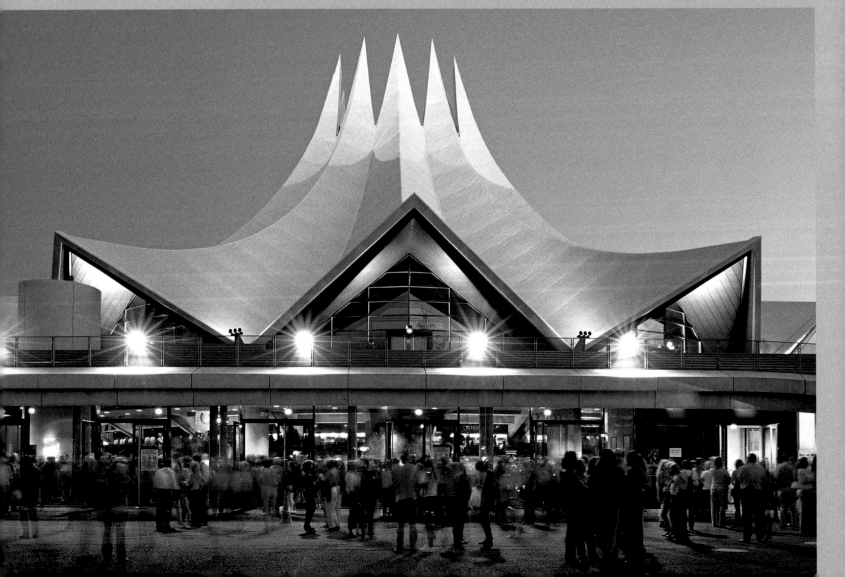

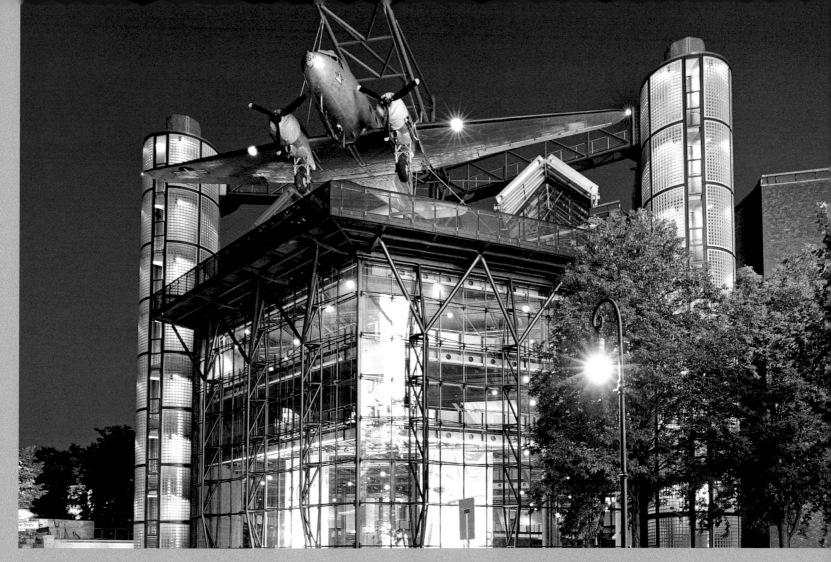

Above:
High up on the roof of Berlin's museum of transport and technology perches one of the "candy bombers" from the Berlin Blockade. Inside steam engines, replicas of the first computers and ancient gadgets and machinery provide technology freaks with hours of riveting entertainment.

Left:
The armadillo of the new Ludwig-Erhard-Haus in Charlottenburg. The building is used by the chamber of commerce and the Berlin stock exchange. The futurist interior is a popular backdrop for promotional films.

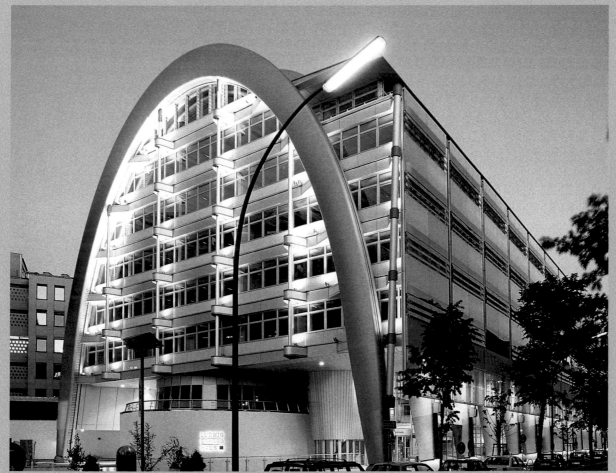

Below left and right:
Daniel Libeskind's Jewish Museum on Lindenstraße in Kreuzberg, a burst glass Star of David, has proved incredibly successful. It documents the history of the Jews in Germany. The tiny slit windows symbolise the streets Berlin's Jews were deported from during the Third Reich. One-and-a-half years after the opening of the museum Libeskind won the competition to build the new World Trade Centre in New York, destroyed by a terrorist attack on September 11 2001.

Right page:
At the Martin-Gropius-Bau on Kreuzberg's Stresemann-straße exhibitions on the history of art and culture are shown. Built in the style of the Renaissance by Martin Gropius and Heino Schmieden between 1877 and 1881, the museum was badly destroyed during the Second World War and not reconstructed until the 1980s. The galleries and glass ceiling of the inner atrium are impressive (below).

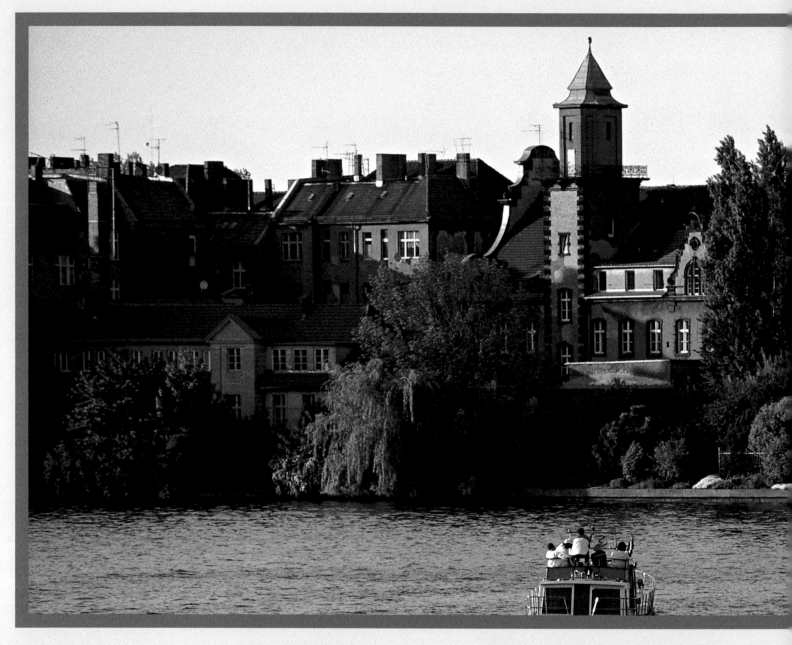

WHERE THE WILD THINGS ARE – THE SUBURBS OF BERLIN

The headlines of Berlin's dailies often boast of the wild goings-on in Germany's up-to-the-minute capital. The trendy clubs frequented by bright young party animals are not, however, where the real wild things are; for these you need to go to Köpenick, Hohengatow and the Schlachtensee on the edge of town.

This is where wild boar traipse from the Grunewald, Köpenicker Forst and Gatower Heide to grub around in what were once respectable front gardens, where deer and foxes are seen sniffing (and sometimes nibbling) the contents of terracotta containers on orderly patios and where nature-lovers go into raptures about the first pair of sea eagles to nest here for 150 years.

The people of Köpenick in the southeast of Berlin, once a fishing village, are spoilt for choice when it comes to water.

The men in orange who sweep the streets of Berlin are only too aware that this is an animal-friendly city; they have to dispose of 40 metric tons of dog droppings a day. On a less unsavoury note, Farmer Giles out in Spandau grows fields of strawberries and vegetables; even grain is cultivated within the city boundaries. Rural Berlin, with its medieval stone churches adorning village greens, with its dairy cows and fresh meat prepared by local butchers, is not everyone's cup of tea, however.

When the morning rush hour is held up not by the crawling convoy of the German president or the black limousines of a visiting head of state but by a tractor lethargically chugging along the suburban lanes, the country air resounds to the impatient chorus of angry horns.

ONKEL TOMS HÜTTE

The desire to live in the suburbs has prevailed for centuries. The occasional villa in Tiergarten, now very much part of the inner city, and the success of Schöneberg's millionaire farmers, who in the 19th century made a fortune selling off fields which had suddenly become lucrative building plots, are living proof. At the end of the 19th century a mass exodus began, away from the dark, claustrophobic, working-class back-to-backs so poetically described in Heinrich Zille's "Milljöh". The excellent public transport system enabled

131

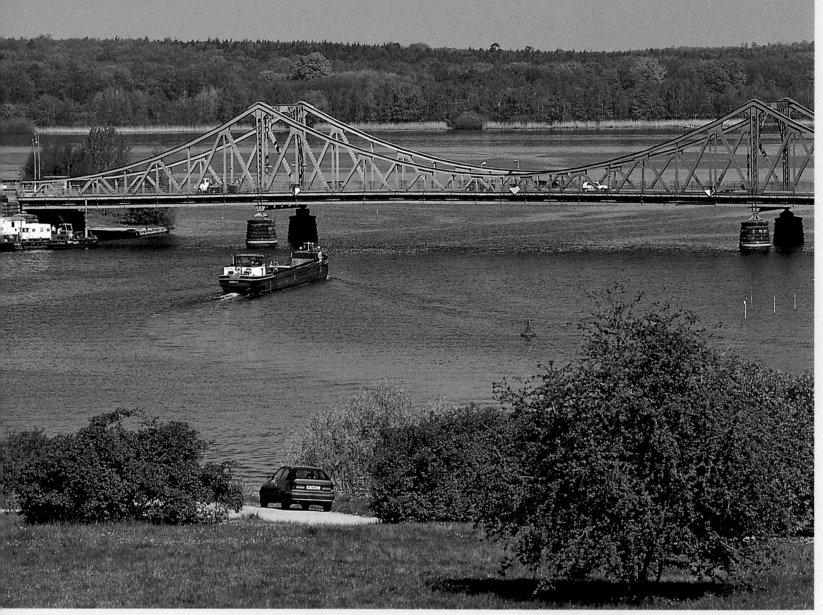

Above:
The historic Glienicker Brücke linking Berlin to Potsdam is the place where secret agents were exchanged during the Cold War.

Right:
On the Heckeshorn terrace in Wannsee, part of Zehlendorf, looking out over the River Havel and the Wannsee. From here you can walk along the shores of the lake to the Glienicker Brücke.

commuters to seek light and air in the new garden cities gradually evolving outside the centre. Still today the Britzer Hufeisensiedlung created by Max and Bruno Taut and Onkel Toms Hütte near the Krumme Lanke river, an estate of terraces and blocks of flats by the same architects, are considered exemplary.

Larger settlements, such as the Märkischer Viertel in the north and Gropius-Stadt in the south, were also built according to the Bauhaus principle, shooting up out of the ground during the 1960s and 1970s out in the sticks, surrounded by fields, meadows and forest. At first much coveted by would-be tenants, parts of these estates soon became a sociopolitical nightmare. Christiane F, the young drug addict whose horrific story was first serialised in a magazine and later published in English (and subsequently filmed) as "Christiane F – An Autobiography

of a Child Prostitute and Heroin Addict", was a product of Gropius-Stadt, her life just one example of the potential conflicts brewing in many of Berlin's tenement blocks.

The city's housing authorities are now making a huge effort to halt the sorry slide towards decline and decay – with some degree of success.

According to recent polls, many in the satellite towns can now identify with their particular district.

THE NOSTALGIA OF THE PREFAB

A very different scenario has established itself in Marzahn and Hellersdorf, stronghold of the GDR prefab "Plattenbau" which was the non plus ultra of modern living under Erich Honecker – and a definite improvement on the crumbling slums which proceeded it, with toilets in the stairwell and log-fired heating. After the fall of the Berlin Wall, however, families migrated en masse to the new semis springing up in the Brandenburg green belt, leaving 10 % of the "Plattenbauten" empty and in the hands of right-wing radicals.

When at the end of 2002 the first Eastern Block high-rise of the type WHH GT 18/21 crumbled to the ground no tears were shed. Those living in the remaining flats, which have since been extensively restored, are to profit from the re-claimed open spaces. Yet the "Plattenbauten" are still a thing of nostalgia, with models of WBS 70 and GT 18/21 on sale at any reputable outlet,

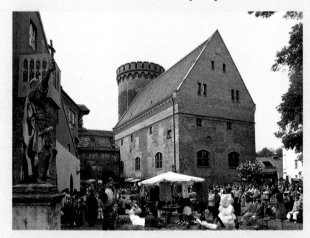

not to mention the dance theatre hit "Allee der Kosmonauten" (a street of prefabs), in which Sasha Waltz pays her respects to the colourful milieu of Marzahn.

Spandau in the west and Köpenick in the south-east come closest to Kurt Tucholsky's Berlin ideal of "Ku'damm up front and the Baltic behind

you". Both districts have an abundance of forest and water and old urban centres in common, also sharing a sense of separatism, of being something special within the giant conglomeration of Berlin. The fishermen's quarters of Köpenick and Spandau are also where the famous Berlin concept of the "Kiez" originated, the neighbourly city district so central to the life and identity of its inhabitants.

Of great importance to the people of Spandau, for instance, are the old town and citadel with its Juliusturm. The inhabitants of Köpenick, similarly proud, have developed a gushing local patriotism for their Captain of

Köpenick of Carl Zuckmayer fame, who is often seen heading festive parades. In 1906, dressed in a hired officer's uniform, their hero took Prussian law and order to the satirical extreme – and pilfered Köpenick's town coffers in the process. Even His Majesty was said to smother a smile on hearing of the rascal's great wit and cunning.

Below:
The great metropolis has swallowed countless tiny villages over the course of the years, each a community in its own right with its own parish church, such as this one in Alt-Marzahn. With many of them medieval and built of local stone, the environs of Berlin are a must for amateur historians and architecture enthusiasts.

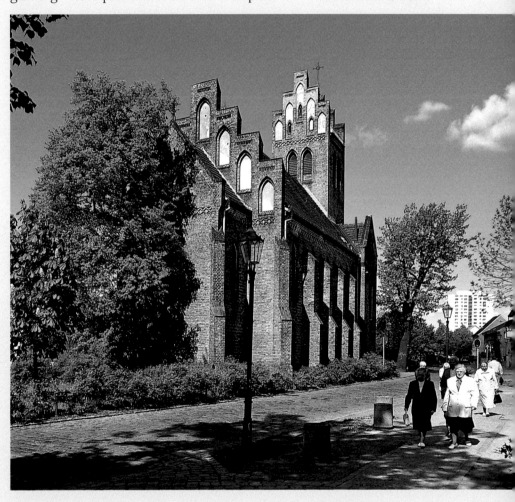

Above left:
The summer festival at the citadel in Spandau. In the background is the medieval Juliusturm, Germany's Fort Knox, which was where after 1871 the "golden treasure of the imperial wars" was hoarded, 1,200 chests of 100,000 gold marks.

Left page:
One of Berlin's most significant secular buildings from the 16th century is the citadel in Spandau, a moated fortress first mentioned in documents in 1197.

You would expect this photograph to have been taken in the Spree Forest or at least somewhere out in the country. This rural idyll can in fact be found in Neu-Venedig or new Venice, an aptly named part of Rahnsdorf in Berlin's Köpenick district.

Far from the madding crowds, but still in Berlin, is this peaceful stretch of water, the Tegeler Fließ in Reinickendorf.

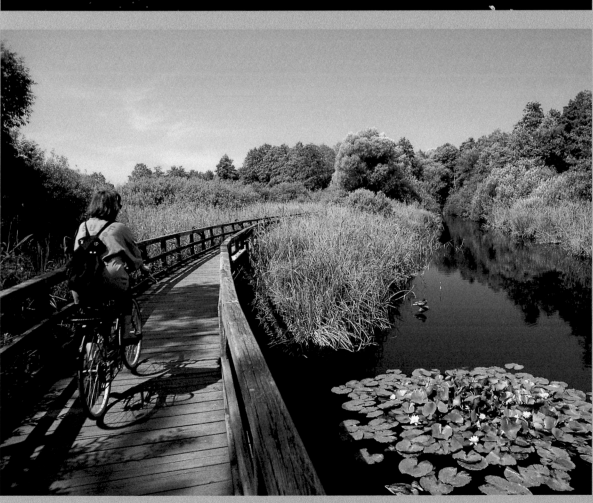

At the landing stage in Kladow the Lichterfelde ferry run by Berlin's public transport system is just about to head off for the Wannsee. The villages of Kladow and neighbouring Gatow are the most sought-after places to live in Spandau.

The Müggelsee in Köpenick is Berlin's biggest lido and glorious on a hot summer's day. The pathways around the lake are extremely green and pleasant and nowhere near as crowded as the Havel-chaussee on the other side of town.

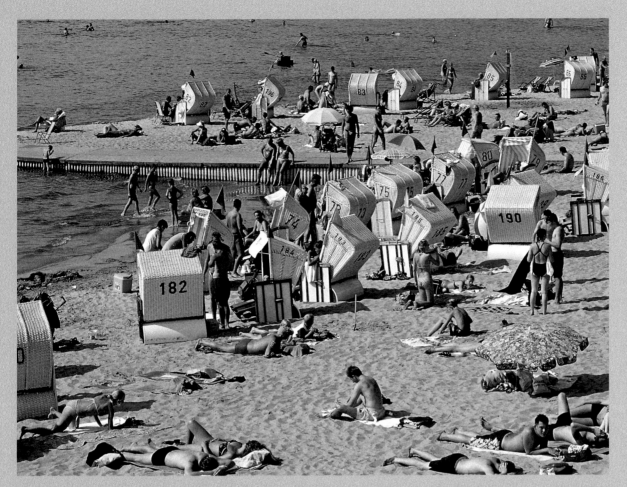

The Wannsee, idolised in an old ditty frequently hummed by Berliners packing their bags for the beach, is a good day out, with fun in the sun guaranteed. However, the sandy shores may be crowded in summer, packed with townies who can easily get here on the local S-Bahn rail service.

Locals find the tiny Teufelssee in Grunewald a bit freaky, probably because it's one of the haunts of the nudist community. Berlin's naturists are of a robust constitution, leaping naked into the icy waters as early in the year as March.

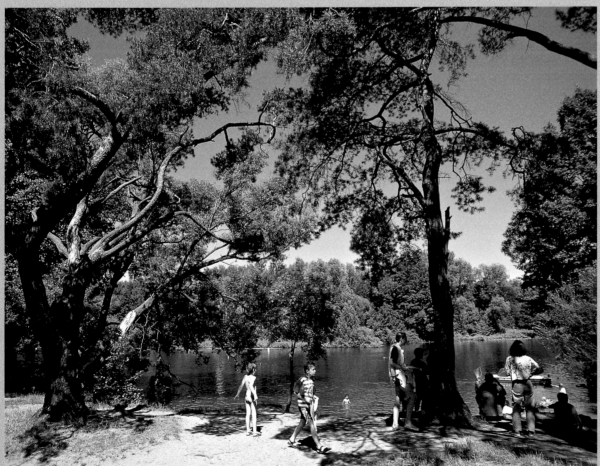

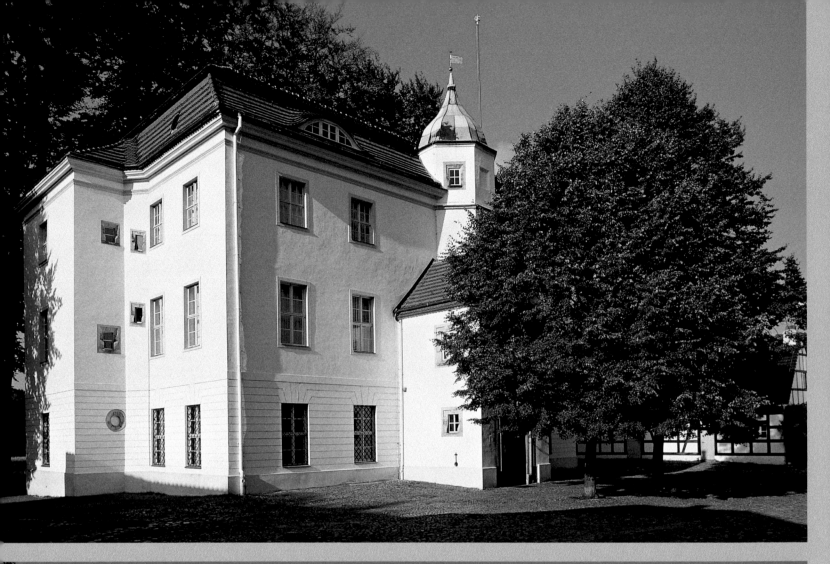

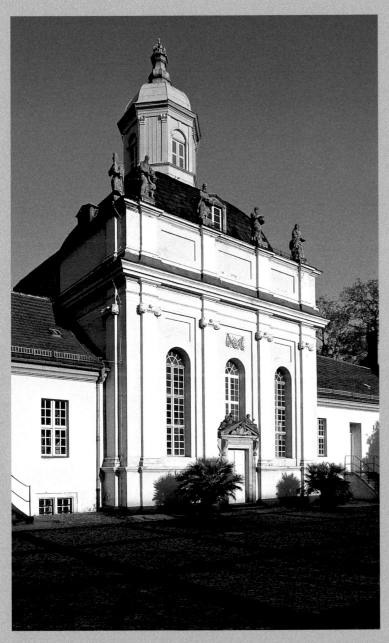

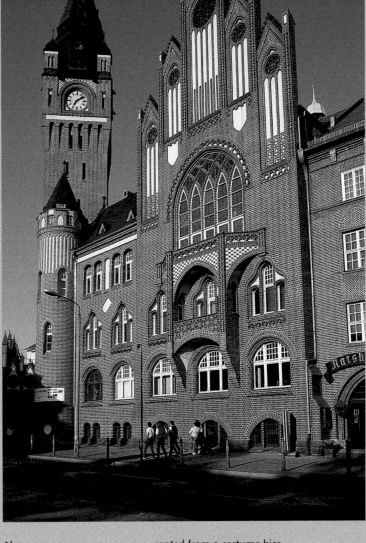

Left:
This splendid half-timbered
abode from the turn of the
last century, not far from the
S-Bahn station Lichterfelde-
West, is just one of the villas
in the commercial and busi-
ness sector of Zehlendorf-
Steglitz.

Above:
Built in 1684 from plans by
Johann Arnold Nering, the
palace chapel in Köpenick is
a celebration of the baroque.

Above:
Within these walls shoemaker
Wilhelm Voigt a.k.a. the Cap-
tain of Köpenick turned the
Prussian principles of law and
order upside down, pinching
the city coffers in the process.
Dressed in officer's garb he
rented from a costume hire
company, in 1906 he strode
into the newly built town
hall and took up office. He is
immortalised the world over
in Carl Zuckmayer's play "Der
Hauptmann von Köpenick",
premiered in 1931.

COUNTRY LIFE – BERLIN'S
VILLA QUARTER

Right:
Villa Marlier, built by architect Paul Baumgarten and better known as the Wannsee Villa, rose to sorry fame during the Second World War. On 20 January 1942 Hitler and associates met here to decide on their horrific "final solution to the problem of the Jews". The park has been placed under a state preservation order as it is one of the few gardens of the Alsen villa complex to have retained its original layout.

Centre:
Built in 1884/85 for cement manufacturer and building contractor Robert Guthmann: the architectural masterpiece at Am Sandwerder 5, seen here from the lake. It is now home to the Literarische Colloquium Berlin, founded by writer Walter Höllerer. The Gruppe 47 once held one of their legendary literary meetings here.

In Dahlem, Grunewald and Wannsee the villas are as splendid as those in Bavaria's Grünwald, where once upon a time Germany's 1970s TV detective Derrick beat crime among the millionaires of Munich. In the palatial colonies of Berlin the inspector would stumble across incriminating evidence at every turn – evidence of Germany's cultural past, that is.

ILLUSTRIOUS INHABITANTS

In Dahlem he would pass the place where Otto Hahn, Lise Meitner and Fritz Straßmann discovered nuclear fission (Thielallee 63–69). Here, among the university villas of "Little Oxford", he'd meander past the abodes of German MPs recuperating from marathon debates in the Cabinet. The political powers that be would prove difficult to investigate, however, his intrusion into their lives monitored by closed-circuit cameras and police patrols. In Grunewald the cultural detective would discover the houses where publisher Samuel Fischer (Erdener Straße 8), founder of the department store Wertheim (Winklerstraße 12) and theatre critic Alfred Kerr (Douglasstraße 10) once worked. The latter, incidentally, loved to ridicule the "millionaire's village" where he himself resided. One example

of this abundance of wealth – and that of the plant world – can be espied in the lush park of Villa Harteneck (Douglasstraße 10), now open to the public.

Industrialists, artists and politicians sought and still seek peace and quiet in the more idyllic areas of Berlin. Memorial plaques remind passers-by of the important men and women who once lived here. Even the top dogs of the GDR weren't adverse to the comforts of the good life. Majakowskiring in Pankow, for example, was popular with the Politbüro; until very recently, patient investigators could even spot Lotte Ulbricht, widow of the head of the SED, taking the air.

Other major architectural attestations of bourgeois living can be unearthed in Lichterfelde-West. Here, inventor and architect Gustav Lilienthal had mini mock-Tudor fortresses erected among the greenery. His granddaughter Anna Sabine Halle still lives in one of them (Marthastraße 5). The old lady still has an anecdote or two to tell about her great uncle, Otto Lilienthal,

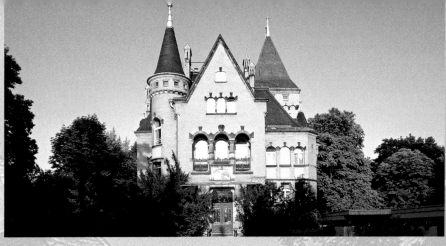

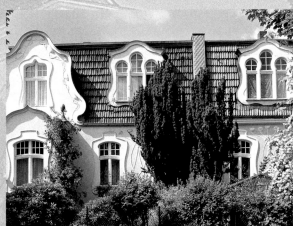

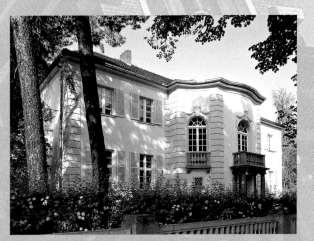

the aviation pioneer who together with his brother worked on models of his flying creations in the basement.

The people of Gatow south of Spandau also have a few tales to tell. When the Allies were still stationed in three of Berlin's four military zones, members of the English royal family often stayed here, taking their regal rest at Villa Lemm on the banks of the Havel (Rothenbücherweg/Am Ortsrand), then commandeered by the British military governor of Berlin. Even the Queen herself made her way here on her visits to the divided capital. Restored to perfection, the villa is now owned by entrepreneur and patron of the arts Hartwig Piepenbrock. One village further south,

in Kladow, Villa Oeding has also been elegantly restored; high up above the Havel, its facade glows an innocent rose pink (Am Roten Stein/ Imchenallee). The goings-on within its walls were anything but innocent; it was here that Hitler occasionally dropped anchor to visit his minister of propaganda Goebbels in his summer residence. An even blacker chapter in Nazi history unfolds in what has become known as the Wannsee Villa (Am Großen Wannsee 56–58). This is where on 20 January 1944 the "final solution to the Jewish problem" was found. A well-presented exhibition now documents the bureaucracy behind the worst butchery in human history, to which many in Berlin's villas tragically fell victim.

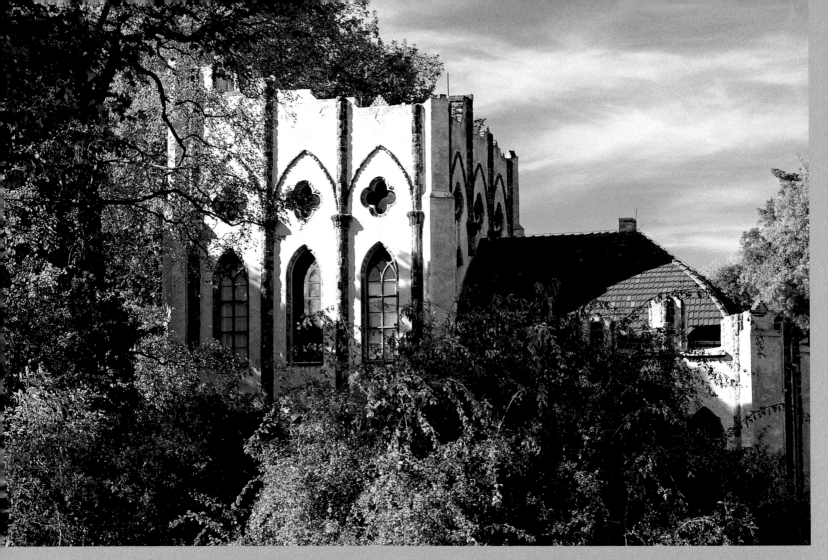

Above:
The Pfaueninsel (Peacock Island) is a masterpiece of German garden design and a prime example of the "sentimental garden landscape". Both the dairy farm in the north and the palace were built in 1795 as romantic ruins with all the usual neo-Gothic trimmings.

Right:
Between 1794 and 1797 King Friedrich Wilhelm II had this palatial residence built for his mistress Wilhelmine Encke on the Pfaueninsel. A narrow bridge links the two slender towers, while beneath a colony of peacocks roams the magnificent grounds. In the 17th century alchemist Johann Kunckel von Löwenstern invented ruby glass here.

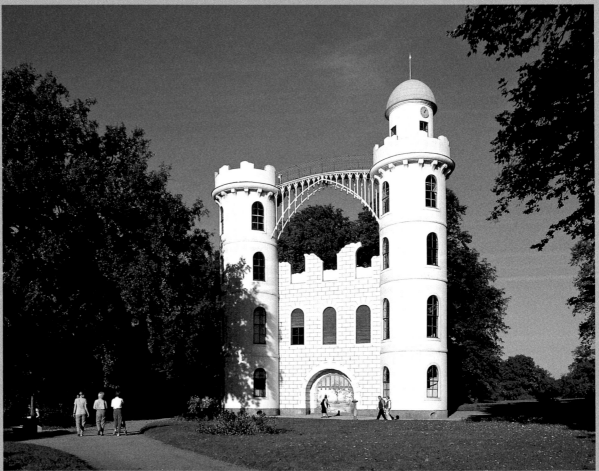

142

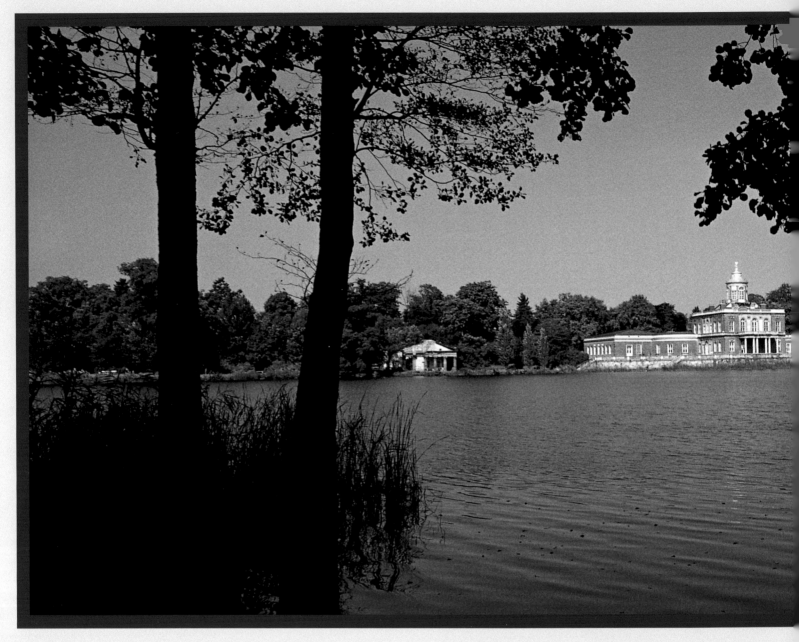

POTSDAM — PRUSSIAN SUMMER RESIDENCE OUTSIDE BERLIN

One of the easier questions posed by quiz master Günter Jauch in his popular programme on German TV could go as follows: Where does the "crème de la crème" of Berlin live? a) Paderborn, b) Posemuckel, c) Potsdam or d) Palm Springs? Potsdam is, of course, the right answer and where Jauch himself resides in a magnificent villa on the shores of Heiligensee, in neighbourly proximity to other stars seduced by the charm of the little Brandenburg capital. Among them are the former Swiss ambassador Thomas Borer-Fielding with his beautiful Shawne, Friede Springer, widow of publisher extraordinaire Axel Springer, fashion designer Wolfgang Joop and top model Nadja Auermann. The palaces and parks, now a UNESCO World Heritage Site, the many lakes

Carl von Gontard built this wonderful marble palace for Friedrich Wilhelm II between 1787 and 1791, choosing an idyllic setting on the Heiligensee in Potsdam. As the palace proved too small for the entire court, Langhans then added extra wings to the building which were linked to the main complex by arched galleries.

fed by the River Havel and the short distance from Berlin make Potsdam a place of enormous appeal for the ca. 140,000 people living here. Just across the Glienicker Brücke, the bridge where during the Cold War secret agents were furtively exchanged, is Zehlendorf, which with the Pfaueninsel, Schloss Kleinglienicke, hunting lodge and Nikolskoe log cabin is strictly speaking still part of the historic Potsdam landscape – although technically a suburb of Berlin.

POTSDAM'S PALACE: SUBJECT OF HEATED DEBATE

Like Berlin, Potsdam has a Brandenburg Gate. And like in Berlin, the reconstruction of Pots-dam's imperial residence, bombed during the Second World War and left standing in its ruinous state on Alter Markt until 1960, is also the subject of heated debate. One of the most voracious advocates of the rebuilding is the aforementioned quiz master. Günter Jauch was the man who promoted the erection of the Fortunaportal, an exact copy of an archway which once belonged to the palace. Whether the rest of the building will follow remains to be seen. Restoration of the old city canal, on the other hand, has progressed in leaps and bounds; the totally dilapidated Belvedere in Park Sanssouci, another war ruin, once again basks in its former glory. The old imperial station is also undergoing renovation. All that remains to be

put firmly back on the Potsdam map is the long vanished Garnisonskirche or garrison church. The local action group already has a lobby…

THE COLOURS OF PRUSSIA

When talking about Potsdam's past people like to paint things black and white – the old colours of Prussia. On the one hand the capital stands for military drill and blind obedience – of the type which led via the Day of Potsdam on 21 March 1933, which Hindenburg and Hitler sealed with a friendly handshake, to the horrors of Auschwitz.

In a totally different vein the town also effuses the liberal spirit of the Edict of Potsdam, signed in 1685, which enticed French Huguenots facing persecution at home to the incredibly poor state of Brandenburg in an attempt to boost the local economy. Potsdam is also a hot bed of culture, once frequented by great architects, artists Pesne and Watteau, Voltaire and Carl Philipp Emanuel Bach, with whom Frederick the Great made music in Sanssouci under the ornate golden cobweb which adorned the ceiling of his music room. The history of the old Ufa or Defa studios in Babelsberg is just as inconsistent; this is where movie classics such as "Der blaue Engel" (The Blue Angel) were filmed alongside Nazi propaganda material. One of Germany's most popular daily soaps, "Gute Zeiten, Schlechte Zeiten" (Good Times, Bad Times), is also produced here. You wonder if the title was chosen in deference to the history of the location…

Despite all this the town refuses to be painted black or white. Potsdam today is a rainbow of

colour, perhaps best epitomised by the costumed Langer Kerls meandering along the main pedestrianised drag, dressed in the bright uniforms of the soldier king. In the Holländischer Viertel or Dutch Quarter, erected between 1732 and 1740, or in the Russian Alexandrowka Colony which evolved in the wake of the Napoleonic Wars,

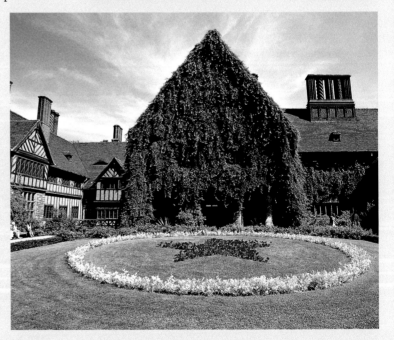

Centre:
Architectural contrast to the marble palace in the Neuer Garten in Potsdam is provided by this pyramid, created in 1791/92 by Carl Gotthard Langhans. It was originally built as an ice house.

Right:
A Russian-style house in the Alexandrowka Colony in Potsdam, constructed in the early 19th century for the Russian soldiers who had fought with the allied army against Napoleon. 14 houses have remained intact. The wooden cladding is for decoration only; the homes are built of stone.

Far right:
The last palace created for the Hohenzollern dynasty was Schloss Cecilienhof on the shores of the Jungfernsee, completed in 1917. It was built for Crown Prince Wilhelm and his wife Cecilie from Mecklenburg in the style of an English country manor.

The Chinese pavilion in the park at Schloss Sanssouci, completed in 1764, is an ornamental gem. Commissioned by Frederick the Great during the 18th century, it pays homage to the great Rococo fashion for all things Oriental.

wherever you turn the cosmopolitanism of the Prussian summer seat gently ridicules the stringent hues of its former livery. The same goes for the Einsteinturm built in 1924 by Erich Mendelsohn, where the Theory of Relativity was put to the test using astrophysics.

MAGNIFICANT ARRAY OF ROYAL RESIDENCES

The main attraction of Potsdam is and probably always will be its magnificent array of royal residences, with Sanssouci high up in the vineyards pulling the biggest crowds. The last will and testament of owner Old Fritz or Frederick the Great, who died in 1786 at the age of 74, was finally fulfilled in 1991 when his mortal remains were moved to their present location next to the monarch's 11 beloved greyhounds. The dogs enjoyed such regal status that fawning courtiers were required to address them as "Sie" – and not with the informal "du" usually reserved for animals and lessers. It's doubtful whether the dogs themselves appreciated such an honour…

Compared to the lavish rococo of Knobelsdorff's creation the other Potsdam palaces rather pale into insignificance. Considerably less public interest is shown in Schloss Charlottenhof, designed by Schinkel, in the proud status symbol of the Neues Palais or in Schloss Babelsberg, whose mock Tudor walls shook in terror each time William I and his better half were engaged in marital combat. One princely abode which should definitely not be missed, however, is Schloss Cecilienhof, erected between 1913 and 1917.

Built in the style of an English country house and equipped with all the mod cons, Churchill (and his successor Attlee) must have felt right at home at the domicile of the crown prince and his wife when in 1945 he, Stalin and Truman brooded over their post-war plans for Germany. This chapter in Potsdam's history is also one of its (Prussian) blackest; it was during the Potsdam Conference that Truman gave the order to drop atom bombs on Hiroshima and Nagasaki.

147

The Rococo palace of Sanssouci towers above the six vineyard terraces Frederick the Great had planted in 1744. The palace itself was begun the following year; construction took two years and was overseen by Georg Wenzeslaus von Knobelsdorff.

Above:
A sun decorates the arbour just outside Schloss Sanssouci which was planned as a summer residence for Frederick the Great. A bronze sculpture of a praying boy stands in the midst of the ornate lattice-work.

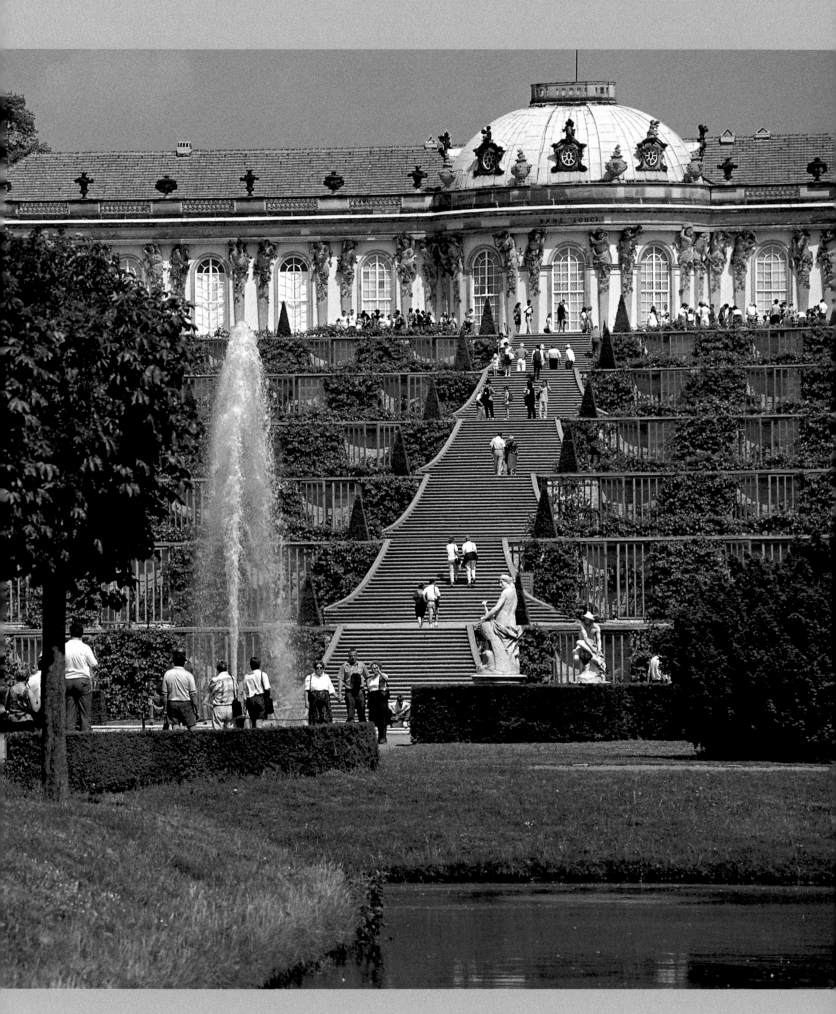

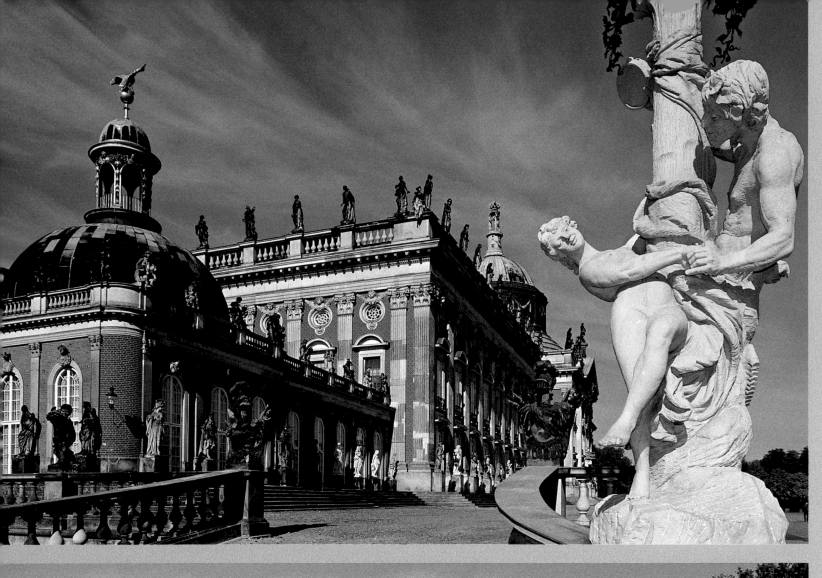
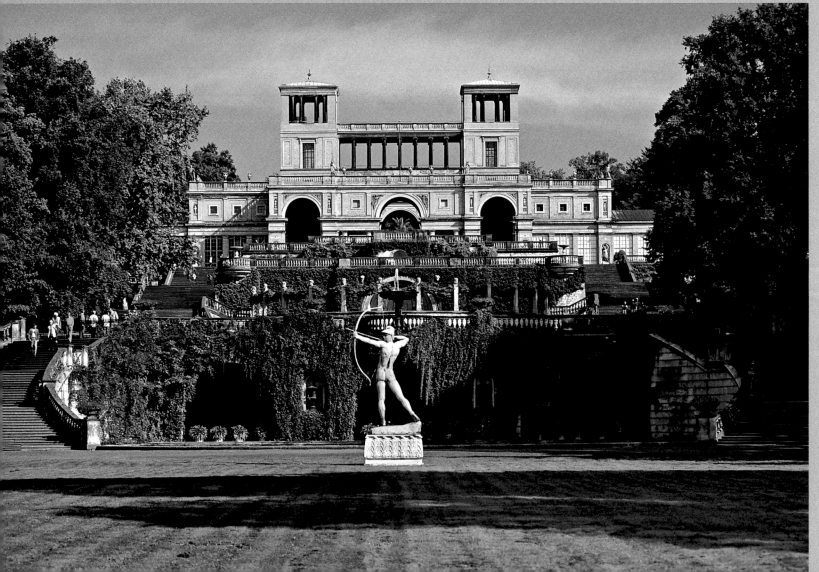

Left:
The Neues Palais Frederick
the Great had erected in the
west of Park Sanssouci is a
lot more pompous than Sans-
souci itself. Construction took

seven years, beginning in
1763 just after the Seven
Years' War, which financially
brought Prussia to its knees
yet nevertheless paved the
way for political supremacy.

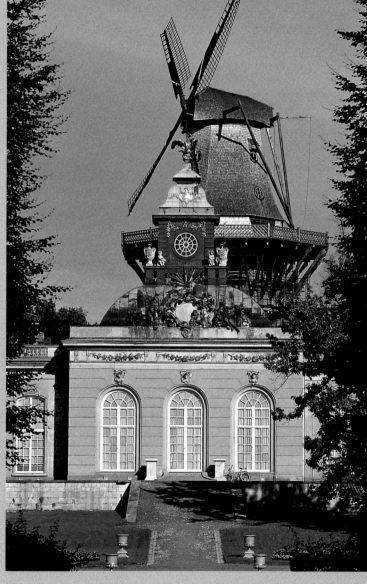

Left:
Between 1851 and 1864
the Mediterranean orangery
was built by architects
Ludwig Persius and Friedrich
August Stüler in the park at
Sanssouci.

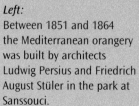

Above:
The Drachenhaus or Dragon
House in Sanssouci's park
was built in 1770 by Gontard.
It was home to the vintner
who tended the vines to the
west and modelled on the
pagoda at Kew Gardens in
England.

Above:
The stone mill at Sanssouci.
Frederick the Great is said to
have once taken a local miller
to court because his windmill
was too loud (losing his case)
when in fact he was settling
differences between Miller

Graebenitz and disgruntled
farmers. The present cons-
truction was erected in 1790,
four years after the demise of
Old Fritz, replacing an older
wooden mill from 1739 which
was destroyed by fire.

Above:
The Alter Markt in Potsdam. On the left is the Nikolaikirche, erected between 1830 and 1849 by Karl Friedrich Schinkel; to the right is the old town hall, now used for exhibitions, built from plans by Boumann and Hildebrant between 1753 and 1755.

Right:
A corner of the Dutch quarter, built after 1734 for Dutch craftsmen summoned to Brandenburg-Prussia by Friedrich Wilhelm I in an attempt to make the backward, rather desolate region more competitive in the struggle for supremacy over Europe. The majority of the crumbling buildings between Kurfürstenstraße and Gutenbergstraße have now been restored and house a pleasant array of galleries and little restaurants.

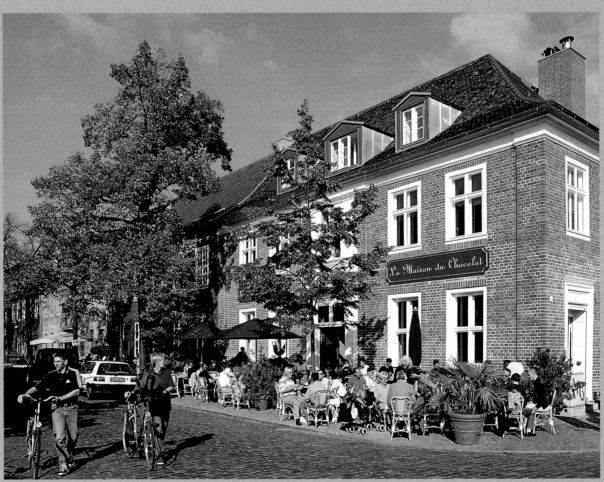

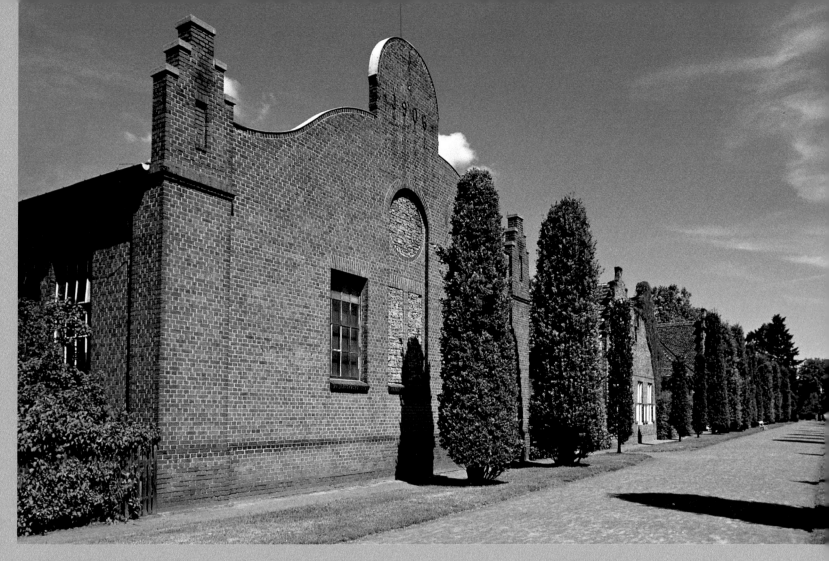

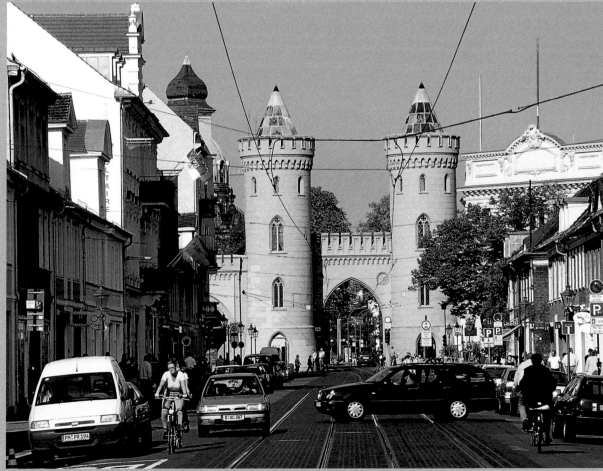

Above:
The red Kavaliersgebäude on the main drag of the Neuer Garten are also known as the "Dutch establishments", an architectural reference to the older Dutch quarter in the heart of Potsdam.

Left:
Tramlines run underneath the neo-Gothic Nauener Tor on Friedrich-Ebert-Straße, built in 1755.

153

INDEX

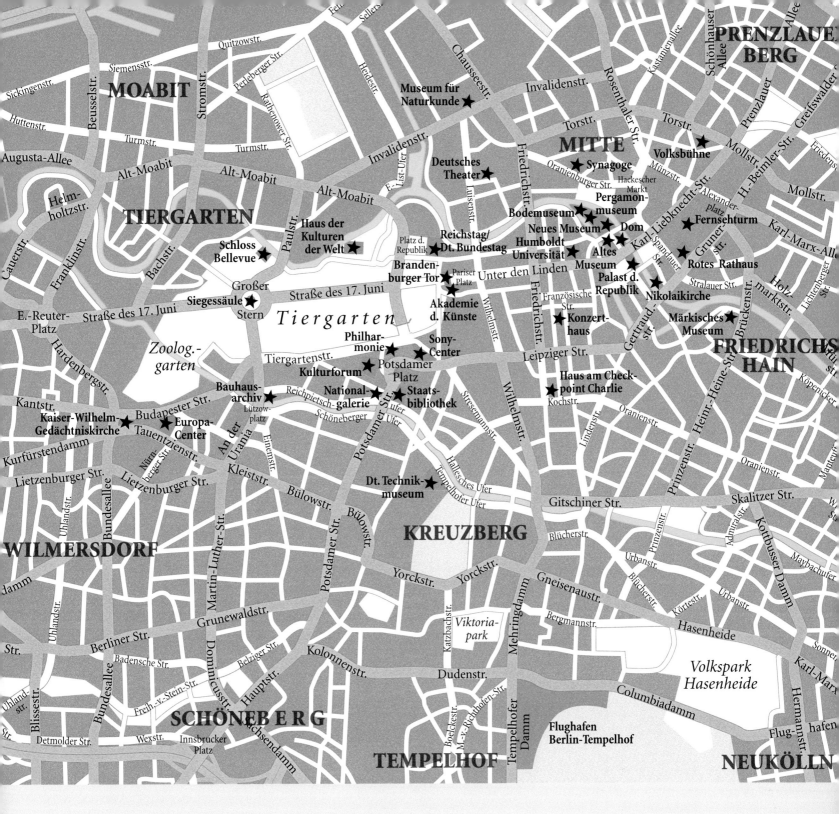

CREDITS

Design
Förster Illustration & Grafik, Würzburg

Map
Fischer Kartografie, Fürstenfeldbruck

Translation
Ruth Chitty, Schweppenhausen

Printed in Germany
Repro by Artilitho, Trento, Italy
Printed/Bound by Offizin Andersen Nexö, Leipzig
Typesetting by Fotosatz Richard, Kitzingen
© 2003 Verlagshaus Würzburg GmbH & Co. KG
© Photos: Jürgen Henkelmann

ISBN 3-8003-1617-X

Billy Wilder's in the Sony Center on Potsdamer Platz pays homage to the Hollywood film director whose greatest successes include "The Seven Year Itch", "Some Like It Hot" and "One, Two, Three". As a young man he worked as a reporter for the "BZ am Mittag" in Berlin.

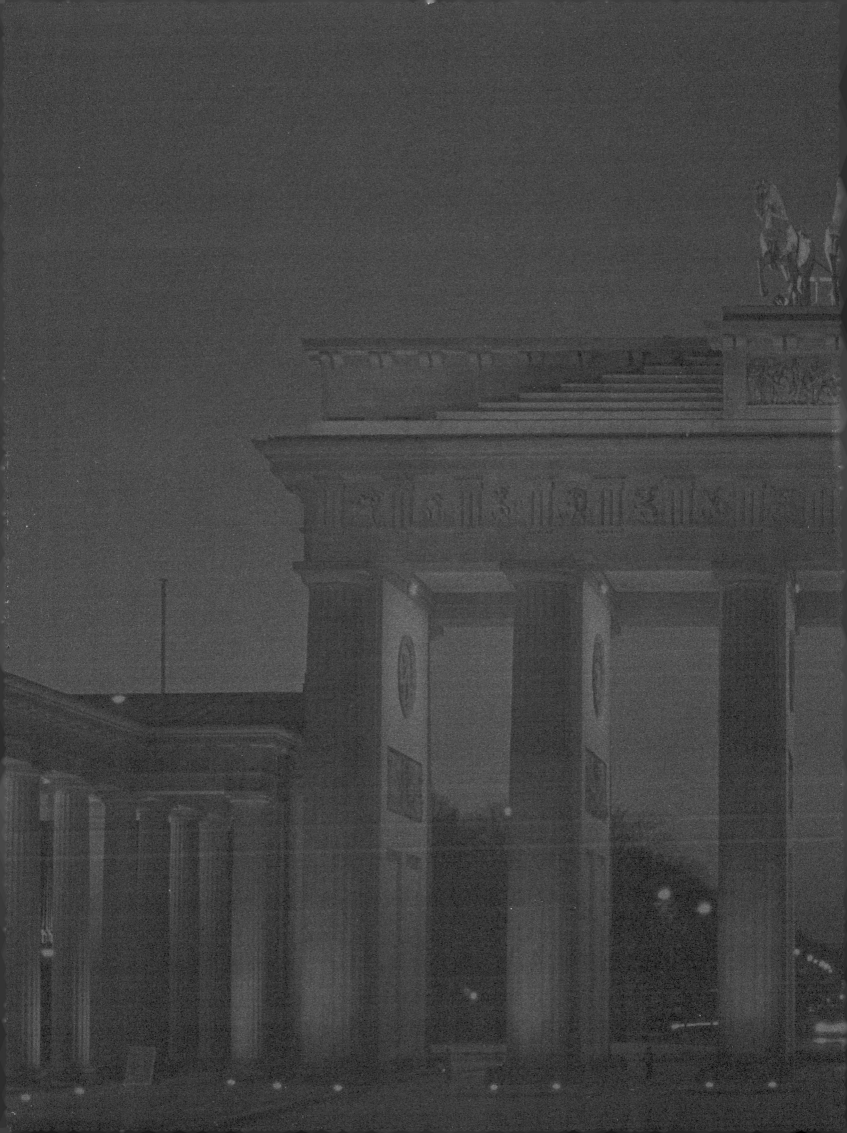